Burlesque

{and the New Bump-n-Grind}

Michelle Baldwin

foreword by Dixie Evans

SPECK PRESS | DENVER

Book layout and design by Margaret McCullough
www.magpiecreativedesign.com

Printed and bound in China

Library of Congress Cataloging-in-Publication Data

Baldwin, Michelle.
 Burlesque and the new bump-n-grind / by Michelle Baldwin.
 p. cm.
 Includes bibliographical references and index.
 ISBN 0-9725776-2-9
 1. Burlesque (Theater)--United States--History--20th century. 2. Striptease--
United States--History--20th century. I. Title.
 PN1942.B35 2004
 792.7'0973'0904--dc22

 2004001149

 10 9 8 7 6 5 4 3 2 1

Burlesque

{and the New Bump-n-Grind}

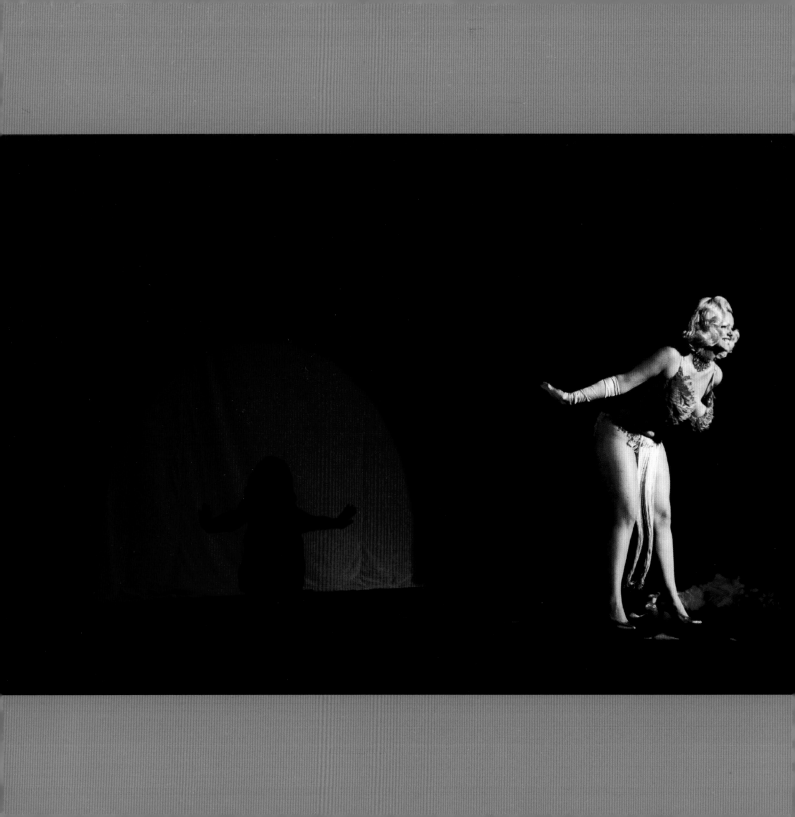

"I'm so proud of my naked daughter".

—Jane Baldwin

To my parents for their unwavering support and love.

Special thanks to Don Spiro and Luke and Laura for the care and attention put into their photography. And to all of the photographers, troupes, and performers who generously gave of their time and their art.

Thanks to all the burlesque folks who took a moment to chat and share their experiences in the nouveau burlesque and to all the Living Legends and all who came before them for helping to create this great American art form. Thanks to everyone who has ever performed or lent a hand to Burlesque As It Was, especially Andrew Novick, Janene Hurst, Aimee Buchwald, Casey Daboll, Laura Jockovich, Misty Dawn Patterson, Meredith Mangum, Jim Compton, Scott Zuchowski, Kamla Presswalla, Roslyn Bauer, Rob Hislop, Bill Boggs, and the Oracle Girls. Special thanks to Peter Yumi and Jake Cressman who made the dream come true and Jason Stoval who kept the dream alive. Thanks to Susan Froyd, Dick Kreck, Laura Bond, Kat Valentine, Ricardo Baca, and everyone else who wrote nice things about us/me, my sister Andrea Baldwin, my ever supportive extended family, and also Mary Robertson, Jerri Theil, John Wallace, Perry Weissman 3, The Stoolies, Frank Hauser Jr., The Down'n'Outs, Maraca 5-0, Dan Case and the 32/20 Jug Band, DeVotchKa, David Arthur and David Booker.

—Michelle Baldwin

Acknowledgements
Laure Leber, Richard Heeps, Dave McGrath, Suzy Swett, Misa Martin, Dixie Evans and The Exotic World Burlesque Museum, Catherine D'Lish, Bombshell Girls and The Lady Ace, Big John Bates and the Voodoo Dollz, Dames A'Flame and Madly Deeply, Gorilla X, Kitten on the Keys, Lavender Cabaret and Franky Vivid, Ronnie Magri and his New Orleans Jazz Band, Stella Starr, the Wau Wau Sisters, Jo "Boobs" Weldon, Margaret McCullough, Susan Hill Newton, Derek Lawrence, Faith Marcovecchio

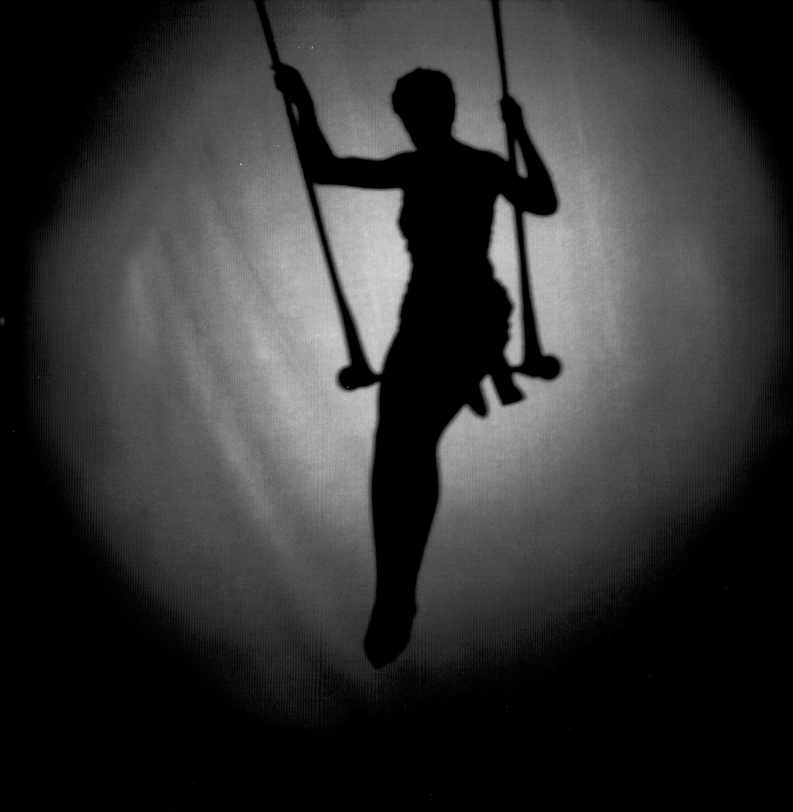

Contents

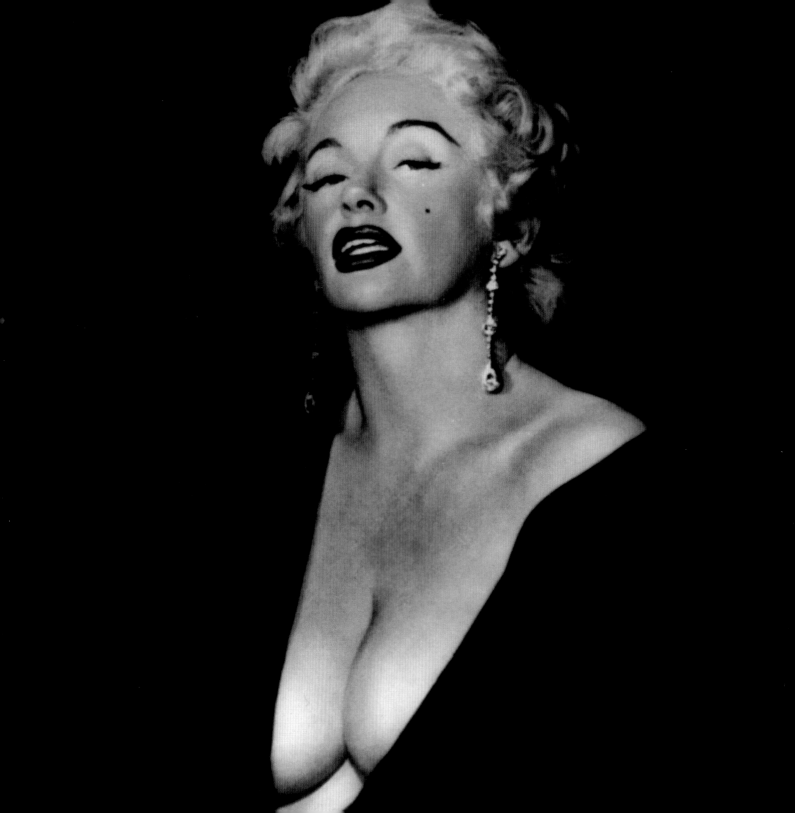

Foreword

Dixie Evans

You might not realize this, but there was a time before television, before the Internet, before cell phones, and even before VCRs and DVDs. Yes, once upon a time, when people wanted to be entertained, they went out.

Back in the day, there wasn't much affordable entertainment for working-class folks, but every major city in the United States had at least two or three burlesque theaters. And burlesque was unbelievably elegant, with white cloths on all the tables and wonderful brass bands, featuring the best musicians in the world. You'd see hilarious comics sharing the stage with stunning dancers with amazing, elaborate costumes, and props, and chorus lines that would take your breath away.

I'll never forget my first burlesque show: I was seventeen, and my boyfriend took me to see Tempest Storm. That titian hair! Those curves! Tempest was a goddess, and she had the entire audience in the palm of her hand. I was bowled over by the glamour and sexiness of it all, and knew right then and there what I wanted to do with my life.

I'd always been considered pretty, and worked as a figure model in my teens, posing for "girlie magazines." My father died when I was very young, leaving us with no means of financial support, and growing up with a single mother in the Great Depression I was taught to take advantage of every opportunity that came my way. Fortunately, while I was modeling, I landed a job at a theater, where another girl and I danced on stage to open the curtains. Somehow, I got noticed, and before I knew it I was onstage as a solo burlesque dancer.

The lovely and classy Miss Dixie Evans (left) runs the Exotic World Burlesque Museum to preserve the history of burlesque for future generations.

Although I was never a terribly good singer or a classically trained dancer, I was enthusiastic and ambitious. Originally billed as "The Southern Comfort Girl," after a year or two of traveling the circuit I met the legendary producer, Harold Minsky in New York. Minsky took one look at me, and said: "You're a dead ringer for Marilyn Monroe. That's how we'll bill you." Suddenly, I had a top gimmick, and was booked two years in advance. I adored Marilyn and always tried to honor her in my performances.

In those days, audiences didn't just pay to see a woman take her clothes off, they came to burlesque shows to be entertained. Every night, we performed for couples, servicemen, and women, people of all walks and backgrounds, often with only one thing in common: they had come to forget the drama of their "real" lives, and lose themselves in a glittering fantasy of live music, beautiful girls, and slapstick comedy. And we dancers constantly competed with one another to give them the best show possible. It was always a struggle to stay on top, but the competition kept us in peak form.

Like others who dedicate their lives to their work, success came with a high personal price for many burlesque performers, myself included. My mother was a religious woman, who never truly accepted what I did for a living, and constant touring made settling down to have a family of my own impossible. I did marry once, to a prizefighter, for thirteen years, but when I started getting jobs in Paris and London, it put

too much pressure on our relationship, and we ended up getting divorced. But burlesque was more than my profession, it was my passion, and I chose to follow the road wherever it took me.

By the time Marilyn Monroe died in 1962, burlesque as I had known it had changed. Television had arrived, and as it infiltrated more and more homes, fewer and fewer people were going out to see live shows. Dancers and musicians still performed, but theater managers were cutting back on club costs, and the whole scene began to lose its gilded glory. For a theater to hold on to the traditions—the bands, the big production numbers—and still make payroll and rent, while fewer and fewer people were coming out to fill seats, well, there was just no way. So the theaters closed, and burlesque just sort of faded away.

In its place, increasingly explicit performances began to replace exotic dance in the remaining clubs, and the suggestive, yet comparatively wholesome, legacy of burlesque was soon eclipsed by "amateur nights," all-nude reviews, and live sex acts on stage. Rather than "more strip, less tease," in most cases it had become all strip, and no tease.

In the years since I formally hung up my pasties, I've heard much about burlesque's demise at different points in history, and due to various, disparate causes. I've also heard much about its rebirth. Every few years, it seems, some new group "discovers" burlesque, and the magical alchemy of glitter, glamour, and guts that can transform even ugly ducklings into sensational swans.

Though I'm thrilled to see the media proclaim, "Burlesque is Back!" and the world at large catch up with those of us who've known all along how special it is—as a historical era, a unique American art form, and a remarkable means for self expression through music, dance, fashion, and beyond—there appears to be a common misconception that burlesque encompasses the entirety of live, adult entertainment, including forms that, however artful, athletic, or beautiful they may be in their own right, have little to do with burlesque's historical origins.

That said, I'm thrilled to see that burlesque as I know it is becoming popular again. I get such a kick out of the young performers who care enough about the art that they want to know about its past. These young girls, the ones who come and perform in the Miss Exotic World Pageant every June, the ones who go to Tease-O-Rama, and organize their own troupes and shows all across the country, may not know firsthand what the old days were all about, but they do have the fire, drive, and ambition to make it their own. This is the same fire that I felt burning in my heart when I first saw Tempest take the stage as a girl. This is the same fire that drove Jennie Lee to dream of Exotic World. And this is the same fire that keeps me going every day to help preserve that dream for future generations.

The future of burlesque may not look exactly like its past, but whenever a carload of wide-eyed young people pulls up to Exotic World, or a wild-looking,

green-haired girl with tattoos and a nose ring asks my opinion on the finer points of bump-and-grind, I feel more confident than ever that the legacy of classic—and classy—burlesque is in good hands.

Dixie Evans with good friend Jennie Lee on the ranch that is now home of Exotic World Burlesque Museum

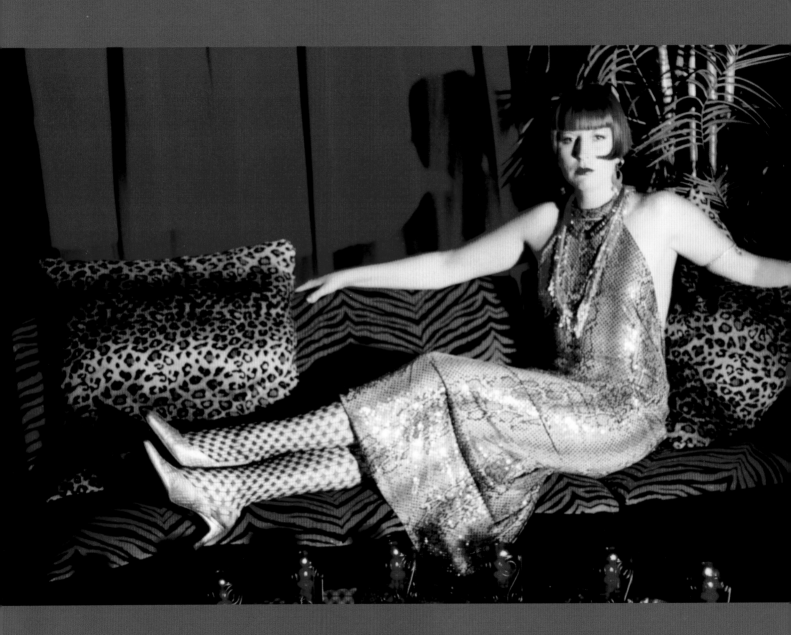

Introduction

Michelle Baldwin

Burlesque found me just after I'd finished college, it caught me in a moment where I was searching for who I was in the greater scheme of things, for what mark I wanted to make on the world. I'd seen photos of burlesque performers in the vintage pinup pictorials that were published in the wake of the swing-dancing culture's craze for anything retro; the statuesque, curvy ladies in their feather- and rhinestone-laden costumes fascinated me. So when the chance arrived to see one of these vixens in action, I jumped at it.

The Mercury Cafe in my hometown, Denver, Colorado, had been advertising a "Burlesque Show" featuring Evangeline the Oyster Girl. Years later I found out this was actually Jane Blevin, who was trained by the original Evangeline the Oyster Girl, New Orleans' Kitty West, but at the time, all I knew was that she was about to bring those old photographs to life.

She came with her own band, and they thumped and blew out a sexy, swampy tune as the giant oyster shell cracked open and the green-haired creature emerged with the pearl, rolling it down her stomach, lifting it into the air like an idol, offering it to the audience and then jealously pulling it back in.

The pace of the song leapt from a languorous beat to a whirling dervish, and Evangeline whipped around, her seaweed tresses flung behind her, her body convulsing, and her breasts popping out of her shiny silver top to reveal two glittering silver discs decorating her nipples. The audience howled as the music quieted and she slunk back inside her shell to wait for the music to lure her out again. I was smitten.

I ran to the library the next day and checked out Bernard Sobel's *Burleycue*, Ann Corio's "This Was Burlesque," and anything else I could find that mentioned the word *burlesque*. Through these texts I was introduced to the stars of the '40s and '50s—Gypsy Rose Lee, Tempest Storm, Lili St. Cyr, and other great performers. I learned about the famous Minsky New York Burlesque houses; the Columbia Wheel that hired early burlesque performers; and Lydia Thompson, who conquered America in the late 1800s with her British Blondes and started a theatrical revolution that would last one entire century and continues into the next.

A few months later I still had burlesque on the brain as I traveled to New York City. I'd seen in *Time Out New York* that there would be a burlesque show

while I was in town, the "Red Vixen Burlesque." After Evangeline and that first taste of burlesque, I was an addict and I needed my fix. My friend Ashton and I made it over to the Flamingo East, headed to the upstairs theater, and took our seats among the other curious hipsters. The emcee was a bit lame, but the performers were wonderful—a kitty cat in black glitter, a boy in an octopus G-string, a Betty Page look-alike on a cabaret chair, and a seventy-year-old magician who pulled off her black-and-silver velvet cape and held it in front of herself as if to disappear, but instead dropped it to reveal a shorter costume and a pair of surprisingly gorgeous legs.

I left New York with a new passion. Now that I'd seen burlesque on a small scale, I wanted to see it big. I wanted to see a show like the shows I'd read about, with sets and large props and spectacular costumes. At that time the Shim Shamettes and the Velvet Hammer were both producing that kind of spectacle, but I was too far inland to have heard about them.

So I decided to create my own show. I'd never done anything like it, but I pushed ahead nonetheless. A friend introduced me to Peter Yumi, a local eccentric with a great creative mind who was also the son of a former Siegfried and Roy costumer. Peter found the girls, worked on the costumes, and spread the word. My friend Jake Cressman built a rocket ship for the space girls, waves for the mermaid, and a giant lighted staircase to make the girls look like they were descending from heaven. I brought in a few local

musicians to accompany the acts, convincing them that though I couldn't pay them, they'd be re-creating history, reviving a dead art … and that it'd be fun!

Jim Compton, a brilliant designer and friend, helped me put together my first flyer, which announced "Burlesque … As It Was, Sunday July 26, 1998, 8:00 P.M. SEE: Fascinating vaudeville performance, Hilarious comedy, The most beautiful women in Denver burlesque!" I stole a quote from an old burlesque ad: "Our girls combine all the requisite qualifications for burlesque in a higher degree than any of the rest. They are simply irresistible, brilliant in appearance, and full of piquancy." I'd hired jugglers, The Stoolies, found a kid who did yo-yo tricks and rode a unicycle in an old-timey suit, and convinced my own sister, Andrea, to put together a little tribute to one of Natalie Wood's numbers from *Gypsy*.

The night of the show, I was a wreck—fretting about the details, afraid no one would show up. That worry was absolved an hour before the show when I heard that there was already a line around the block. Now all I had to worry about was whether anyone would like it. And soon that worry left me too as the audience hooted and hollered for the girls. They booed and catcalled the comics and yelled for more when the curtains closed at the end of each girl's act. Most of the girls in the show didn't quite "get it." Their background was in modern stripping, and their dance moves sometimes left too little to the imagination, but they still understood that it was all to be

done with a sense of fun, a wink, and a smile—and the audience loved it.

In the end no one got paid, as I'd spent all my money renting the theater, printing flyers and tickets, and creating costumes. And the greatest irony of the evening was that though I'd created this thing so I could see a big burlesque show, I was mostly downstairs coaching and dressing the girls and taking care of things backstage—I'm not sure I saw more than pieces of each act. When it was all over, I swore I'd never do it again—it was too stressful and too expensive. But over the next few months I started getting calls from women who had seen the show who loved it and were interested in doing another. I kept putting them off, giving them my sad story of debt and exhaustion. Then Jason Stoval from Grim Productions called and offered to help me get the money through advertising dollars, to get us booked into the theater rather than having to rent. I promised I'd do another show if he got the dough together, never thinking he would. He did. And I've been doing burlesque ever since.

As the movement grew I learned about and eventually came to know other troupes and other girls in other cities. Mostly we communicated via e-mail, which seemed ironic: modern technology connecting a community reviving an old-fashioned art. It was through this kind of networking that the first burlesque convention, Tease-O-Rama, was born in 2001. Old stars were rediscovered and revered as "living legends,"

and from them we had endless fountains of knowledge and a better view of who and what had come before us.

The neo-burlesque community had its growing pains. There were those who wanted to define burlesque as one thing or another, who had either an overly modest vision of burlesque or a questionable and overly risqué interpretation. However, overall, the consensus was that as long as it was sexy, comedic, and fun, it was likely burlesque.

Most of us don't strictly re-enact historical acts, rather we reinterpret burlesque for our own time and to our own tastes. For the ladies of burlesque—from Lydia Thompson in the 1860s to Dixie Evans, Kitty West, Satan's Angel, Cynthiana, and others who watched it fade out in the 1960s—burlesque was a commentary on their time. Now, the new burlesque is influenced by and a reflection of our time.

None of us know if this wave of burlesque will endure. We do know that regardless of whether it can hold the attention of the MTV generation, the spirit of burlesque will live on, as it always has, as an art form that is originally American and uniquely feminine.

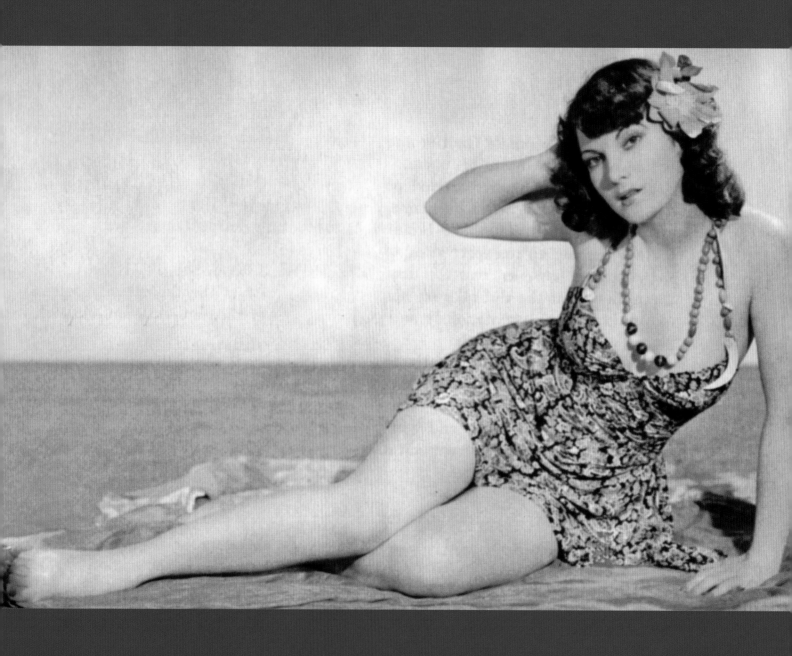

History of the Tease

The Golden Age

When Ann Corio, a former burlesque queen of the 1920s and 1930s, called her 1960s revue "This Was Burlesque," she was publicly declaring what the masses already knew was true: burlesque was dead. It had lost the charm and comedy of its early days and had devolved into rough and artless nudie shows, the predecessor to the modern strip club.

Corio was a star during what is known as the "Golden Age of Burlesque." In those days every major city had multiple burlesque venues and burlesque stars toured, playing to packed houses and commanding top dollar. Comedians still hammed it up between dance numbers, and the theatrical genre held on to its early roots in sexy satire.

Those roots grew from a seed planted in the late 1800s by British actress Lydia Thompson. Thompson, accompanied by her British Blondes, conquered the American stage with their satirical and bawdy performances and revealing (for that era) costumes. Burlesque existed before Thompson, but only as parodies of plays that mixed classical theater with humorous commentary on events of the day.

Dancing across the stage dressed in skirts cut above the knee, their legs clad in pink tights, Thompson and her company shocked and delighted New York audiences with their brief costumes, portrayals of classical male roles, and integration of witty satire between the lines of respectable text. This potent theatrical cocktail of sex and wit proved to be irresistible to audiences. In their first season, Thompson's troupe brought in $54,487 in one month, more than any other New York theater in the two preceding years.

Ann Corio reclines in her island-girl themed costume. The burlesque performers of her day made big headlines, and Corio kept the spirit alive into her later years.

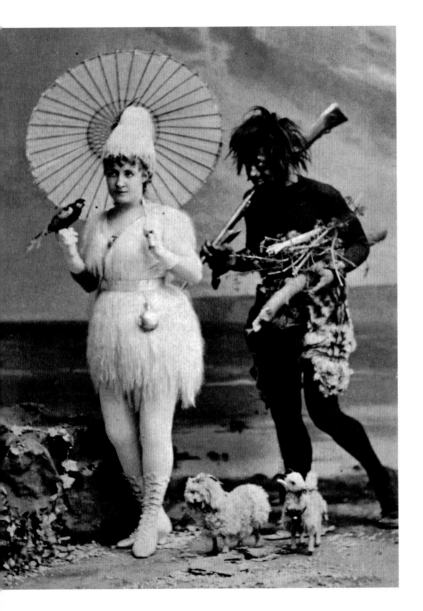

After conquering New York in 1868, Thompson and her troupe quickly moved across the country, through Chicago, New Orleans, Saint Louis, Cincinnati, and other major American cities, changing the landscape of theater as they went. In their wake could be found other theater companies, who upon realizing the mass appeal of burlesque brought it into their own theaters. Their focus, however, moved away from the quick wit of the cross-dressing ladies to their sexy costumes and what they revealed.

As burlesque became more commonplace and less novel, it moved out of the arena of middle- and upper-class entertainment and into the smaller theaters of the working class. As with any mass-produced entertainment, those in control were interested less in the art of burlesque and more in the money, and they seemed to believe that it was the physical form of the girls, not the substance of their performance, that brought in the crowds.

Soon "hootchy-kootchy" dancers, who based their movements on belly dancing and other Oriental dances, joined the show. First seen on the Midway at the 1893 Chicago World's Columbian Exposition, dancers performed scintillating hip gyrations with their navels exposed. Long lines of curious Americans poured out of the "Streets of Cairo" and Algerian exhibits, queuing up for the chance to be among the first to glimpse the exotic imports. The moralists of the time denounced the hootchy-kootchy, but the fair refused to remove the exhibit, as it was of ethnological interest and

importance, meeting the exhibition requirements. Fair organizers also knew that up until the public heard about the hootchy-kootchy dancers, the fair had been a terrible failure. Known as the "White City" for the beautiful and immense whitewashed architecture, the Chicago World's Fair was laid out among stunning and innovative landscaping and filled with modern feats of technology and fascinating scientific and historical displays, but the public wasn't interested. The best architects and designers of the day had been brought in to create the fair, and there had been numerous setbacks and disasters, all costing millions. When the fair opened, the first few days were successful, but then attendance dropped off and the White City was a ghost town. However, attendance picked up as word spread about the exotic dancing exhibit. The great crowds the dancers brought in were credited by some for having saved the fair.

The most famous and popular of these dancers was Little Egypt. She claimed to be a native of Armenia whose birth name was Fahreda Mahzar Spyropolis, though both her name and birthplace were likely much less exotic. However, audiences didn't seem to care about the authenticity of the dance, they were simply fascinated and aroused by the quake of Little Egypt's hips and stomach.

Sadly, after the fair, burlesque started to focus solely on the appeal of the female form rather than the female wit, and women in burlesque were relegated more and more to only performing mute and frivolous

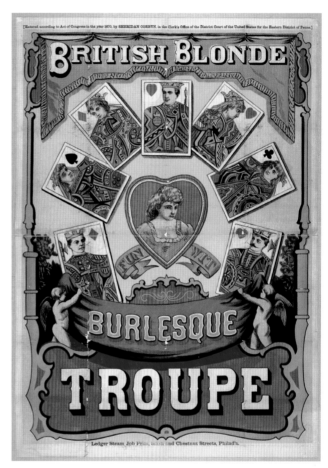

One of the many colorful lithographs (above) produced for Lydia Thompson's "British Blonde Burlesque Troupe"

Lydia Thompson (left) shown here posed in a promotional shot dressed as Robinson Crusoe with her man Friday in tow

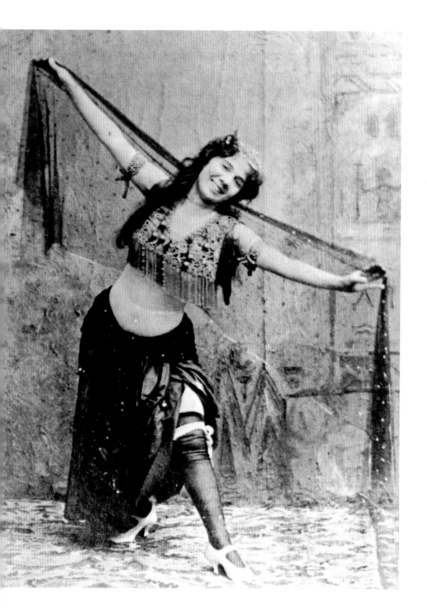

dances. Men took over the speaking parts, comedy bits, and lowbrow scenes. As burlesque continued to change, women were allowed to speak again, but only in "talking women" roles where they played ditzy broads or vile vixens as defined by the humor of the male comics.

The Great Silencing

Though their leggy figures still dominated burlesque posters, women's influence on the burlesque stage was diminished. In the century following Lydia Thompson and her ranks, women did, however, try to step back out of the shadows.

Sophie Tucker sang songs filled with double entendres and Eva Tanguay moved about the stage with sexual abandon. But these women were old and overweight, and since audiences did not find them physically attractive, their aggressive sexuality wasn't threatening. It was considered comedic. There were also Bessie Smith, Ethyl Waters, and Lizzie Miles whose pointed musical sensuality was subjugated by the their "otherness"—they were African American and their ethnicity kept them out of mainstream white performance venues. However all of these women did, in their way, help to preserve and carry on a little of Lydia Thompson's spirit.

The most successful woman to carry on the Thompsonian torch was Mae West. She wrote songs that emphasized naughty lyrics and coupled them with erotic gestures just to be sure the audience got

the joke. Though she longed to make it in vaudeville, her divine figure, combined with her sexy humor, was considered too blue for the big time. Vaudeville frowned upon theater that addressed the audience directly, and West talked to the audience like it was an old friend who was in on her jokes and privy to her randy view of the world. Claiming to have single-handedly brought the shimmy down from Harlem herself, she performed the sexy body-shaking dance, which, at that time, was considered the newest form of the old cooch dance and, again, far too related to burlesque for vaudeville to embrace it or her.

However, West blew past the stuffy old variety shows and headed straight to Broadway with her shocking stage plays. Theater about strong women characters who used their sexual charms to dominate men didn't appeal to the men who were in control of most theatrical production companies, so West produced them herself. For her first show, explosively titled *Sex*, she found the financing, put up some of the money herself, and hired her own producer and director. The show was a smash success when it opened in the spring of 1926, but a year later West, along with her producer and director, were charged with putting on an indecent and immoral play and each served ten days in jail. But this didn't stop West from going on to create more scandalous works such as *The Drag, The Pleasure Man*, and *Diamond Lil*. All were box office smashes except *The Pleasure Man*, which was shut down by police on opening night.

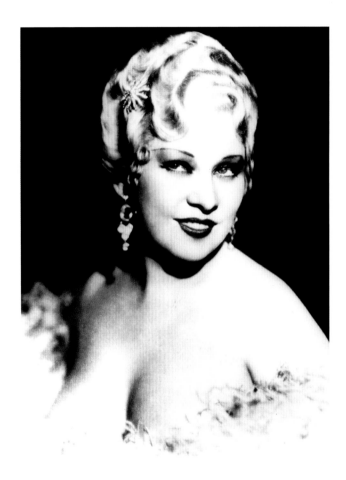

Brilliant, business savvy, and funny, Mae West (above) made sex appeal a successful life-long career not only as an actress/bombshell, but also as a writer and producer.

The very famous Little Egypt (left) demonstrating her exotic if somewhat creative dance steps

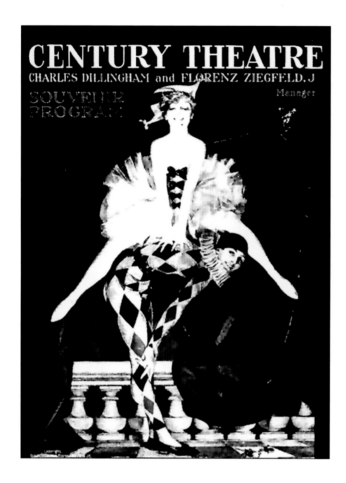

This handbill from a Charles Dillingham and Florenz Ziegfeld production tantalized its recipient with promises of frolicking fun.

Later in the 1950s and 1960s, bawdy-singing comediennes started entertaining at clubs and theaters, bringing the voice of female sexuality back to the stage. Belle Barth, who owned her own club called the Belle Barth Pub in Miami Beach, fell in line with Sophie Tucker and other early performers who were considered too unattractive to be threatening in their overt presentation of sexuality. However, there were glamorous young women who came of age in the cocktail culture, sang "dirty" songs, and traded naughty banter with the audience on the same nightclub stages that sometimes featured burlesque strippers. They fit in with the *Playboy*/Rat Pack/swinger style of that era.

Rusty Warren started working in nightclubs in 1953 just out of college, and at first she borrowed material, sometimes from Sophie Tucker and others, that combined sexuality and old age to create comedy that was terribly inappropriate for her own young age. When she finally met Tucker, the pretty redhead was told to, "Be honest, don't lie to your audiences, they're smart. Tell them the truth as you see it, and they'll love you."

Warren started drawing from her personal experience and what was going on in the world. Singing about birth control in "The Pill," women taking over politics in "Madam President," and encouraging women to mentally and physically "Keep Your Knockers Up," she had a sense of women's liberation before it was even called that. Her bawdy and outspoken songs

made her wildly successful by 1960, and of her eleven albums, seven went gold.

Other bawdy singers included Ruth Wallis, who was famous for the song "(You've Gotta Have) Boobs" and later *Boobs: The Musical,* which was based on her music. She played the lounge circuit and released risqué records backed by a full orchestra. Faye Richmond entertained on the lounge circuit and at Playboy Clubs with songs such as "It Was Hard When I Kissed Her Goodbye" and "You Ought To See Her Box." She also had a string of popular party albums, which besides the titillating music also featured tantalizing packaging: nearly nude models sporting removable "For Adults Only" labels to cover their naughty bits.

Wiggling from Prude to Blue Again

As burlesque continued into the twentieth century, it continued to change. The hootchy-kootchy dancers became more creative, molding acts around their dances, re-creating classical scenes such as the "Dance of the Seven Veils." A dancer known as Omeena, who claimed to have been among the belly dancers exhibiting in the Chicago World's Fair, joined the Saint Louis World's Fair in 1896 where it was advertised that her version of the hootchy-kootchy involved taking off her clothing as she wiggled her hips. Other dancers began incorporating ballet and other forms of dance into bathing acts, boudoir scenes, and other good excuses for shedding their clothes as they danced. Up until the late 1920s, these early disrobing acts still held on to a bit of modesty, creating the illusion of nudity with body stockings, shadow screens, and creative lighting rather than true exposure onstage.

Through the 1900s, the ultraconservative Sam Scribner ran the main circuit of burlesque houses known as the Columbia Wheel. He monitored and censored all audible and gestural allusions to sexuality, doing away with the broad bawdy humor and wrapping the women performers in full-length costumes.

Unfortunately, the new novel entertainment of the movies was drawing the American general public away from the theater, and the high-class theaters was featuring stages full of half-naked nymphs in Florenz Ziegfeld's "Follies" and Earl Carroll's "Vanities." Ziegfeld also started luring the best comedians from the burlesque stage. Fanny Brice, Leon Errol, and Eddie Cantor all went uptown when Ziegfeld called, and burlesque was left floundering, looking for a way to draw back its audiences.

The famous Minsky brothers were among the theater producers who founded what were known as stock burlesque troupes. They took advantage of the theater industry's slow months by taking over what would otherwise be empty and shuttered wheel houses in the summer or, as the Minsky's did when they acquired the National Winter Garden Theater on the lower east side, they bought theaters in less than desirable city neighborhoods. Cheap overhead and recycled acts kept the ticket prices low, and the

Minsky brothers were outside of Scribner's control so they were able to make the shows as racy as possible to lure the crowds in. By offering cheap tickets, highlighting striptease artists, and padding out the rest of the show with classic burlesque comedy and routines, Minsky's and the other stock burlesque companies brought audiences back to burlesque and effectively forced Scribner to stop censoring his shows and allow nudity and blue humor. After a few years, the Minsky brothers became the best-known name in burlesque, and owned a chain of burlesque houses throughout New York City.

The Accidental Stripper

There are various stories about who invented the modern striptease, but most accounts point to a woman working for the Minsky brothers' burlesque in 1917. Mae Dix danced in a dress with removable cuffs and collar, and as she left the stage one night she took off the collar, hoping to keep it clean enough to last through a few more performances. The audience went wild, so she headed back out onstage and removed the cuffs. Then, as Morton Minsky remembers it, "Mae lost her head, went back for a short chorus and unbuttoned her bodice." There are other reports that Dix created a number around that same time where she let nearby patrons tear away pieces of the newspaper she was reading until there was just a little newsprint preserving the last bits of her modesty.

Hinda Wassau was another "accidental stripper." She stepped into the wings of the stage to take off her chorus outfit, under which she wore a beaded costume intended for her solo act. The zipper stuck on her outer costume and as she struggled with it, her music began playing and the manager pushed her onstage. With the outer costume half off, she began her act. As she shimmied, the outer costume started to shake off. She threw it aside, and the crowd went nuts.

However, the first real striptease where the woman used the tease of the strip was performed by Carrie Finnell. Finnell started out as a chorus girl in Ziegfeld's show, working for years in burlesque billed as the "girl with the million-dollar legs." Every night she would take off an item of clothing and then promise to take off another at the next show. Her brilliant gimmick kept the audience coming in every night to see her.

The Novelty of Nudity

By the late 1920s, burlesque was synonymous with striptease, explaining why, despite its rich history in comedy and satire, most anyone today equates the word *burlesque* with stripping. Strippers were the main feature in burlesque, and the rest of the program—the comics, the variety acts—was there to fill out the show.

In the 1930s, the peeling occupation became more competitive as promoters realized that the only way to keep the audiences coming in, once the novelty of nudity wore off, was to hire the women with the best props, techniques, and style. Costumes and props became more elaborate as the dancers realized that the longer they stayed onstage and captivated the audience's attention, the more money they could demand.

According to New Orleans filmmaker and burlesque historian Rick Delaup, the old acts were about fifteen minutes long using three songs to tell stories. Talking about Dixie Evans, "The Marilyn Monroe of Burlesque," Delaup says that when she danced she never, "stopped moving the entire time. Her body, her legs, her arms were just constantly in motion and you'd be mesmerized."

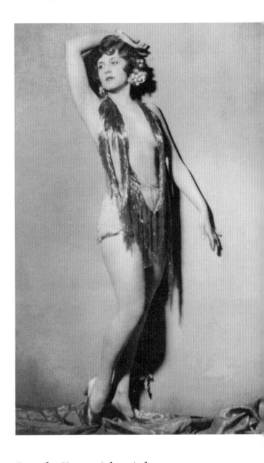

Dorothy Knapp (above) shows off a costume that leaves little to the imagination

Hinda Wassau (left) was an accidental stripper, claiming it all came off on its own.

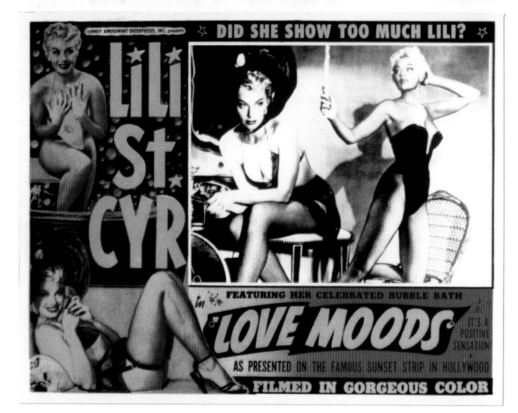

FEATURING HER CELEBRATED BUBBLE BATH in "LOVE MOODS" AS PRESENTED ON THE FAMOUS SUNSET STRIP IN HOLLYWOOD · IT'S A POSITIVE SENSATION · FILMED IN GORGEOUS COLOR

Lili St. Cyr (left) shows off some of her "love moods" in a poster made during the height of her career

Gypsy Rose Lee (right) combined brains and lady-like charm with her beauty to keep her audiences enthralled.

Got to Get a Gimmick

In the stage bio of the famous striptease artist Gypsy Rose Lee, *Gypsy,* a trio of veteran burlesque girls, Miss Mazeppa, Miss Electra, and Tessie Tura, sing to her: "You've got to get a gimmick, if you want to get ahead." In the day, every performer had to have a gimmick to draw in audiences and keep their names on the marquee. Some had natural ability, such as Georgia Sothern, who whirled and shook like a human cyclone, and some had physical features that piqued interest, such as the six-foot-four Lois DeFee or the unusual insurance policy covering Evelyn West and her "$50,000 Treasure Chest." Others used animals as their gimmick, such as Rosita Royce whose doves perched on her anatomy as she danced

or Yvette Dare who trained her parrot to swoop in and remove her clothing.

Elaborate stage props were also a terrific draw. Lili St. Cyr created a boudoir scene, complete with furniture, a dressing screen, and a bath. Coney Island favorite Tirza created a fountain of wine for her famous Bacchanalian wine bath, which set off a "battle of the bathtubs" in the press when Dorothy Henry opened her milk bath show down the boardwalk at Coney's Star Follies.

Carrie Finnell, famous for dragging out a strip for weeks, returned to burlesque in her forties with a new act. Finnell had an "educated bosom" that she had trained to pop out of her dress and dance using pure muscle control to launch her hefty breasts right, left,

up, down, and, when she attached a pair of tassels, around and around. Thus, the novelty of tassel twirling became popular and other teasers such as Sally Keith, Rosa Mack (a.k.a. Baby Dumpling), and Bambi Lane took it up as well, though no one had the muscular ability that Finnell boasted.

For *Gypsy Rose Lee (right)*, Ann Corio, and others, their reputation was their gimmick. Lee was known for her high-class manners and she mingled with the rich and famous. Combining brains and beauty, she removed her layers of satin and lace with a feminine and ladylike style, crafting witticisms and conversing with the audience as she did. Corio became famous for her costumes and acts that emphasized her youth and the way she feigned innocence with her wide eyes. Starting out when she was fifteen, she played to men's desires, contrasting herself against the rest of the women she worked with who were all far older. In her book, *This Was Burlesque,* Corio bemoaned the wide use of gimmicky props as they eventually led to more obscene acts in the 1960s. "The power of sex is in the power of suggestion. Take off a glove in the right manner and a man will ask you to marry him." Corio felt that a good teaser had no need for gaudy props. "A woman's greatest asset is a man's imagination."

Fading in the Harsh Spotlight

As the popularity of burlesque once again surged in the 1930s, the Minsky's New York burlesque chain

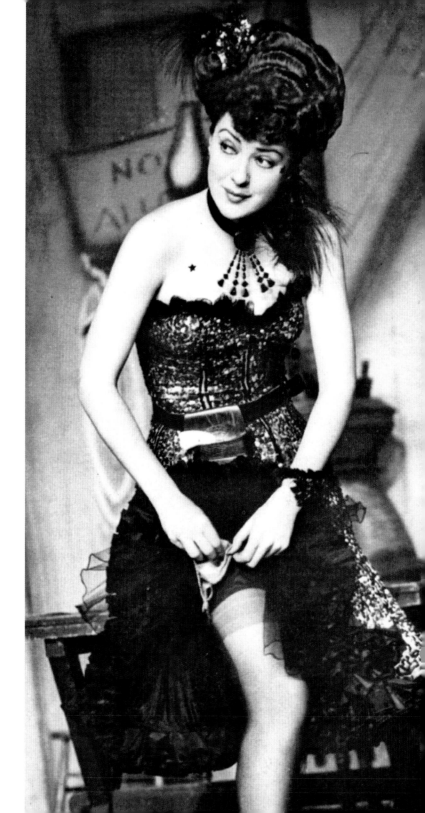

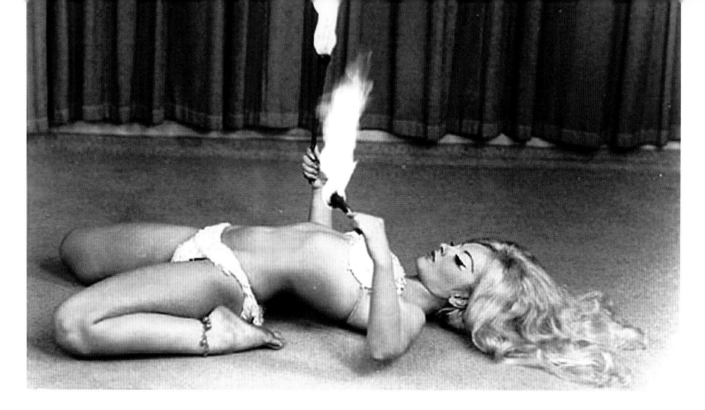

made the decision that it was time to move out of the Bowery and on to Broadway. They took over a venue in the Times Square theater district after the depression had put many legitimate theaters out of business.

Unfortunately, the bright lights of uptown shone a harsh spotlight on the naughty underbelly of burlesque. Once the censorship cuffs had been removed when Scribner lost power, burlesque became racier and racier with each passing year. Producers encouraged their performers to make their dances more risqué and their comedy more vulgar. The city took notice and sent out warnings that burlesque needed to tame it down. But despite operators' best attempts, they couldn't clean up their shows. They'd spent too many years proving to the girls and the

comics that pushing the limits brought in the dough. Eventually, Mayor La Guardia cracked down on producers and performers, and by 1937, theatrical burlesque was all but dead in New York. The word *burlesque* was outlawed as was the use of the Minsky name to advertise any production.

Just as burlesque began in New York and spread throughout the country, so did the death of burlesque. Burlesque houses across America were converted to movie theaters, playhouses, or simply demolished. Some of the comics moved on to radio, movies, and, eventually, television. A few burlesque striptease stars such as Ann Corio and Gypsy Rose Lee were also briefly lured to Hollywood, but most striptease artists moved into the nightclub circuit.

Burlesque Grinds On

In the March 1942 "Special Burlesque Issue" of *Film Fun,* editor Charles Saxton commented on the tenacity of burlesque, saying, "Surviving depressions, wars, women's clubs, and bingo, burlesque will live forever." And it did live on. Men's magazines such as *Eyeful, Cabaret, Cavalcade of Burlesque, Peep Show,* and others kept burlesque striptease stars in the forefront of the public's imagination. Nightclubs hired the headliners to star in their shows, and burlesque clubs were born. Most featured striptease, though some brought in burlesque comedy and variety acts to fill out the show.

In the mid-1940s, some headliners such as Gypsy Rose Lee, Sally Rand, Georgia Sothern, and Faith Bacon formed their own companies and spent their summers out on the road with traveling carnivals in what were called "girl shows." With these tent shows, they were able to keep their names on the marquees and in the minds of the American public. And by running their own shows they were able to use their fame and name recognition to accumulate new fans and sustain a good living. The women brought burlesque to people who, outside a movie theater, had never seen a glamorous stage show with brilliant costumes and Hollywood-style dance numbers. They packed the house and with twenty-plus weeks booked solid from the spring to the fall, the performers were able fill the hole that censorship had left in their pocketbooks. A show like Sally Rand's brought in as much as one-third of a carnival's entire take.

The new generation of acts became even more inventive and the props and costumes more extravagant as dancers competed for top billing. There were peelers such as Princess Do May (a.k.a. Cherokee Half-Breed) who wore giant headdresses and exaggerated Native American costumes while she performed her "Sacrifice to the Totem Pole" and Dixie Evans who gave audiences a Marilyn Monroe who would show a little more than the real Marilyn, dancing with a Joe DiMaggio dummy or vamping around a casting director's office.

Go-Gos Go Beyond

In the 1960s, things changed again for the tease artists. For a while go-go clubs, where girls danced on stages or in cages, were popular and although, beyond the occasional flasher, they didn't show more than their brief outfits allowed, their suggestive dancing was the forerunner of modern strip club dancing. Go-go clubs also invented the modern use of multiple girls on multiple stages.

According to the famous flaming tassel twirler Satan's Angel, who started dancing in 1960, the invention of gentlemen's clubs created mass-produced strippers, expanding shows from the original eight exotics featured in burlesque to thirty-five strippers in this new forum. She believes that gentlemen's club owners felt, "If you had ten or

twenty women on runways that ran through the club, the customers would stay longer and eventually find what they wanted to see."

As social morals loosened through the late 1960s into the 1970s, so did the morals and tastes of the clubs. Satan's Angel stuck it out into the early 1980s, but reflects that, "It just got to the point that they didn't want a clean act, and the nastier you were, the better they liked it." In later years, she even found herself performing after a porn movie, a difficult act to follow for someone who was trying to tease the audience by keeping hidden the same body parts that had just been up on the screen, large and in color.

Feature strippers were still able to keep the fantastic costumes, props, and novelty stripteases, but the girls who worked the clubs day by day had to compete with the triple-X theaters and the general boom of the pornography industry. The only thing strippers had left to offer was that they were "Live Nude Girls."

Visits to the Past

Despite the downward spiral of the tease, the tradition of burlesque carried on in television with shows such as the 1965 *Danny Thomas' Wonderful World of Burlesque, Johnny Carson's Tonight Show, Saturday Night Live,* and *The Carol Burnett Show.* Even Bob Hope's television specials followed the old format, but replaced the stripteaser with a starlet or sex symbol in a song, dance, or comedy routine.

Sometimes burlesque did return to the stage in revivals such as Ann Corio's stage show, "This Was Burlesque," and Mickey Rooney's 1979 musical *Sugar Babies.* In the late 1970s there was Will B. Able's "Baggy Pants and Company Burlesque," and another Ann Corio show, "Here It Is, Burlesque," which toured until 1991. In the early 1990s Tempest Storm toured with Morey Amsterdam (from the Dick Van Dyke Show) in a burlesque show called "Back to the Catskills." Las Vegas showgirl extravaganzas sometimes borrowed from burlesque traditions, though they followed more of a follies pattern with their topless and crystal-clad showgirls filling the stage in old Ziegfeld style. The long-running "Bottoms Up!" at the Flamingo Hilton still offers a full burlesque show with old-style comedy and burlesque striptease.

Though these revivals let people revisit the past, the vital, living art of striptease was lost. The headliners faded into obscurity, moving away from stripping and on to other careers. Some strip clubs operated under the old burlesque marquees, but the distinct difference between the two was lost to the public imagination. There was no tease left in modern stripping, and, up until the beginning of the twenty-first century, most anyone who heard the word *burlesque* assumed it referred to topless or bottomless clubs. Thankfully, a new generation of women was determined to change that. They were determined to bring burlesque back to its rightful, blooming glory.

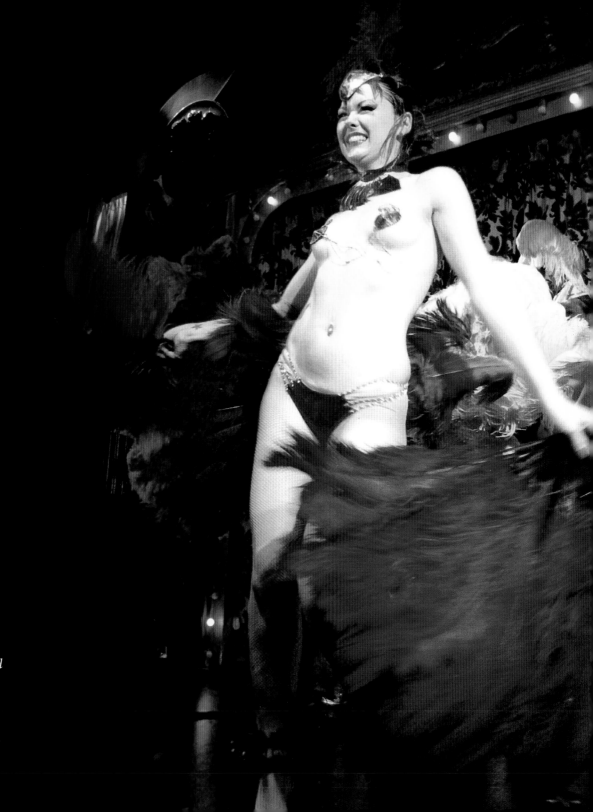

An enthusiastic bombshell, The Lady Ace shakes out her feathers at a club called "Show" in New York City

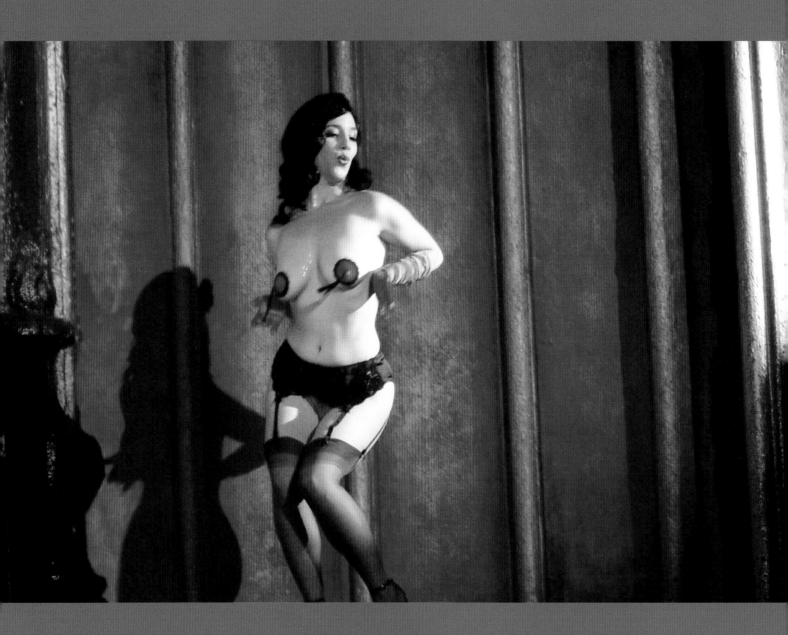

The Sequined Revival

From Goat Farm to Hall of Fame

For most of the last few decades of the twentieth century, burlesque was all but completely forgotten. But out in the California desert, an old teaser named Jennie Lee (a.k.a. The Bazoom Girl) installed her massive collection of memorabilia at an old goat farm that she and her husband, Charlie Arroyo (a former singing cowboy), moved to after Lee was diagnosed with breast cancer.

After her passing, Lee's friend and fellow dancer Dixie Evans moved out to the ranch and began to transform Lee's personal collection into a public shrin to burlesque. The hallowed goat farm is now known as the Exotic World Home of the Movers & Shakers' Burlesque Museum and Striptease Hall of Fame.

Evans also started the Miss Exotic World competition and reunion in 1992 to generate publicity for the remote museum on famed Route 66. In the beginning, she invited retired dancers and anyone who wanted to compete for the title to her poolside stage under the hot desert sun. The competition mainly consisted of faded stars of yesteryear and feature adult entertainers. Happily for Evans and the dance community, Miss Exotic World continues to this day, with the troops of attendees growing with the popularity of the revived tease.

Saved from History's Dustbin

Except for a couple of revivals featuring old stars and a few feature strippers who incorporated the old style into their new dance, burlesque was still a relic when Dixie Evans first started calling the old gals back to the ranch. But slowly a wide variety of burlesque media materials began to resurface, and lo and

Miss Indigo Blue demonstrates her formidable tassel twirling talents at the Henry Fonda Music Box, Tease-O-Rama show

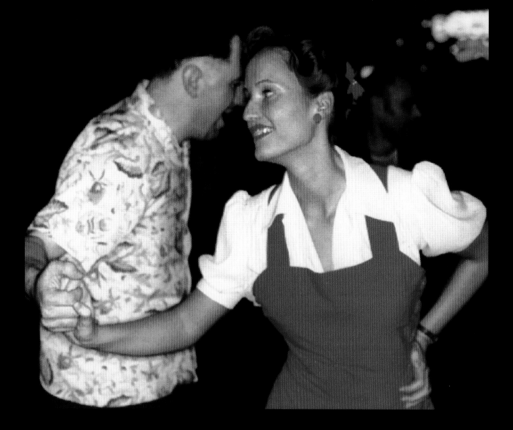

A pair of retro, swing dancers take a twirl on the floor.

Swing Was Out, Burlesque Was In

Swing made vintage hip. It put flames and martini glasses on the teen set's slippers and on the weekend wear of otherwise staid business types. Its style had legs; however the dance culture could not overcome the habits of its die-hard members.

The problem with the swing movement, according to Eric "Eddie Dane" Christiansen of Dane's Danes, was that swing dancers didn't drink. Venues that banked on their bar when they set up shows stopped booking swing bands and swing dance events. That was bad news for Eddie Dane, who had been organizing swing events in the San Francisco area at the time. Bemoaning the demise of the swing culture but unwilling to say uncle, he began brainstorming. What would have the same appeal to the retro style culture, give people a chance to wear their vintage best, could still include the old time music that they loved, and keep them in their seats buying drinks and having a good time? The answer was burlesque.

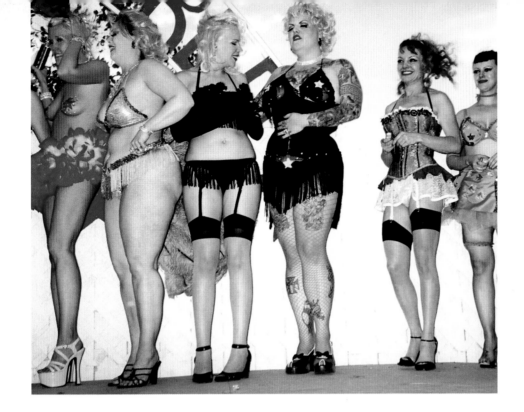

Ladies line up to hear results of the Miss Exotic World Pageant in 2003. Shown here from left to right are Bambi, Dirty Martini, Sparkly Devil, Eva Von Slut, Bonnie Delight, and Augusta

behold a new generation was finally starting to latch on to it.

This new scene tapped into the collective subconscious of women and men who, for the most part, had never seen live burlesque and whose parents were often too young to have experienced it. New devotees were refugees from the swing revival, tattooed rockabilly chicks, strippers bored with the same old pole dance, dancers and artists looking for a more risqué outlet, and ordinary folks who had a love for the old glamour and the innocent naughtiness of the old peek-a-boo striptease.

The rockabilly and swing kids of the late 1980s early 1990s were defining their style by rifling through their grandparents' closets. While they were digging, they found more than starched crinolines and zoot suits. This fashionable set started collecting men's magazines and old stag films featuring pinup queens and burlesque girls of the 1940s and 1950s. As the culture grew, so did the demand for these images.

Not everyone was lucky or patient enough to find vintage cheesecake on their own. So, the 1950s Irving Klaw feature film series of burlesque shows, *Striporama, Teaserama,* and *Varietease,* were re-released on video in 1993. Drawn in by the already popular pinup darling Bettie Page and Klaw's reputation as a fetish filmmaker, little subcultures were introduced to Tempest Storm, Lili St. Cyr, Georgia Sothern, and other big burlesque names of the golden age. Companies such as Something Weird Video,

which also carries at least 100 other burlesque titles featuring old 16mm, 8mm, and super 8, saved these odd little films from history's dustbin.

Striptease music was also becoming fashionable to absorb, ranging from vintage vinyl to forgotten and re-released recordings for collectors. Crypt Records came out with a series of albums in the early 1990s containing recordings from strip-club house bands of the 1950s and 1960s called *Las Vegas Grind,* which featured burlesque collages and art on the covers. Jumping on the Bettie Page trend, QKD Media packaged a selection of dirty bump-and-grind tunes with pictorials of the pinups in the liner notes: *Danger Girl* with her fetish photos, *Jungle Girl* with her Bunny Yeager exotic series, and *Private Girl* with boudoir and candid shots. A collection of all the best 1940s striptease classics such as David Rose's quintessential tune "The Stripper" was compiled by Rhino Records on a CD called *Take It Off.*

As aforementioned, burlesque was being fed to the next generation through film. Young filmmaker John Michael McCarthy already had a bit of a cult following for his homage to 1960s b-films when he and his partner, Victoria Renard (a.k.a. burlesque girl Candy Whiplash), convinced burlesque-inspired and other vintage culture enthusiast gals to take it off for the camera. McCarthy's Big Broad Guerilla Monster films produced vintage-looking stag films that emulated those old bachelor party films and capitalized on the modern interest. Such films

included *Shine on Sweet Starlet,* produced in 1997 just before the burlesque movement really started to grow, and *Broad Daylight,* made in 2003 in the midst of the revival.

This renewed enthusiasm also convinced alternative and art publishers to put out compendiums of vintage girlie magazine art featuring Petty, Vargas, and other pinup pictorials. Books such as Len Rothe's collections of old glamour shots and poster images from the burlesque stars, *The Bare Truth: Stars of Burlesque from the '40s and '50s* and *Queens of Burlesque: Vintage Photographs of the 1940s and 1950s,* were also a big hit. Eventually stickers, T-shirts, and other products featuring retro pinups were sold at chain stores such as Hot Topic and every hipster vintage boutique.

Comic book illustrator and publisher Greg Theakson also felt the early burlesque ripples and came out with his first issue of *The Bettie Pages* in 1987. Chronicling his personal search for the real Bettie Page, he wrote about the pinup queen and other aspects of vintage cheesecake and helped bring back the art of the old pinup to a new and appreciative audience. Once he found Page, he then embarked on another magazine, *Tease!,* along with Eva Wynne-Warren (a.k.a. Torchy Taboo of Atlanta's Dames A'Flame). The mag covered more of the scope that the original men's magazines did, including burlesque. In the early days, *Tease!* only talked about historic burlesque, but as the magazine continued

Fetish and Burlesque

At the same time swing and vintage style were turning up in movies and being exploited by ad execs, another scene was starting to emerge from the underground. A deeply buried subculture explored only behind the closed doors of dungeons and in pornographic magazines had started to surface. Fetish clothing was adopted by the goth community in the 1980s. However, once Madonna's 1995 video "Human Nature" featured the pop star wielding a whip while clad in a patent leather catsuit and dominatrix heels, fetish theme parties became common at mainstream dance clubs. While definitely more sexually explicit and different in its purpose of submission, domination, and pleasure in pain, the rise of fetish is linked to the rise of burlesque.

Both burlesque and fetish exhibit sex in a new way that is at the same time linked to the past. Fetish can be found in the 1950s magazine *John Willie's Bizarre* and early century postcards featuring women in leather outfits spanking and whipping other women. And both burlesque and fetish consider Bettie Page as an icon, and filmmaker and photographer Irving Klaw as an inspiration. There are a number of photos and films of Page that feature the busty brunette tied up, tying other women up, and delivering whippings all while smiling, winking, and making exaggerated expressions of mock pain and surprise.

Many modern burlesque performers have done fetish work. Dita Von Teese is an internationally known fetish pinup and **Bambi the Mermaid** (**shown here**) was a favorite subject of fetish photographer Doris Kloster. Other performers have taken odd fetish jobs; sitting on and popping balloons, letting pies be thrown at them, posing in tap dance shoes, or posing in trick photos as 'giant' women.

Because most of the people involved in the modern fetish scene are in it for the fashion and the bizarre parties, there is a sense of frivolity, gentle mocking, and detached fascination that doesn't exist within the true practitioners of fetish.

Fetish burlesque performer Bambi

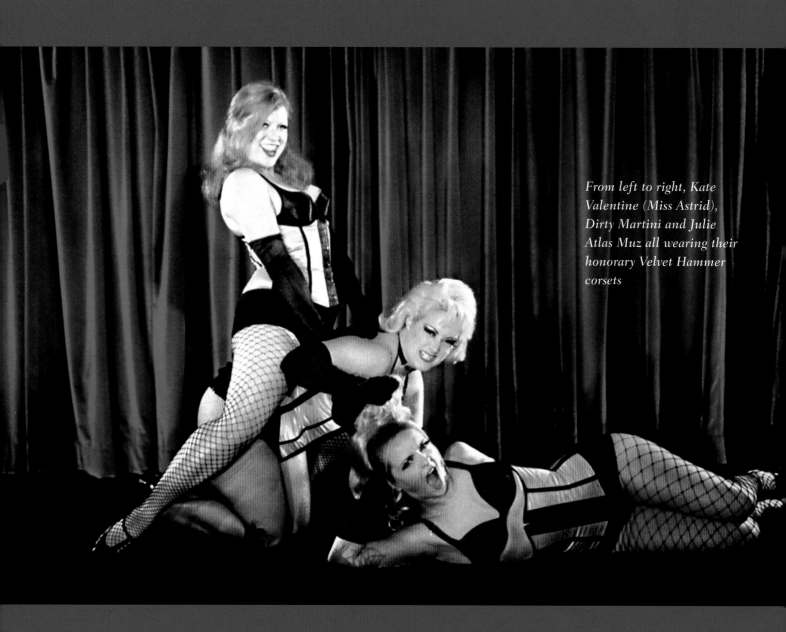

From left to right, Kate Valentine (Miss Astrid), Dirty Martini and Julie Atlas Muz all wearing their honorary Velvet Hammer corsets

and new burlesque grew, so did the coverage of the new movement.

Kutie Magazine also tried to recapture the appeal of vintage men's magazines. It featured articles on rock 'n' roll, cars, and other traditional male pursuits alongside photography of modern girls in retro pinup style. Victoria Renard, who also worked on Guerilla Monster Films, photographed Gun Street Girls founder Nico Jeffries (a.k.a. Bella Beretta) and alt-country star Neko Case for the magazine. Interestingly, Renard transformed into Candy Whiplash during the time she was photographing for Kutie as she, "made girls a little more innocent, left more to the imagination." Her interest in burlesque grew as she photographed more and more of the early neo-burlesque performers, such as Bella Beretta, and she soon joined up as one of The Gun Street Girls. Her disgust with modern pornography's tendency to show everything gave her a desire to "see it come around full circle and turn into something pretty."

Renard and other photographers captured a wide variety of classic-looking lovelies for tasteful throwbacks to old girlie pictorials. The pinup image fueled the imagination of a lot of future burlesque performers. Many pinups featured curvy women in scenarios that seemed to tell just one moment of a full story. Holding up strings of paper dolls to cover their bare chests, revealing the top of a stocking as their dress catches on a fence post, fighting to keep their clothes on in a strong wind, pinup girls seem just a moment away from leaping off the page and finishing the scene. By posing in fantastic settings in outlandish costumes, these images gave women in love with that combination of fun, glamour, and simple storytelling something to latch on to, to be inspired by—a place to start creating an act.

Bella Beretta loved the idea of pinups as performance: "I think burlesque is so fascinating because it's a live-action pinup. You take the aesthetic you would see in traditional pinup and still photography and apply it to a live-action person." Beretta especially loves a specific type of pinup, the pulp novel cover girls. "I knew that I always wanted there to be a very evil and very violent aspect to what I was creating. I love '30s and '40s pulp novels, and I love the glamorous covers of the woman wearing a low-cut dress, pulling the revolver from underneath her fur coat. Those are the icons I latch on to. Pinup is cute, but I'd rather see something vicious."

In concert with the culture that surrounded the swing movement, Michelle Carr, founder of Los Angeles' Velvet Hammer Burlesque, also found herself intrigued by the photographs and stories of burlesque strippers that were re-emerging. She had always loved all things vintage—clothes, hair, and tattoos. Entering her L.A. bungalow was like walking into a time warp. After visiting a strip club and wishing the girls swinging from the poles were more like the strippers from the vintage men's magazines she'd been collecting, she created her show as an answer to what she wasn't seeing at those places.

Oh, It's Called Burlesque?

When burlesque performance first started re-emerging in the 1990s, almost no one was actually calling it *burlesque*. The word was vintage, and its meaning had been twisted. Burlesque's association to theater and the blending of comedy and sexuality had been forgotten. Burlesque simply was, to most people, synonymous with modern pole and small-stage stripping. Old burlesque clubs had become strip clubs and many had kept the old signage and terminology, blurring the visible line between the two types of dance.

However, though the word became misconstrued, the style stuck around. Its roots were far too deep in American history and, though it had moved out of the theaters and clubs, it continued on in other popular media outlets. Its influence could be found in *The Carol Burnett Show,* in the one-liners of most sitcoms, the performances of Las Vegas showgirls, in the Mae West-like humor of Bette Midler, and even in Jim Henson's *The Muppet Show.*

Though most neo-burlesque performers don't have a memory of consciously watching and absorbing these programs and performers as burlesque, they do remember seeing them and being drawn to them. Jo "Boobs" Weldon, a New York burlesque dancer and researcher, cites *The Muppet Show* as an influence, and Vancouver's Empire Burlesque Follies even finishes their act with a sample of the two old men Muppets, Statler and Waldorf, who were an institution of the show. And when San Francisco cabaret singer,

piano player, and burlesque girl Suzanne Ramsey, "Kitten on the Keys," was young, she wanted to be just like Carol Burnett when she grew up. She even wrote Burnett a fan letter and requested a photo, which inadvertently led Kitten to another obsession—false eyelashes.

Another instance of practicing burlesque without the moniker occurred in 1994 when the Fallen Women Follies—an event staged twice a year by Seattle's Tamara the Trapeze Lady—first started up. Amelia Ross-Gilson, who performs as Miss Indigo Blue and is the founder of Seattle's queer burlesque cabaret BurlyQ, unwittingly found herself performing burlesque. The Follies was initially created as a forum and a creative outlet for female sex-industry workers to perform belly dancing, nontraditional dancing, singing, acting, or whatever performance art they practiced outside their paying jobs. Entertainers also used it as a space to perform striptease for women who, they felt, could appreciate a strip with higher production values. Most of their regular customers were men, and the kind of work that strippers, peep-show girls, and other women in that industry do for the male audience is rather structured and regulated. The Follies gave the women a space to step outside the box.

As noted, Miss Indigo Blue didn't call what she did at the show "burlesque" until later. "I called it comic erotic performance, and what I did initially were acts that had commentary on the sex industry.

Shake Your-Burlesque-Tail Feathers

Hot Pink Feathers is a San Francisco based Brazilian dance troupe that has its roots in traditional dance, with burlesque-style dance seeping in. The troupe's founder, Kellita, commented, "I didn't know about burlesque when I started Hot Pink Feathers, but when I saw the first Tease-O-Rama I realized that we fit under the greater umbrella of burlesque. Our dance felt more related to burlesque than if we were put into a lineup of other Brazilian dance troupes."

Hot Pink Feathers' acts are based in Brazilian dance, but they also use humor within the music.

Their aesthetic is similar to the "exotics" of the 1950s and 1960s who incorporated ethnic dance into their striptease numbers, a tradition that can be traced back to Little Egypt and her hootchy-kootchy belly dances performed at the 1893 Chicago World's Fair.

"It's a funny journey," Kellita mused, "being already drawn to do something and not knowing where someone would do it, and finding a whole bunch of people who are creating a place to do it."

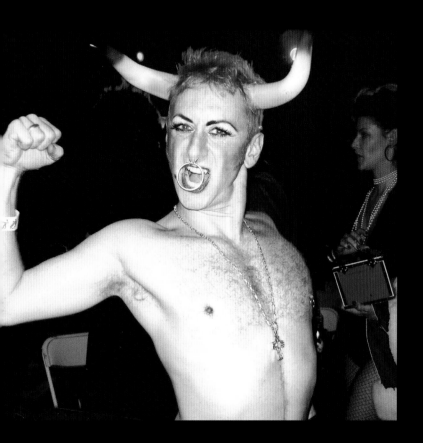

The ever versatile, and sexy beast, Tigger, (above) displays his horns after performing with Kaplan's Burlesque

Jo "Boobs" Weldon (right) does a classic tease as she peels off her opera gloves

What Can I Do?

James "Tigger" Ferguson, one of the few male dancers of the burlesque revival, had roots in New York City theater and performance art. His friends were pulling together variety shows and creating short and shocking acts using circus skills such as eating fire and glass, and though he wasn't interested in those kinds of acts, he still wanted to get involved. Coming from an extremely eclectic performance background, which included everything from stripping to Shakespeare, he wondered, "Well, what the hell can I do?"

"Ahh!" he thought. "I'll take off my clothes!"

At that time he still wasn't calling it burlesque or thinking about the history of burlesque. "Burlesque wasn't a term running around. This was 1997 and I'd been doing stripping with Penny Arcade [a New York performance artist whose work centers on contemporary political issues, especially sex and gender topics] since 1992. But 1997 was when I started making up my own numbers and performing as Tigger. And within a few months after I started, suddenly Red Vixen [one of the early New York neo-burlesque venues] had its first show." Tigger realized that somewhere in the back of his mind he knew that he'd been performing burlesque all along; it had just taken the reintroduction of the word to connect it to what he was doing.

I did female-to-female drag. I came out dressed up as a jack-o'-lantern and I gradually stripped off all my layers and in the end I had jack-o'-lantern eyeball pasties and a big smile across my crotch, so I actually was the jack-o'-lantern. I also did really strange things like bringing Barney, the purple dinosaur, out onstage to sing a song chastising male customers of strip joints that they should mind their manners and tip a lot."

New York Dusts Off Its Pasties

During the early 1990s, the spirit of burlesque had begun to rise again in New York. But unfortunately, it had been dead so long that initially no one recognized it. Performers, audiences, and the press instead referred to it as performance art, or female-to-female drag, or just creative stripping. There seemed to be a sort of collective unconscious moving just below the surface of everything they were doing, as if the ghost of burlesque was floating all around, whispering inspiration into their ears, trying to find a way to live on in a new generation. Like Miss Indigo Blue of BurlyQ and Kellita of Hot Pink Feathers on the opposite coast, these performers were burlesque before they knew what burlesque was, and they were all simultaneously driven to create this kind of theater and dance.

Bambi the Mermaid, who eventually formed Burlesque on the Beach with Coney Island Circus Sideshow sword swallower and emcee The Great Fredini, was exploring what she called "weird nude

performance" at strip clubs based partially on her self-portrait photography work in which she dressed as freak-show characters such as the Claw-Handed Lobster Girl and Bambi the Dog-Faced Girl. "I wasn't working there to make money … I was creating these acts and that was the only venue for it." She wore the animal masks and sparkly showgirl costumes and lingerie from her photo shoots and brought her still images to the stage. Her friends showed up to watch and support her, but selling it to the rest of the room could sometimes be difficult. "I worked at a few of those really upscale gentlemen's clubs and they really didn't go for it, and I didn't last long in those places." However at the, "really down and dirty, blue collar, hole-in-the-wall strip clubs, the patrons perhaps expected less and appreciated the humor and spectacle."

As she brought her sideshow creations to life onstage, she didn't connect her performances to burlesque until she joined up with Fredini and the Coney Island Circus Sideshow, a revival featuring self-made "freaks" rather than the less politically correct, physically deformed human oddities of the past. There were fire eaters, snake dancers, sword swallowers, and Bambi. Her acts combined the sideshow and the traveling burlesque "girl shows" that were always a part of the old traveling carnival world. Though she knew about old burlesque and its presence in the history of Coney Island and carnival traditions, "It didn't really occur to me that we were reviving some neo-burlesque scene. I had probably thirty feather boas before I ever started performing, and I had a whole drawer full of pasties before there was ever a scene. I would use them in pinups and in artwork. So when there finally was this scene and these stages opened up, I was ready for it."

And then there is The World Famous *BOB*. After beginning her career as a female-female impersonator, go-go dancer, and nightclub personality first in Los Angeles and then in New York, *BOB* found herself unwittingly led to burlesque. Her performance art transformed from drag to burlesque in 1998 while she was working a weekly party called "Foxy" at The Cock, a gay bar in the East Village. Her admiration of 1950s glamour queens had always influenced her performance, and she dressed and performed as her favorite blonde bombshells, wearing a Marilyn Monroe wig and developing numbers to the music of the 1950s. "My performance art was already known for partial nudity, and the next thing I knew I was doing burlesque quite by accident. Someone said, 'I love your burlesque,' and I thought, 'Oh, that is kind of what I'm doing.' It was a subconscious inspiration, I think, and once I realized what I was doing, my interest in it grew."

Despite the budding artistic displays of unknowing burlesque folks such as Bambi and *BOB*, New York's revived scene was not just a rebirth, but also a reaction to Mayor Rudy Giuliani's sanitization of the city—an act of survival, if you

will. Strip and sex clubs were pushed out to the city's fringes or shut down completely.

The Blue Angel was a performance collective that emulated the Weimar Berlin and combined stripping, burlesque, and performance art. After Giuliani's crackdown, Blue Angel continued on under the cover of performance art and the legitimizing new heading of "Burlesque Revival." They had to get rid of the lap dances like everyone else, but they were able to still feature nudity because their strips were theatrical and it was considered art. The Blue Angel and the burlesque shows that followed offered naughty fun, and even if they didn't match the down-and-dirty strip clubs that "progress" had swept away, they still managed to give New Yorkers a place to see a bit of flesh.

Even Broadway unconsciously helped to bring back burlesque way back when. The yearly event *Broadway Bares,* which boasts about "taking it off for a good cause," originally began as an evening of striptease dance and naked theater featuring some of Broadway's hottest performers. In 2003, though the evening of spectacular striptease was already burlesque flavored, dancer Jerry Mitchell researched the history and its headliners to really make it a burlesque show and titled it, *Broadway Bares: Burlesque Is Back.*

In addition, back in 1991 Mitchell was dancing nightly half-naked on a drum as the Indian of the Dawn in The Will Rogers Follies, and he was inspired

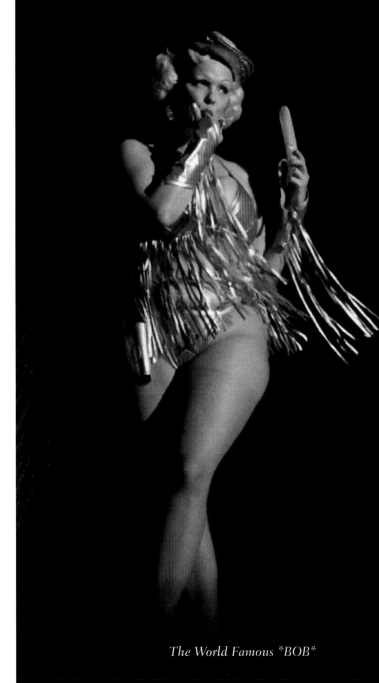

*The World Famous *BOB**

to convince a few of his fellow dancers to join him in a benefit striptease for Broadway Cares/Equity Fights AIDS, a not-for-profit AIDS organization that collaborates with the theater community to raise funds for people with AIDS, HIV, or HIV-related illnesses.

Christopher Byrne in *Lesbian & Gay New York* said of the event, "Gypsy Rose Lee must somewhere feel vindicated because as a form of entertainment, the strip has never looked better or been more appealing … the challenge seems to be just how far one can go without baring all. From G-strings to hats to shaving cream, this year's productions all seemed to push the limits as far as possible. The strip, it seems, has arrived." Indeed. New Yorkers can now take in a burlesque show any night of the week.

So What's the Allure?

Modern glamour is the sleek, sexy aesthetic of technology. Everything from the ultrathin models featured on magazine covers to the tiniest cell phone to the most unobtrusive stereo speaker sets the pace and look of modern life. Burlesque glamour, on the other hand, is larger than life, filled with innuendo, and coated with glitter. Burlesque offers something different than the standard mass-produced culture. In burlesque, girls can have curves, often big curves. They can be loud and funny and still be sex symbols. The basic elements of burlesque are things that are missing from contemporary life.

According to *BOB*, "Burlesque is glamour. It's

so nice to see women get excited about glamour—from the bad gang-girl image of The Gun Street Girls to the really classic, almost stereotypical pinup of Dita Von Teese to the all-out broad, larger-than-life glamour of Dirty Martini. I think it's really great to see that the pallet of glamour is so varied."

Many performers experienced a love of old dance and musical film extravaganzas that was sparked in childhood and has burned out of control as they have grown capable of re-creating it for themselves. They also started to realize that some of those dance numbers were more than kick lines and fancy outfits.

"Busby Berkeley was very sexual with his images, he had girls with six-foot bananas waving them up and down, and he had a dance line where it looks like a zipper closing and then all these girls come down into it in a straight line—it's very suggestive and satirical," says Angie Pontani of the

The ladies of Lavender Cabaret (above) reach for their toes while stepping through a high-energy dance act at Tease-O-Rama

Miss Astrid (left), dominatrix and emcee of the Va Va Voom Room belts out a sarcasm-laced song

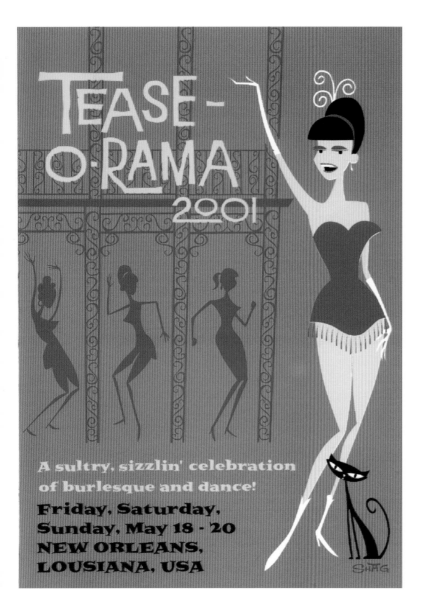

TEASE-O-RAMA 2001

A sultry, sizzlin' celebration of burlesque and dance!

Friday, Saturday, Sunday, May 18 - 20
NEW ORLEANS, LOUSIANA, USA

World Famous Pontani Sisters. However, at the same time she adds, "It's also very innocent, and it's over the top, and laughable but beautiful, and elegant and glamorous, and takes a lot of skill. And to me that's what burlesque is. It's that attitude accompanying any kind of performance."

The Pontanis have been able to make burlesque their full-time career without having to compromise their super-realistic, dazzling style. For Tara Pontani, "Part of the appeal of the burlesque world is that it's open to anyone and anyone can get onstage if you put the time into a routine and put a costume together. It's open and nonjudgmental—it's not like you have to audition for it. And that has really helped its growth and made it very attractive to people."

Burlesque is an alternative to most any performance. It's the funnier, glitterier, over-the-top sister of performance art, cabaret, legitimate theater, modern dance, comedy, and circus. It's an art form that doesn't take itself too seriously even when it might have a point. Actors and dancers love burlesque for its instantaneous gratification. Rather than tepid clapping for a long piece that they've poured their heart into, they get wild applause after a fun and funny three- to five-minute act. Tigger explains: "It was really great for a lot of people from dance or theater or whatever to be able to just go out, have a number, make people scream, and get immediate contact with an audience." For him, burlesque started as a break from the serious theater he'd been doing all his life, as an opportunity to shift gears.

Yet, even though the stage doors are wide open, some in neo-burlesque knew they were destined specifically for something exactly like this when they were growing up. Though his father was a Southern Baptist preacher, Franky Vivid, creator of Chicago's Lavender Cabaret, remembers going with his family to the Texas chain restaurant Old San Francisco Steakhouse, which attempted to re-create the decadence of the Barbary Coast. They had a girl on a swing over the bar, and patrons would place bets on how many swings it would take for her to kick the bell hanging just out of her reach. Young Vivid would sit at the bar on Sundays while his family dined with the other church families and try to catch a glimpse up her skirt. In high school he composed a report on the old Parisian Moulin Rouge, for which he received an F, not for quality, but for content—his teacher was upset that he'd selected to do a report on a whorehouse. Undaunted, his fascination with vintage sex icons continued into adulthood and inspired him to create his burlesque troupe.

Catherine D'Lish had a background in classical music, but she went into stripping when she found that stripping was a great way to make enough money to pay for all of the private music classes that she loved taking. With her aesthetic leaning toward the more classic vision of striptease, she danced to bump-and-grind burlesque music rather than the usual rock soundtrack featured in most modern stripping. The positive reaction of club owners and

Burlesque Opening Doors

Though there is the chance that hitting the mainstream may be bad for thriving underground art, popularity has also brought opportunity for those in burlesque. Kitten DeVille played a burlesque stripper in *Auto Focus*, the biopic about actor Bob Crane, and Miss Indigo Blue started up her Twirly Girl pastie company after the first Tease-O-Rama inspired her to invent a comfortable pastie with a trademarked TurboTwirl tassel (motto: "these things practically spin themselves!"). She gets regular orders with very little advertising or promoting, and also teaches wildly popular tassel twirling classes and burlesque history courses.

Cecilia Bravo, The Blaze, teaches "Everything You Need to Know about Burlesque" as a workshop in Vancouver, B.C. In New York, sexpert and burlesque girl Ducky DooLittle teaches "The Art of the Classic Striptease." *The World Famous Pontani Sisters (above)* sell a tape of their Go-Go-Robics and teach their fun dance workout at the New York Crunch Gym. For others, the popularity of burlesque has just simply made it possible to perform more

patrons coupled with her own competitive nature drove her to create more elaborate shows with giant props including a champagne glass, a golden birdcage, and a waterfall. Soon she found that she loved it: "I became a full-time performer mainly because it is just so much fun, in fact, I don't really consider this a career as much as a hobby that has gotten completely out of control."

Despite where the dancers have come from, a huge part of the attraction to burlesque is the glamour of the original era. That interest is uniform throughout the scene and is reflected in their lavish costuming and makeup. For some, burlesque seems to just be a fun outlet, a place where performers are allowed to cover themselves in sparkles, put their hair in pin curls, dress in rhinestones and beads, and paint their faces in the image of Marilyn Monroe, Greta Garbo, Clara Bow, or other glamour queens of the past, and possibly the present. Still others take the stage to make their own definitive mark on burlesque and take the tease with a great deal of seriousness, in addition to love. But the basic allure brings them all in … performance with an edge, and a wink.

Reviving with New Technology

Once the revival began to push forward, performers started looking for inexpensive marketing outlets for what they were doing, and soon enough burlesque started to appear on the Internet. The site www.JoeBates.com features pages of pictures and

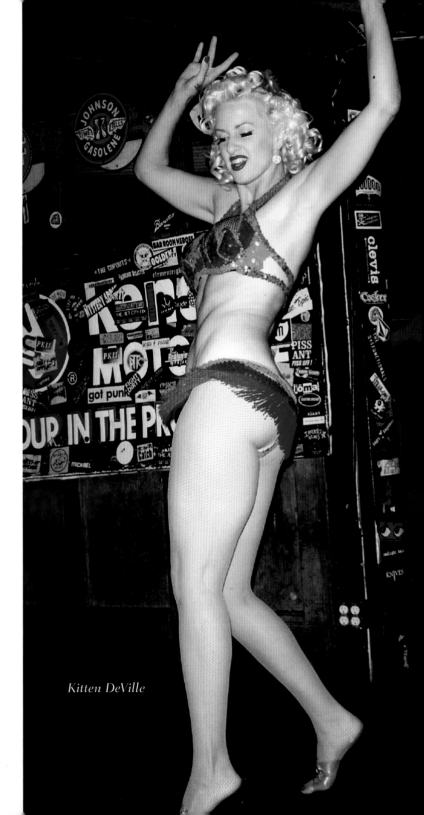

Kitten DeVille

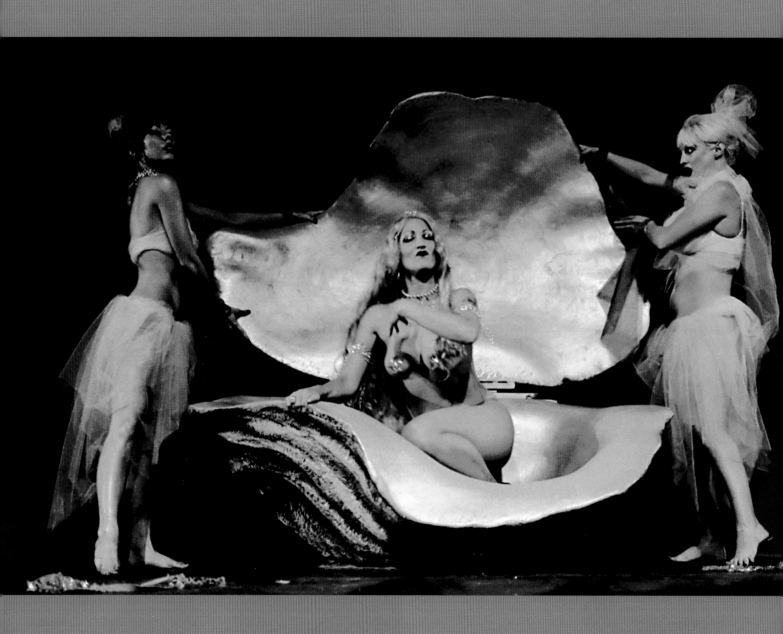

Kitty Diggins (above and left) in her mermaid routine, emerges from the shell that was created for Jane Blevin, the original re-incarnation of Evangeline the Oyster Girl

old ads from burlesque stars Lili St. Cyr, Tempest Storm, and Blaze Starr on a site that that hasn't changed much in the years it's been online. Bill Reagan, of Red Light Ray's www.bootlegburlesque.com, makes similar use of midi, early animation, rough html, and lots of pictures of old burlesque stars, but also posts his own pen and ink buxom burlesque renderings. Jo "Boobs" Weldon, a self-proclaimed "burlesque groupie" and performer, has an online fanzine, www.gstringsforever.com, that is a treasure chest of all things burlesque—modern groups, cool sites, a huge list of articles on burlesque, and a big bibliography.

Soon performers realized that the new technology was a cheap and easy way to promote their endeavors when all their money was going into glitter, fabric, music, and other start-up costs—and they created their own web pages. Some had web experience already or had a kind web design friend who was willing to donate time to the burlesque cause. But many others sat down on their own to forge their web identity with a computer book in one hand and a copy of website software in the other.

In November of 2000, the Tease-O-Rama Yahoo Groups list launched and it changed new burlesque for the better. It provided a place for the community to connect, to exchange information, and to debate issues and questions about new and old burlesque that had been rolling around in everyone's mind. It brought everyone out of their little corner of the country and gathered them, virtually, all in the same room. Soon after, at the first Tease-O-Rama Convention in New Orleans, everyone met in person, but that online introduction and the endurance of that online group conversation constructed an informal alliance among these like-minded individuals that continues today.

Making It More Than a Revival

There's an undeniable attraction to re-creating the past, to participating in living history. From Civil War reenactors to those reviving the Old West, there's an American obsession with role-playing history. For some, burlesque is no different, but they are in the minority. Most neo-burlesque performers have

studied the history and the traditions of burlesque, and then they have taken it in their own direction. The roots of burlesque, as with any other entertainment, should always be evident in its modern performance. It's that structure, that consistent reference to the divine mixture of the sexy and the satirical, that makes it burlesque.

All modern musicians, dancers, painters, sculptors, and so on strive to make good new work within the bounds of their medium and try to avoid directly copying the art of the past. Burlesque artists, like any other fine artists, look at the work of those who have gone before them and translate it for their own time and tastes. Anyone putting in the time and effort to exactly reenact and preserve the performances of Evangeline the Oyster Girl, Lili St. Cyr, Sally Rand, or any of the incredibly talented ladies of burlesque history is to be commended. However, most women in the new burlesque would rather have the same chance that those ladies did—to invent their own stage persona and burlesque specialty based on their experiences and the things they love.

When reaching into the history of burlesque for inspiration, Franky Vivid of Lavender Cabaret tries to figure out "what they were thinking at the time, instead of just doing what they did. And what they were thinking was, let's use everything at our disposal—modern technology, all the newest lighting equipment, and newest fabrics." Ziegfeld used turning stages and burlesque dancers lit their

costumes with strings of electric bulbs. With that in mind, Vivid has reinvented the old bump-and-grind music by remixing it with new electronic beats. And rather than using bulky and inflexible back drops, Lavender Cabaret performs in front of projected images to set their scenes (as does London's Whoopee Club).

The trick seems to be taking this retro glamour and presenting it in an interesting and new way. Dirty Martini strives to imitate the elegance of the dancers of the 1950s in her sequin gowns and blonde bombshell hair, but she still does it with an offbeat comic flair, contorting her mouth as she "accidentally" pops her balloon costume with a cigarette or giving the audience a naughty wink with one of her glittery blue-shadowed eyes as her dress falls away from her buxom body.

Incorporating traditional ideas can add to the intelligence of burlesque while still playing to everyone. It satisfies the historians in the audience who look for and get the references, even if they fly over the heads of the rest of the crowd. The tableau vivant and later the pedestal show were used as a device to showcase nudity because the models, while standing still, were considered art. Acts such as the New Orleans Dolls, Burlesque As It Was, and especially London's Whoopee Club use it as a device in their modern shows. The New Orleans Dolls used tableau vivant to make an *Alice in Wonderland* illustration come to

*Dirty Martini does the
signature fan dance that
won her the Exotic World
Sally Rand Award*

life, and Burlesque As It Was put girls on pedestals as classical statues that curiously came to life as a ballerina danced around them and pulled away their togas. The Whoopee Club reflects more Victorian and early twentieth century burlesque in general, and they feature artistic tableaus such as Leonardo da Vinci's "The Birth of Venus" against a projected slide of the original painting.

Other forms of dance have crept into and expanded the definition of burlesque as well. Jazz and tap have been integrated, and a few dancers have performed burlesque en pointe. Miss Delirium Tremens, who sometimes incorporates her classical ballet training into her burlesque numbers, explains that even classical dance pushes the envelope. "Choreographers do not always use the classic 'turn-out' position. They try new lifts that would have been unheard of one hundred years ago. They work from a tradition but they don't try and replicate, they develop, they progress."

Burgeoning Burlesque

One of the questions posed to the panel of troupe leaders presiding over the Tease-O-Rama 2003 panel "How to Be a Burlesque Star for Fun and Profit" was about introducing burlesque to a community where there is no burlesque. The panel response can be summed up as, "We did the work so you don't have to." An army of believers had been laying the groundwork for the revival since the early 1990s, and

San Francisco's Finest presents...

Le Chat Botté

at The Odeon
17 January 2004
9 pm $8

CABURLESQUE

thelollies.net

Starring.................The Lollies!
Musical Interludes by The Tanglers
Comedic Interludes by Mad V. Dog
Chanteuse Ariela Morgenstern
The Devastating Roky Roulette
La Peligrosa y Las Terrores
Daring Duet Lotta y Legya
Solo Siren Roxie Shocks
Plus
DJ Delachaux
Burlesque Costumes
by Inga
Chocolate Nipples!
& more!!!

The Odeon Bar 3223 Mission St. in S.F. (415) 550-6954

San Francisco burlesque poster (above) for The Lollies

The Poubelle Twins, Fifi and Bibi (left), from the Velvet Hammer, vamp between sets to provide diversion and laughs for the crowd.

anyone who started out in burlesque after the turn of the new century had an easier path to tread, as it was lined with innumerable articles about sold-out performances, glowing reviews, and burlesque's hipster status on all the "In Lists."

In the early days of the new movement it was hard to convince venues and clubs to book burlesque. When the Pontani Sisters first started calling what they did "burlesque," people would assume they were strippers in the modern sense, when, in actuality, most of the Pontani Sisters' acts are clean enough for a PG audience. Angie Pontani remembers "calling Philadelphia and trying to find clubs and trying to explain what we were. Nobody knew, they had no idea. They'd say, 'Well, you need to call Satin Pumps down the street' and I was like, 'we're not strippers!'" Sometimes it was easier to just call themselves tap dancers, even though that didn't even come close to describing their comedic, ecstatic, and saucy choreographed dance numbers.

Everyone invented their own way of bringing burlesque back. The Gun Street Girls got on the bill at venues by hitting the stage between Seattle bands; the Velvet Hammer brought in Russ Meyer film star Kitten Natavidad to one of their first shows to draw in the L.A. crowds; and the Shim Shamettes relied on the ever-abundant tourist crowds from nearby Bourbon Street. Other troupes such as Memphis Confidential, Vancouver's Fluffgirl Society, and Denver's Burlesque As It Was found that by just

putting the word *burlesque* on their flyers they were able to pique the interest of the local media and pack the house.

Kate Valentine, who started out in the Velvet Hammer, created the Va Va Voom Room in L.A. to showcase her enigmatic one-eyed dominatrix character, Miss Astrid Von Voomer. She moved her act to the Fez under the Time Café in New York in 1999 and invited the abundant number of cabaret and burlesque performers in the New York community looking for a place to show off their talents.

As with any sort of start-up group, you have to look to the forerunners to help you make your way. The burlesque girls of today have a paved road to slide onto. But there will always be a few bumps along the way, forgive the pun.

All Aboard the Burlesque Bandwagon

As the movement has grown and more take up the art, sometimes the scene feels a little claustrophobic. Burlesque's revival originally sprung from the hearts of women and men who created because they desired something that didn't exist. But within just a few years the scene exploded and it seems like everyone is now doing burlesque.

The Internet 'alterna-porn' site, "Suicide Girls", featuring fierce young punk girls in playful nude pictorials hit the road to bring their fans a burlesque show of belly dancing, Betty Boop songs, and fire dancing, plus less traditional acts such as their

performance set to Bjork's song "Hunter" featuring two girls ripping electrical tape off one another with their teeth. In the second installment of the Charlie's Angels films, *Full Throttle,* Hollywood's "burlesque-flavored" cabaret act the Pussycat Dolls backed up Cameron Diaz as she posed and swirled in a replica of Dita Von Teese's signature martini glass while wearing a very Von Teese-esque rhinestone bikini. Britney Spears showed up in a *New York Times Magazine* spread that included a shot of her in a boa, top hat, rhinestone shoes, and nothing else, and was captioned, "From bubblegum princess to burlesque queen, Britney tips her hat to Gypsy Rose Lee."

The media also took notice. Burlesque was a quirky and fun thing to write about, so they did. First locally then nationally, papers and magazines wrote about the new burlesque revolution and its major players. Unfortunately, everyone had their own spin on it and often their view was wrong. When the movie *Moulin Rouge* was released around the time of the first Tease-O-Rama, media outlets such as *Entertainment Tonight* were incorrectly claiming that neo-burlesque was inspired by the luscious musical. And after *Chicago* was released, the same comparisons and assumptions were made.

In 2000, the Arts and Entertainment (A&E) cable channel produced *It's Burlesque,* which was mostly on the history of burlesque but used footage throughout of the Velvet Hammer, Burlesque As It Was, and the Shim Shamettes, and spent the

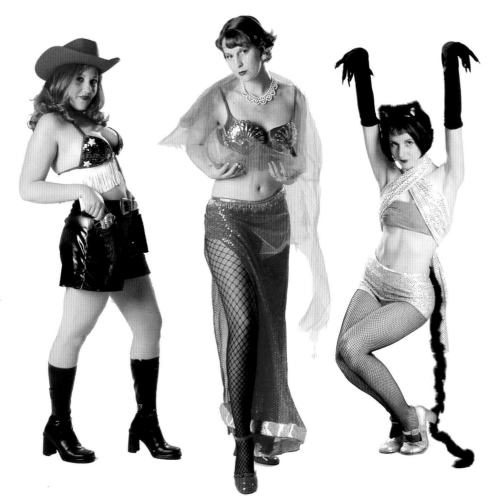

Denver based Burlesque As It Was poses in their finery. From left to right are Cheri Bomb, Vivienne VaVoom, and Honey Touché.

last twenty minutes talking to the troupe founders Michelle Carr, Michelle Baldwin, and Loreli Fuller about the new movement. Other independent documentaries include *The Velvet Hammer Burlesque* from Augusta of It's a Chick Productions, and Steffie Nelson and Barry Link's *The Big Tease* about the new burlesque focusing on the first Tease-O-Rama.

Popular magazine and fine art photographer Katharina Bosse became a burlesque fan while living in New York City, and she channeled that love into a book of brilliant portraits of neo-burlesque performers called *New Burlesque*. Though she shot some of it at the first Tease-O-Rama in New Orleans and some of it in New York, she also traveled across

the country to photograph the performers in their own environment. Now living in her home country of Germany, she's still showing her photos in Europe and piquing the European media and public's interest in the American art of burlesque.

Wary of what can happen to burlesque as its popularity and visibility increases, some in the community imagine the dark side of burlesque's increasing popularity. Exotic World's Laura Herbert protests that, "I don't want to see the people who inspired me get swept under the rug to make way for model-actress types who get trained to do a fan dance. But at the same time, I am psyched that I can get lingerie that I like at Target. And if they sell pasties I'll be tickled pink, but will Amelia [TwirlyGirl.net]?" In reference to the scene in *Charlie's Angels: Full Throttle* featuring the aforementioned Diaz in Von Teese's signature martini glass, Herbert commented, "I think it probably sucks if you spent the past eight years perfecting your routine and then you turn on your TV and Cameron Diaz is doing it."

Clubs such as 40 Deuce in Los Angeles who hire professional dancers to perform burlesque (including an Argentinian world champion salsa dancer) are beginning to crop up, and as burlesque grows those people looking for the "next big thing" will jump on the bandwagon. Even Larry Flynt is using the legitimizing idea of burlesque to circumvent the laws in Los Angeles that would otherwise prevent the mixing of flesh and food at his Hustler Club of

Beverly Hills. Many in the neo-burlesque community wonder how long the mainstream will pay attention to burlesque—for better and for worse.

Lemons or Lemonade

With the overwhelming popularity of burlesque, it was not unexpected that those who started it back up would experience rather disenchanted feelings from the thing they love being homogenized and co-opted. The World Famous *BOB*'s reaction was to turn lemons into lemonade. First she created a number called McBurlesque as a commentary on mainstream culture's tendency to dumb down everything to make it more palatable and to brand everything in an attempt to make it seem less foreign and more acceptable. Then, inspired by the vast number of ladies clamoring to be burlesque stars, she started inviting starlets to a monthly show that she presents to give girls a chance to make their dreams come true and do their first number.

Bella Beretta stared her own 'Burlesque Army,' recruiting for herself and other troupe leaders with her Anything Goes shows. Though she was originally turned off by women who inquired about joining The Gun Street Girls, she later softened to them, realizing that they weren't approaching her because they thought they could do it. "What they were saying was, 'I love watching you do what you do, I want to be that happy.'" That's when she decided that every girl should have the chance to get up on the stage

and have the opportunity to shine. Beretta's only rule was that they had to comply with the liquor laws regarding what needed to be covered. She didn't take resumes or photos, and she didn't help them with their acts. Often the newbies made burlesque out of whatever subculture they were a part of, whether it was rave girls with glow-stick pasties or goth girls with darker acts, which really embraced the "Anything Goes" motto.

As for the unknown, changing path of burlesque, *BOB* sums it up nicely: "You can stand in the room and get bitter at the people who are going to take advantage of it and make money off of it and tell us everybody has to be a size eight, or you can look around the room and see who you can help. So many people have helped me and been so supportive, like Dixie Evans from Exotic World, that I feel like if I can pass that on then that's what the community is about."

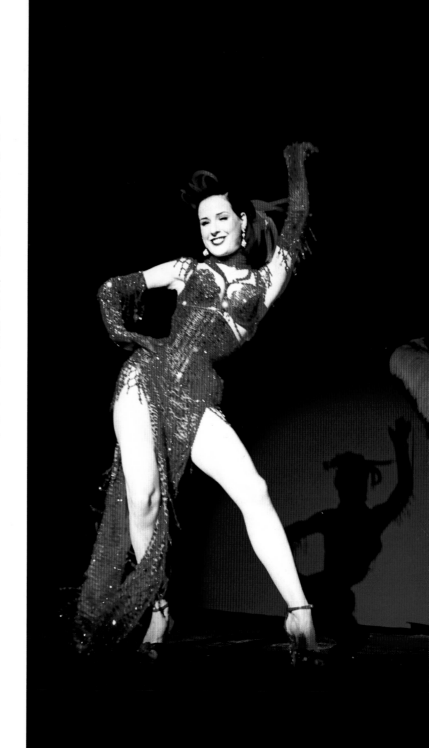

Dita Von Teese shimmers in the spotlight while doing a roaring '20s inspired striptease

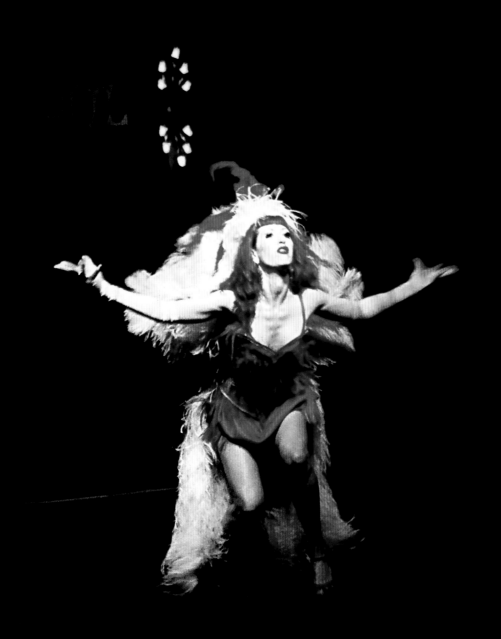

Neo-Burlesque & All Its Trappings

The Burlesque Work Ethic

The birth of the new burlesque seemed to spring, fully formed, from the heads of one hundred new feminists. In what can only be described as a moment of collective subconscious, these young women, whose mothers had burned their bras, discovered that they actually liked their bras and thought they might look lovely covered in sequins, taken off, and tossed into the stage lights.

Feminism today is something far different from the feminism of the 1960s and 1970s. Still, then and now, feminism is a fight. It's about fighting for your place in society and fighting against a world that was set up to benefit the opposite sex. Burlesque springs from that fight of establishing one's self and working hard to do it. Dirty Martini insists that, "The way I and a lot of my colleagues perform is feminist. It's a backlash from women wanting to be sexy *and* powerful."

Because most were born in the 1970s or later, a majority of the neo-burlesque women were essentially born feminists. By and large they were always told that they could be whatever they wanted to be when they grew up. Heavily influenced by television and movies, they had no conflict about the fact that their heroines were the likes of Linda Carter's tough and sexy Wonder Woman or loud and funny women such as Roseanne and Carol Burnett. They loved pop stars like Madonna, who brought back the icon of the blond bombshell for a new generation. And unlike the feminists of the 1970s, they didn't see glamour and feminism as mutually exclusive.

"I think the new burlesque movement is extremely positive," says *BOB*. "I've seen a lot of glamour, positive energy, and self expression, and I think any

Ginger Goldmine strikes an "eat-your-heart-out" pose at the Punch Bowl

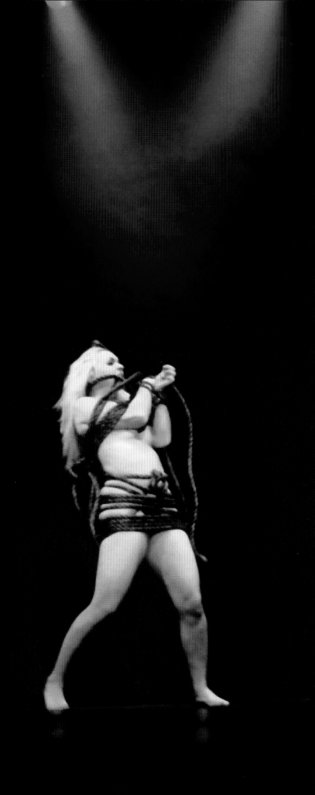

time a woman is utilizing her feminine assets in a positive way, I think that's being a feminist. Because of that I think Mae West was a feminist, I think Marilyn Monroe was a feminist, and in the '70s a lot of people would have turned up their noses at a Marilyn type."

Women in burlesque are taking what was an art form performed by women but run by men and changing the rules by putting themselves in a place of power and determining how they and other women of the movement are perceived. Burlesque, according to Tara Pontani, "tries to eliminate the objectification of women because women are taking it as their own and reinventing it and creating great performance." By and large, burlesque is a women's movement: it's run by women and it stars women. For Dirty Martini, the most feminist thing about burlesque is, "that most of the revues are run by women—produced, directed, costumed, everything." Tara Pontani compares the Pontani Sisters to a mom-and-pop business, "For us it's a very grassroots movement. Ang [Angie Pontani] once said that we basically started our own business from scratch just as if it was a store on the street, learning the hard way."

Most of the original neo-troupes and performers started out that way. They started with an obsession to make something out of nothing, to take what made them happy and put it out into the world. Angie Pontani believes that "if you do what you want to do to make yourself happy, you're making a feminist statement."

There is something awesomely powerful about waking up one day with a completely strange and original idea and deciding that despite any lack of experience in business, theater, marketing, or any of the other pieces that it takes to run a successful show of any type, you'll go for it. As the little mom-and-pop burlesque shows across the country started up, the people at the helm had to figure out how it was all going to work. Since all of the old structures that originally supported burlesque were gone, anyone bringing it back was essentially re-creating the wheel. Along the way they learned how to find talent and book a venue; how to create posters, flyers, and web pages; how to write a press release and make friends with the local press; the best and cheapest way to silk-screen shirts; how to make costumes; and, most importantly, how to find the right people for the things they couldn't do on their own.

Burlesque, Just a Euphemism?

As the new burlesque community grows, one of the most divisive issues is the difference between modern stripping and burlesque-style striptease. The question asked most often in the early days of the new burlesque was, "Are you a stripper?" To which many answered an emphatic "No." They were dancers, striptease artists, burlesque performers, but they wanted nothing to do with the term *stripper*. Many still hold true to this position.

One example of the fun poster art used to promote *Velvet Hammer Burlesque (above)*

Julie Atlas Muz (left) performs to Leslie Gore's hit "You Don't Own Me" while stripping off her binds, literally and figuratively

Kelly Ball (a.k.a. Francean Fanny) believes that there is, "a lot of confusion to the masses regarding what is and isn't burlesque. If you type the word into a search engine you will see what I mean. My ideas about it are … wholesome, if you will."

She believes that burlesque should be more about the tease, the humor, and what you don't see. "Some of the more well-known neo-burlesque performers seem to go dangerously close to that fine line between the two. I am a burlesque dancer, but I don't consider myself a stripper, at least not in the modern sense, and I work to keep that distinction evident."

Simply put, for many performers and burlesque enthusiasts, there is just no art in getting up on a stage to be naked and on display for a song or two. Laura Herbert, photographer and Exotic World representative, sees a stark and distinct difference between the two types of stripping. As she explains, "There's strippers and there's humpers. Yes they take off their clothes, but they hump poles, they hump laps, they're humpers, they're not burlesque. To me, they are both about fantasy, but one, humping, is more transaction oriented and less about self expression."

Strippers, because their performance is a commodity and their ability to hustle the customers increases their pay, cut their acts down to the basics. No-frills, explicit moves are what the average customer desires, and the location of dollars on the stage directs the movements of the dance. Burlesque acts don't change when tips are involved. For

burlesque gals such as Bella Beretta of the former Gun Street Girls, the difference between going to a burlesque show and going to a strip club is that "somebody could put five grand on the stage and they're going to see the same damn show I've been rehearsing in my living room. It doesn't change my show. You come to my show; you don't come to my work. Money does not decide what I do."

The World Famous *BOB* also draws an economic distinction between the two: "Strippers make money and burlesque dancers put it into their next costume. I would love to see the bank account of anyone who says they're getting rich off of burlesque right now, because they would be a liar." But truthfully, *BOB* doesn't see anything wrong with stripping and believes it is just another dance art form. "It's definitely a skill—I can't climb a pole. But it's a job, and burlesque, for most people, is more than a job."

Similarly, Miss Indigo Blue looks at modern stripping as a form of dance and expression. In her experience as both a trained dancer and a sex worker, she has learned that "there are the five positions in ballet, there's the five positions of the peep show, there's the five positions of burlesque, and there's the five positions of jazz. There are dance technique forms that are unique to any kind of performance, and I do think technique-wise there are some real sharp distinctions between what is burlesque and what is striptease and what is *stripping*." However, she also believes that burlesque performers have a lot

No Fake Boobs

Michelle Carr of the Velvet Hammer has had a longtime audition policy: (1) No professional strippers; (2) No fake breasts; (3) No porn stars; and (4) No bad attitude. It's a very simple formula, and it works. She believes that by only putting natural, non-surgically altered women on the stage can the burlesque aesthetic work. Le Cirque Rouge de Gus in Minneapolis has the same rules and even hangs a shingle up outside the venue declaring, "No Fake Boobs, No Stripper Moves" in part to differentiate their show from the strip clubs in town.

Satan's Angel, who started in burlesque in the early 1960s, insists that's the way burlesque was. "In the old days we were all natural—no face jobs, boob jobs, Botox, tits and ass done, no fake weaved hair or nails, no tats—it was all us."

Jo "Boobs" Weldon and Laura Herbert weigh busty issues back stage.

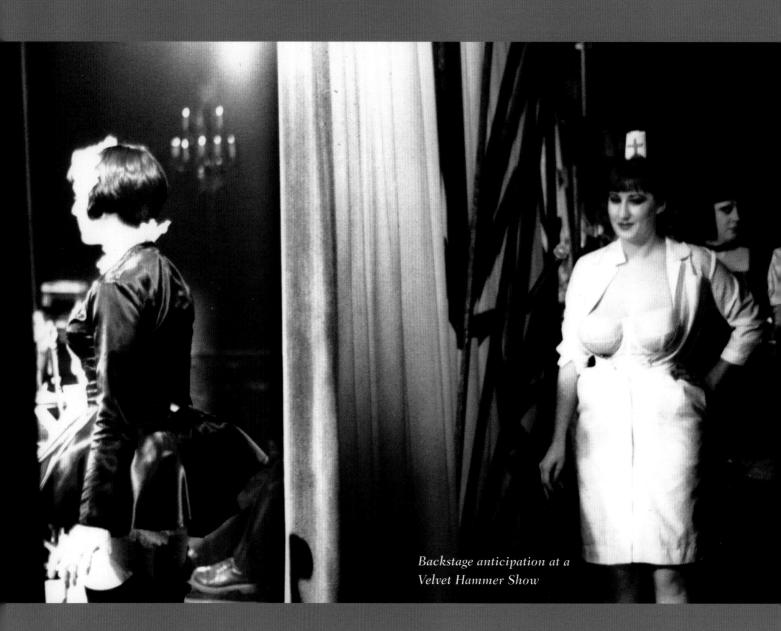

Backstage anticipation at a Velvet Hammer Show

they could learn from dancers at a strip club about eye contact, staying connected with their audience, how to artfully remove clothes, and the technique of erotic dance. "I feel that my work in the sex industry as an exotic dancer, as a stripper, as a peep show performer, has strongly influenced my burlesque performance. I get a lot of feedback about my facial expressions and my eye contact and connecting with the audience."

She also learned to separate her body movements: how to be sexy and funny at the same time, to wear an expression, or to do something silly while moving and dancing erotically. These skills developed naturally as she was working in peep shows, where "someone can be very sexy in front of a pop-up window while they're picking spinach out of their teeth in the mirror. The customer can't see that, so you learn how to isolate and separate functions, which is an extremely useful skill."

Essentially it's all about disrobing, so the lines between stripping and burlesque can be blurry. Most performers highlight the differences between the two without disparaging either, but there are some who have definite opinions about the lines that burlesque should or should not cross and what makes burlesque *burlesque.*

At base, the burlesque performance is about sex and issues related to the body, but it's not focused on the audience's sexual gratification. The purpose of most burlesque numbers isn't just to portray a sexy girl taking her clothes off, it instead gets the audience members thinking about the entire woman and what she's thinking, feeling, and creating, and the ideas around the act she's doing. The audience is not fixated on the woman as simply a sexual object, per se, because there is so much more going on around the erotic presentation, including props, fabulous costumes, and some kind of plot or reason for the strip.

The Boundaries of Burlesque

The early to mid-twentieth century burlesque that most modern burlesque performers were emulating was not a sanitized strip show by any means. It was risqué for the time, and sometimes, when girls flashed a little more than they were supposed to, it would even have been scandalous by today's standards. Interestingly, revisionist views of the dance's history would rather see the early ecdysiasts as more saintly than sexy.

Miss Exotic World 2001 and self-described "Prudist of Burlesque" Cherry Malone believes that burlesque should stay within certain boundaries of taste. Remaining within what she considers to be her "moral bounds" and stripping to a sparkly nude thong bikini, but never less (and generally much more), she calls herself a "stripteaser and nude illusionist." She insists that "burlesque stars in the Golden Era had morals and limits to what they would do onstage and in public; they were respectable and influential women that were far from sex objects."

By and large, compared to what is accepted in modern stripping, most traditional burlesque was tame and did have limits that were self-imposed or

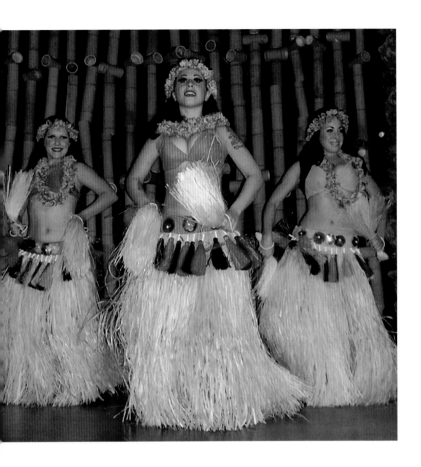

The World Famous Pontani Sisters (above) show off their moves as they hula their way in to the audience's hearts

imposed by the clubs and the standards of the era. The great burlesque acts of the day attempted to stir the heart and the mind as well as the loins, and they teased as much as or more than they stripped.

However, burlesque dancers were still not considered respectable by any means. Being a stripper, no matter the era, has never been a respectable thing to do. Neo-burlesque performers are influenced by yesteryear's ladies of burlesque and respect what they did, but the majority of that generation would have more likely admonished than admired them. We are far enough removed from that time and that place to romanticize burlesque and see the glamour and freedom of the dance—women working on their own, out on the road, performing under their own rules.

From a distance of fifty-years, we are able to take what we like about traditional burlesque and leave what we don't. Nonetheless, there is a part of that history that is related to modern stripping, with some dancers showing more than others and a prevalence of men in positions of power dictating what women did. Even Dixie Evans, who is revered and admired by modern performers, had one hell of a shocking act, which is immortalized in the burlesque film *Too Hot to Handle.* Evans' pantomimies an audition for an imaginary producer, decked out in her Marilyn Monroe ensemble, and ends the act thrusting around in a sexually suggestive way on the sofa. Rick Delaup, New Orleans burlesque historian and preservationist, has been researching burlesque for more than ten years

and attests that "a lot of people don't realize that a lot of these numbers were really raunchy."

With that said, burlesque does have limits that, according to Miss Indigo Blue, " [It] allows you to appreciate something really sexy while still feeling like there's something sacred." She also thinks that "burlesque is bringing the sexy back in this good, clean, fun way that has boundaries, which are like, well, I'm going to show you my body, but I'm not going to show you my nipple, and I might shake my butt, but I'm not going to show you my pubic hair."

Within those boundaries there is still so much that can happen, from gestures to costuming to attitude that can be very, very risqué without losing the lovely charm and humor of burlesque. Tigger, who has written, directed, designed, dramaturged, and performed burlesque, and has also done a variety of sex work including stripping and porn, says that he thinks the "push to try to define what is and what isn't burlesque and the people who are saying things like, 'Oh, that's not burlesque, that's just porn,' are so full of shit. The most beautiful, hopeful thing to me about burlesque is how immediate it is, how loose it is. If this is going to be a new movement at all, and not just reviving an old corpse with pasties, you better be willing to let the definition expand."

Body Type and Gender Issues

As Miss Astrid so eloquently put it, "Does an eagle cry because it's not a swan? No. Is a dove sad because it's not a flamingo? No. And so it should be, ladies and gentlemen, with women. Different shapes, different sizes, tall, short, fat, thin are all beautiful."

In the 1890s, May Howard's troupe boasted that they would hire no woman who did not weigh at least 150 pounds, and W. B. Watson's "Billy Watson's Beef Trust" had performers who weighed as much as 200 pounds. Their standards reflected the tastes of the times, which were toward more voluptuous women. Today, burlesque goes against the standard and the norm by welcoming women who don't fit the standard of beauty promoted by the popular culture and media.

Though vintage burlesque photographs feature curvy women, Laura Herbert finds that modern burlesque is still much more inclusive of body type: "I think that is incredibly empowering. If you're really skinny or really heavy, there's room for everyone. It's about confidence, it's about going out there and saying, 'You know what, I'm not going to let you tell me whether or not I'm beautiful, I am going to put out how I feel.'"

In the past, burlesque featured the popular body type of the day, from the 1800s ideal of "Billy Watson's Beef Trust" to the 1950s perfect 36"-23"-37" figure of Blaze Starr. Larger women were only in burlesque in the mid-twentieth century if they had a novel specialty, such as tassel twirling. However, take a quick look through Len Rothe's burlesque pictorial The Queens of Burlesque and it becomes clear that

the body types in the burlesque of the 1940s and 1950s were closer to the average woman's body type today. There were women with bellies, wide hips, and small breasts, as well as large. None of them compare to the super-skinny, clothes-hanger models or to the thin, toned, and busty strippers who are promoted as the ideal today.

Part of the soul of new burlesque is size acceptance, and so it seems especially appropriate that Ms. DeMeanor's Fat Bottom Revue, a performance group of fat activist artists, would be part of the community. Created and choreographed by Ms. DeMeanor (a.k.a. size-acceptance activist Heather MacAllister), the revue and her burlesque dance workshops encourage "big-bellied, bodacious babes" to revel in their sexuality and self-expression through burlesque dance.

In addition to being the troupe's leader, MacAllister is also a public speaker and sex educator who offers workshops on self- and size-acceptance around the country. While living in Michigan in 1992, MacAllister founded the Venus Group, a social

and support network for large women. She is now based in San Francisco, where she moved to pursue her dream of being a plus-size dancer in a community where, she believes, people are pushing the same envelopes she's pushing.

And sometimes just getting into the spotlight can speak volumes. When the women of the Fat Bottom Revue strut out onto the stage, celebrating their Rubenesque figures in choreographed dance, they have the power to change perceptions about full-figured women everywhere. While many of the performers in the Fat Bottom Revue would find modern stripping demeaning, they're comfortable performing burlesque because it is "an art/dance form, a form of self-expression, and we have thus far always had a wonderful, respectful audience. It is about humanizing, not dehumanizing, our bodies and ourselves."

The Glamazons, hailing from New York, is another troupe of plus-size gals who are all over 5'8"and wear at least a size 14. They perform tongue-in-cheek routines to "I Want Candy" and the Wonder Woman theme, and sing songs such as Ruth Wallis' comedic "(You Gotta Have) Boobs." All the Glamazons have backgrounds in professional dance and were inspired to start the group when they heard about a plus-size ballet troupe in Russia.

The World Famous *BOB* performed with the Glamazons when they first started out. She continues to share their belief that burlesque is an art form that

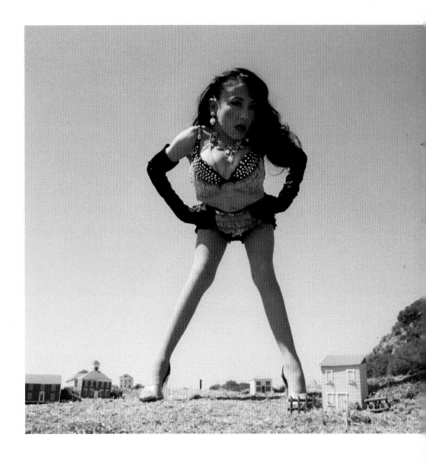

Diminutive burlesque queen Bobby Pinz (above) redefines sex appeal for her audience. Shown here in a satirical pose as "Attack of the 50-Foot Woman."

The Fat Bottom Revue (left) challenges the stereotype of sexy at Tease-O-Rama

Neo-Burlesque and All Its Trappings

Fanny Fitztightlee of Ooh-la-la Burlesque

celebrates women of all sizes, "even if they don't fit in to the square box of what the advertising industry, television, and movies say is what you need to be beautiful. You can be really thin with no boobs, you can be really curvy, you can be short, you can be tall, you can be black, you can be Asian. You can be anything. And if you have self-confidence, a smile, a cute little outfit, and a number, you have a spot in the community. And it's not just a spot; it's a spot that celebrates beauty."

When audiences show up to a burlesque show and are introduced to the wide variety of women onstage, their perceptions are often changed. It is hard to tell whether that body-positive force will spread from the burlesque stage to the media. Angie Pontani loves that in burlesque there are so many women getting on the burlesque stage and saying, "Screw them if you think you have to be 5'9" and 110 pounds." She hopes that "now that the media is catching on, maybe that will take it even further and make an impact on society at large and get rid of some of these ridiculous body types and body images that exist." Her sister Tara continues, "It's changing those barriers and starting to reshape what you see onstage, and hopefully what you'll see on television."

Still, there seems to still be a long way to go. Musing on burlesque's move toward the mainstream, Rick Delaup wonders whether girls with big curves such as Dirty Martini, *BOB*, the Glamazons, Miss Marabou and others will be embraced. In the old days of burlesque, patrons visited burlesque clubs to "see

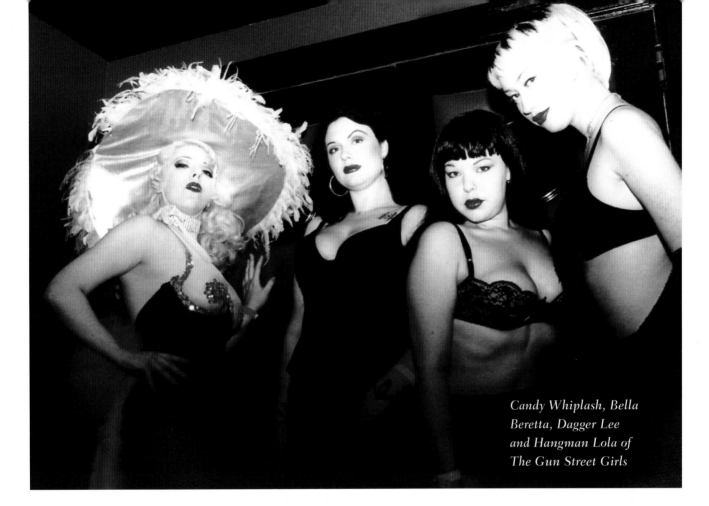

Candy Whiplash, Bella
Beretta, Dagger Lee
and Hangman Lola of
The Gun Street Girls

the most gorgeous creature you've ever seen. They were going to have bodies unlike anyone you've ever met or dated." Burlesque was and is about fantasy, the difference now is that though audiences are still going to burlesque shows to see a body, the audience is mostly women and they want to see someone with a body like theirs doing things they only dream of doing.

More than a twinge of pained sarcasm creeps into Bella Beretta's voice when she remembers, "I've had girls walk up and say, 'It's so good to see a big girl up onstage.' And at first I was thinking, 'Great, I'm going to go stick my head in the oven. I'll be right back.' I didn't know how to process it." Then she started to see those girls strutting around the club afterward with a new confidence. She realized that those women were changed for the better because of what they had seen. Feeling sexy and powerful onstage and knowing that you are possibly changing the way the world looks at you and others who look like you is an incredibly rewarding by-product of the burlesque experience.

But "big girls" aren't the only ones hit by body issues. All performers, even those who are closer to the ideal, sometimes have trouble getting out onstage. Even with her flapper girl-thin body, stripping down to thong panties for the first time was traumatic for Michelle "Toots" Lamour of Lavender Cabaret. "I was freaking out, I'd never done that before and it was a big issue, but afterwards it was like, 'I can do anything now, it's not a big deal' and," she says with a laugh, "it feels good to have the air on your butt!" Lamour's business partner, Franky Vivid, added, "This is from a guy's standpoint, but it seems like it would be much more liberating and freeing and much less degrading to just own what you look like and say, "this is who I am.'"

The Statement Behind the Tease

Burlesque is about fun and spectacle, but seriously intense messages can still slip in at the edges, and in fact, it's one of the best mediums in which to voice such messages. Miss Indigo Blue rationalizes that, "images laced with humor are so much easier to ingest for a consuming public. The eroticism kind of sneaks up on them, subtly, under the humor, the story … and the garments being flung about." As Mary Poppins said, "A spoonful of sugar helps the medicine go down," and in this case, where it's offered up by glitter and flesh, it really is "in the most delightful way!"

Julie Atlas Muz wowed the burlesque community at the first Tease-O-Rama with her striking number set to Leslie Gore's "You Don't Own Me." Muz started off blindfolded and wrapped tightly in rope, which she then stripped out of. In an era where almost a third of all American women are at some point physically abused by a husband or boyfriend (Commonwealth Fund Survey, 1998), the same act, if it had been set on a stage with different music and performed with a different attitude, could have been serious and scary performance art. However, the bondage and her self-release combined with the familiar '60s pop song made it feminist, sexy, and darkly funny all at the same time.

"The World Famous *BOB*: She's A Fucking Genius" is the title of an act by *BOB* herself, which features voice-overs speaking all the terrible and hurtful things that people had ever said to her over the years. "I was in a really dark place emotionally one day and I pulled out a piece of paper, and it was like I had tapped into this section of my brain where all those things that hurt my feelings from the time I was really little to now just sat and lived." The list was filled with comments from "basically everyone from my mom to guys on the street to ex-fiancées to friends to my brother. Some of them are so embarrassing that it was hard to tell somebody that someone had said that to me, but by releasing it I was able to free myself." The number works for burlesque because despite the terrible things that are being said, in her presentation of it, she mocks what the voice-overs are saying to her. "I also thought it would let

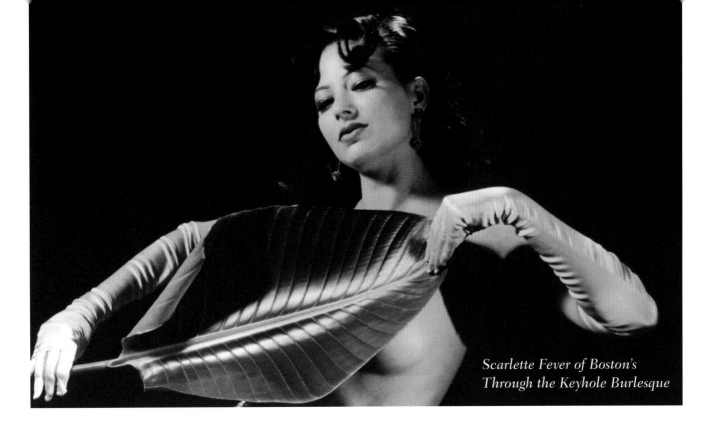

Scarlette Fever of Boston's
Through the Keyhole Burlesque

people who had heard anything like that know that they're not alone. The motto behind it is to just keep dancing, to not let those things in life that affect all of us get you down for too long."

All the way back to burlesque foremother Lydia Thompson, burlesque has had a tradition of women commenting on events of the day through their performance, sending a message while still preserving it as palatable and fun entertainment. Dawn Fornear (a.k.a. Scarlette Fever of Boston's Through the Keyhole Burlesque) enjoys the chance to step out of her everyday self to play with female stereotypes, "the nurse, the geisha, the sexpot, and so on," but she also appreciates that the medium allows a message to come through, and she has used the stage for an Iraq War protest strip and a burlesque interpretation of the Glenn Close character in the film *Fatal Attraction.*

In early 2003, as the political climate of the world was heating up on the eve of the American war in Iraq, a collective of performers in Austin, Texas, produced a night of Burlesque for Peace, with all proceeds going to Adopt-a-Minefield. Then, in the spring of that year in the midst of the war, The Sissy Butch Brothers of Chicago titled their April 2003 Girlesque Burlesque show "Burlesque Not Bombs" in protest of the war, including a performance that ended with the dancer stripped to a G-string with "Fuck" written on one butt cheek and "War" written on the other.

Neo-Burlesque and All Its Trappings

At that time, antiwar activists were also performing in the Lysistrata Project, reviving the 2000-year-old burlesque play with a performance including a collective of neo-burlesque performers in Australia and in New York. Many historians consider Greek playwright Aristophanes the father of theatrical burlesque for Lysistrata and his other satirical works. He was the first to have taken topics of the day and turned them into farces to make audiences laugh at themselves and the world they live in. In Aristophanes' Lysistrata, the wives of Athenian warriors refuse to have sex with their husbands until they stop the war. It's an effective commentary on war and female sexual power that has remained topical through the ages, as with the "Make Love Not War" philosophy of the 1960s.

Bringing politics and issues onto the stage, besides being a part of the history of burlesque, is also a natural part of our modern take on it. Many in the New York burlesque scene have an experimental theater and conceptual art background, and they often find themselves easily drawn to acts that subvert a common notion. As Tigger explains, "It's not something we sit around and discuss ... 'Gee you know I feel like I really want to subvert this notion,' you just do it, it's just what makes sense to you, what strikes you as funny and interesting."

Burlesque is about the performer's vision of what they want to see onstage without having to consider what is acceptable or appropriate. They can reverse or go beyond the audience's expectation of them. Bella Beretta had been in theater for years and found that the theater community was pigeonholing her into certain roles. "One director (when auditioning for a show) wanted no part of me in the role I really wanted." He stopped the audition and told her, "You can be as talented as all get-out, but you need to remember that what you're going to make it on is that face and that rack." She was deeply hurt. "I had gone to school for theater, and Shakespeare was my focus. I was pretty damn good, but it just devastated me ... so I quit." She didn't perform again until she formed her troupe The Gun Street Girls and was able to create her own roles on the stage.

Because it is expected to be larger and louder than life, burlesque lets women speak without reserve. The performers tell stories using pantomime and dance, combined with an expressive costume and an inspiring music choice. They reveal not only their bodies, but also statements about life.

Dirty Martini and Tigger getting ready to go on at Coney Island

All Sewn Up

The Basic Uniform

Burlesque costumes have always been about fantasy and glamour. In vintage burlesque portraits, heavy waterfalls of glass beads cascade off dancers' hips and bust, rhinestones stud the fabric of their dresses, and glitter and sequins coat the surface of their pasties and G-strings. Burlesque costumes were designed to sparkle, shine, and flow in the spotlight as the dancer moved across the stage. Acts of that era were expected to last ten to fifteen minutes, and so the more complicated the costumes and props they had, the more time they could tease, dance, and keep the audience's attention.

Most costumes included an outer costume, a decorated bra, sometimes a second sheer bra, a paneled skirt made of a light, often sheer material that would float around the dancer as she twirled, glamorous opera-length gloves, and a G-string that was often little more than a triangle of fabric and sequins that moved with the stripteaser's bump and grind. However, endless variations on that base costume could be admired. There were exotic costumes covered in Oriental-patterned beading, satin gowns peppered with rhinestones, fingerless sequined gloves, chiffon scarves that wrapped across the neck and draped over the bra cups, frilly corsets, bustles made of boas that came off one by one, simple black numbers, and wire-formed and highly detailed showgirl outfits.

With the necessity of so many pieces, the price of a seamstress could really cut into a burlesque gal's paycheck. So many women created costumes on their own rather than paying for their construction. In fact, Gypsy Rose Lee had a sewing machine mounted in the back of her Rolls Royce, and Tempest Storm

Performers dedicate hundreds of hours to make a show happen, constructing elaborate costuming —applying makeup is just the final touch. Ming Dynatease at the mirror.

Glitter, Shimmer, and Shine

Glitter, shimmer, and shine are the three omnipresent features of any burlesque costume. One of the questions the filmmaker Augusta asks of performers in her film *The Velvet Hammer Burlesque* is, "How much glitter do you eat in a year?" Though it was a question posed in jest, burlesque performers will attest to the amount of glitter coating everything they own. Even between shows, burlesque girls are likely to have glitter on them somewhere, picked up from the furniture in their house, the sleeve of a coat worn to their last show, or their floor, which always seems to be littered with a piece or two. In the film, Velvet Hammer's Ming Dynatease expresses sympathy for her poor cats who are always coated in the sparkly stuff.

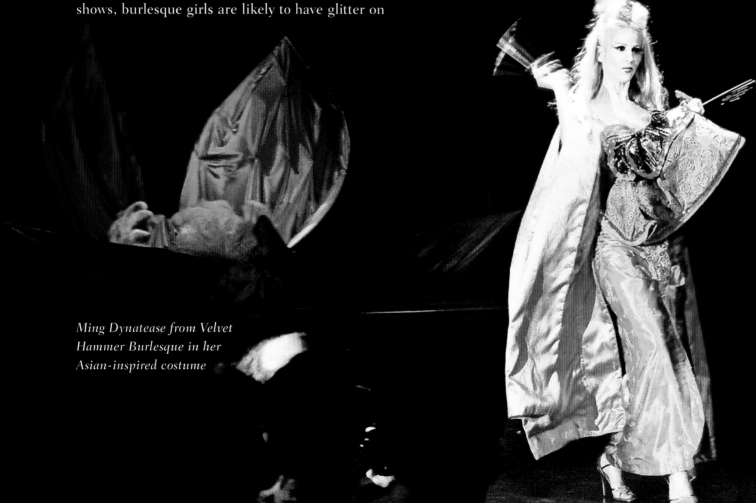

Ming Dynatease from Velvet Hammer Burlesque in her Asian-inspired costume

and Blaze Starr also sewed their own costumes. Often, when they came up with a new act, the girls would just rework an old costume, adding a few more sequins, cutting up a top to make a bra, or ripping the seams of a dress to create a panel skirt.

Functionality and Form

Today, the new burlesque generation continues the do-it-yourself tradition of their foremothers. Luckily, they have access to resources that the women of the Golden Age didn't, such as chain hobby and hardware stores and the vast resources on the Internet. They're also fortunate to live in an era of innovative craft. Besides the omnipresent Martha Stewart and her drive to make crafting respectable, The Learning Channel, Discovery Channel, Home and Garden Television, and other cable stations feature highly creative programs that have made crafting trendy and fun. Even new feminist magazines such as *Bust* feature articles on sewing and knitting. They might not be making pasties and G-strings on these shows, but for anyone with a little burlesque imagination, it's easy to see how something like a fabulous glittering fruit centerpiece would also make a magnificent headdress.

The construction of a burlesque costume has many facets. Not only should it look good onstage, it also has to be easy to remove and look attractive coming off. Struggling to squeeze out of a tight costume never looks good. Peelers have to watch out for stuck zippers and keep in mind other possible costume mishaps when they're putting an outfit together. They have to think about their number and which colors will reflect the mood of the act, the look of the era they're trying to portray, and the overall theme of the design. It's like any other theatrical costume, with the added challenge of creating multiple layers that will all look good onstage and will be able to be artfully discarded.

Other self-costuming burlesque girls have bigger challenges. For high-flying acrobatic acts like the Wau Wau Sisters and Trixie Little, they not only need sexy breakaway costumes, they also need them to be functional on a trapeze and streamlined enough to allow gymnastic movement. For Little, whose stage character is a super-burlesque-heroine, the challenge is to make, "costumes that are cute but tough, that can be easily removed, and that won't get me tangled on a trapeze or while doing partner acrobatics with my nemesis."

Secrets of the Trade

The craft of creating burlesque costumes is only limited by the designer's imagination. Burlesque costumes are purposely over-the-top feathered and sequined extravaganzas and can be made from nearly anything. Old-lady sequined cruise shirts can be made into costume appliqués, a bridal bustier can be embellished with glitter and rhinestones, and even a funky 1960s bathing suit plus a little fringe can be used as a go-go getup. In a moment straight from *The Sound of Music*, when the Pontani Sisters were

starting out they would "literally make costumes out of old drapes and bedspreads!"

Besides shopping at chain stores and on the Internet, many burlesque crafters have their secret stashes, stores they found by chance that carry sparkly odds and ends that no one else will have. Bonnie Dunn makes whimsical pasties and most of her G-strings, but the pieces she doesn't make herself she buys in the garment district of New York City. In Seattle, Miss Indigo Blue has found a treasure trove of fantastic costumes and supplies at the Greg Thompson Productions showgirl company garage sale, which happens every few years. She also regularly visits Goodwill where at a $1.29 a pound she can usually find something to inspire her next act.

Francean Fanny, who originally performed with Memphis Confidential and has appeared in the Guerilla Monster stag films, was often frustrated that her visions were larger than her pocketbook and grander than anything that existed. She would search for costuming items to fulfill her costume fantasy and hit a dead end or discover the perfect thing only to realize that it was far too expensive. Turning to innovation when she couldn't find what she needed, she has "used old lingerie or swimsuits found either in the back of my own closet or at a Goodwill shop as a base. Anything can be added to transform it to my needs—sequins, spray paint (light coats on stretched fabric), lace, beads, tape, feathers, fringe, and other goodies found at sewing stores."

Kitten on the Keys also uses vintage pieces in her costumes and she, Bella Beretta, Michelle Carr, and many others are thrift store treasure hunters. Kitten and Beretta both work for vintage stores, picking through the items that come through before anyone else gets a shot at them. Carr digs through the bounty of Los Angeles thrift stores, supplying both her everyday and burlesque wardrobes with vintage gems.

Then there are the true seamstresses. To quote Tessie Tura from *Gypsy,* "Will you look at them lady-like stitches?" Jo "Boobs" Weldon perfected the art of the glamorous stripper costume in the two years she spent making costumes for feature and house dancers while recovering from a car accident. She can make anything out of any material including lycra, sequins, leather, plastic, and feathers. She was even fascinated with making garments out of food for a while.

And anyone who has the pleasure of getting a closer look at the costumes of Dita Von Teese or Catherine D'Lish will attest to their incredible detail. Onstage, the tons of glitter, mirrors, sequins, and rhinestones that coat every surface of their costumes and props create a look of complete fantasy. For example, D'Lish's peacock costume is a wonder of beauty and construction. The corset is encrusted with hand-set crystals reflecting the greens and blues of the peacock feathers. Her long train is covered with iridescent eye feathers, and she has sewn long bones into the lining so she can flip it up and flare her tail to become the peacock.

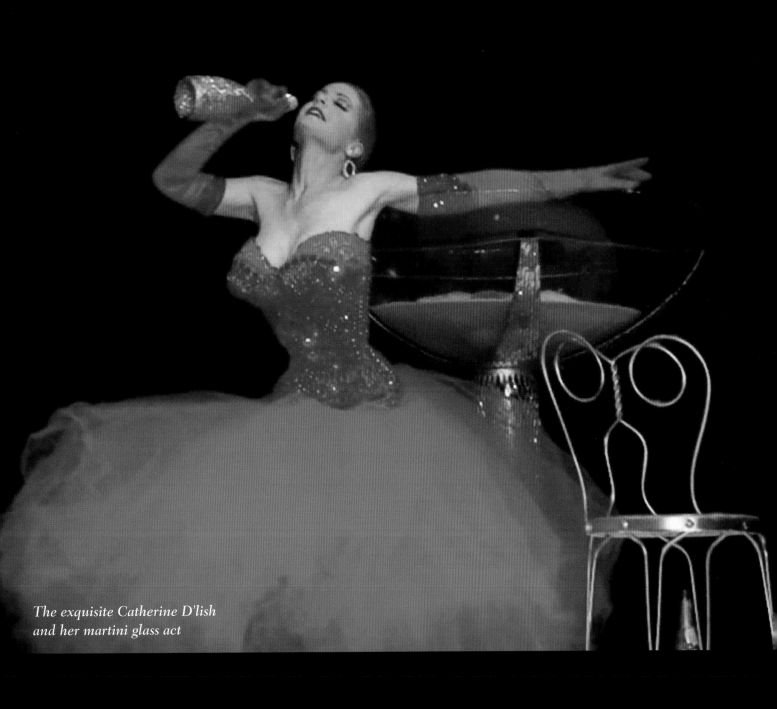

The exquisite Catherine D'lish and her martini glass act

D'Lish also makes most of Von Teese's wardrobe. "She has exceptional taste and I trust her and her alone to dress me for the stage. We plan each outfit out months ahead of time and spend a lot of time on the details." Some of her costumes are covered with as many as 20,000 rhinestones, all set by hand.

They also work with renowned corsetiere Dark Garden. After working with Von Teese and D'Lish and designing dance costumes since 1989, Dark Garden proprietress Amber Carey-Adamme stepped out from behind the scenes to become Honey Le Bang of the San Francisco three-woman troupe Kitty Kitty Bang Bang.

Points of Inspiration

Costume design ideas can come from photographs of old performers, album covers, vintage pinups, the circus, silent films, or b-movies. Jo "Boobs" Weldon, who produces "Paperback Burlesque," where pulp novel art is brought to life, made one of her outfits based on the cover of an old pulp book called Stag Stripper.

Amber Ray loves the costuming in Cirque du Soleil and Ziegfeld Follies, but finds that Japanese and children's cartoons, wacky comedy, and children's toys all inform her costumes. "I am always looking to bring more of an over-the-top fantasy look rather than your traditional glamour-puss."

Kitty Diggins loves the silent film era, the Old West, Weimar Berlin, and her vampish early century

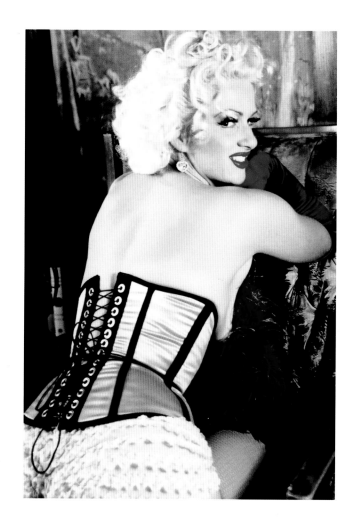

Kitten DeVille, Miss Exotic World 2003, shows off the back of her Velvet Hammer Burlesque corset designed by Sue Nice

costumes are "directly influenced by fashion and art from the turn of the nineteenth century and beyond."

Sometimes something as simple as a line of beaded fringe, pieces of metallic fabric, or a bit of boa trim have inspired entire acts. Angie Pontani has come across a piece of fabulous fabric and insisted, "We have to make a costume out of this. It's green, let's do an Irish number!" Kitten DeVille finds inspiration everywhere, but sometimes it can be as simple as seeing the color of a rhinestone, falling in love with it, and creating the costume around that.

Debra "Kaplan" Roth (a.k.a. Rhinestone Debbie), of Kaplan's World Famous Burlesque creates costumes with the same eye for the whimsical and wacky that she uses in her costume and décor designs for her company, Pink Inc. Using innovative fabrics, she's created a birthday cake that ran around the stage before Julie Atlas Muz popped out of it; unearthly satellite-like costumes for a number set to spacey cocktail music; and mermaids and showgirls with towering feather headdresses and oversized breasts and butts.

The Fashion Designers of Burlesque

Some in the burlesque world actually rely on professional fashion designers and costumers to provide at least the base of and sometimes their entire costumes. Hot Pink Feathers starts with mass-produced or custom items and then embellishes them with feathers, sequins, and rhinestones. Kitten on the Keys relies on Monique Motil, a costume designer for the long-running "Beach Blanket Babylon" in San Francisco. Kitten appreciates that Motil is "patient with my 'body issues.' She knows how to accentuate the right stuff!" She's made a variety of costumes to fit Kitten's numerous onstage personalities, including everything from frilly little-girl dresses to a sexy silver and pink belly dance-inspired costume to an over-the-top black and white striped Victorian circus outfit with a tiny top hat.

Non-burlesque world designers have been inspired by the new burlesque as well, and have created pieces based on its glamour aesthetic. Yves Saint Laurent and Nicolas Ghesquière of Balenciaga both seemed to take notice of the burgeoning burlesque scene in their 2003 runway shows. Frederick's of Hollywood has also been bringing back the sexy glamour that they once stood for with frilly, fringed, and rhinestone-studded lingerie that would make more sense onstage than under clothes. A quick search online reveals an explosion of corset designers, and the online lingerie company Cameo has introduced a "Burlesque Bra" with tassels. And though Inga at BurlesqueCostumes.com sells bikinis for the neon stages of modern strip clubs, most of her line is fringed two-pieces, pasties, and the filmy circular panel skirts they wore in the Golden Era. She also created the amazing deluxe "special occasion" suit for San Francisco's Gorilla X—a gorilla suit made completely of black fringe.

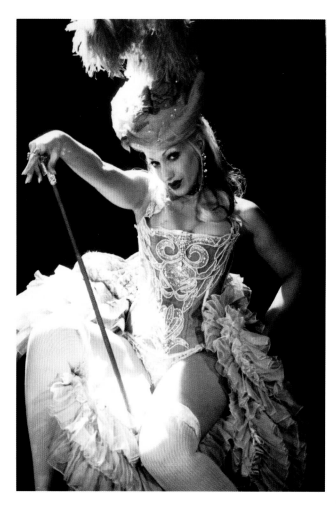

Ursulina (above) in one of her many original designs; this one reminiscent of turn-of-the-century glamour. Many Los Angeles performers utilize Hollywood costume talent to realize their designs.

Some clothiers have collaborated with burlesque talent to show off their designs. U.K.-based high-end lingerie brand Agent Provocateur hired the Velvet Hammer to perform a Valentine's Day burlesque/fashion show in their shop window on Melrose in Los Angeles. Lane Bryant referenced the burlesque aesthetic at their 2003 fashion-week intimate apparel runway show with sexy cabaret acts from Patrick Bonomo of Epicurean Productions, longtime New York burlesquer Ami Goodheart's "Rouge, The New Bohemia," and full-figured burlesque girls The World Famous *BOB* and Meryl "Lady" Finger working the catwalk. Annamarie Finley, owner of ReVamp and a designer who makes new "vintage" fashions, teamed up with Dark Garden and Michelle Landry of Lucy B., a retro lingerie company, to create a series of burlesque fashion shows in Los Angeles at the swank retro supper club Maxwell's. The models—Kitten DeVille, Kitty Kitty Bang Bang, and others from the West Coast burlesque scene—wore ReVamp clothes on the runway and then stripped down to Lucy B. and Dark Garden. The Mission Boutique in Lakewood, Ohio, was also tired of doing the same old fashion show, so they featured their fashions in burlesque acts from the turn of the century to the 'sleazy '60s.' And in New York, burlesque stars Dirty Martini, Julie Atlas Muz, and The World Famous *BOB* catwalked in a show for Williamsburg vintage/local design boutique Fortuna, who advertised the event by saying, "Come see NYC's stars of burlesque like you've never seen them before … CLOTHED!"

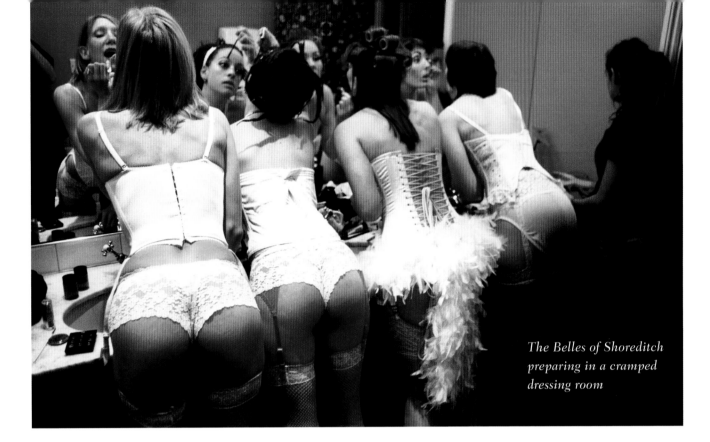

The Belles of Shoreditch preparing in a cramped dressing room

Behind the Stage Door

In her book *This Was Burlesque*, Ann Corio describes a typical '30s backstage: "Chaos always reigned backstage at burlesque. In addition to comics tearing to and fro to make costume changes, there were scads of girls in various stages of undress. Most of the time they were in a hurry too; and they would emerge from the dressing room pell-mell, only half-dressed. There they would be in the wings, chattering away, perhaps completely naked on top while they finished dressing."

Though troupes such as Lavender Cabaret, whose five dancers may perform in twenty-plus short acts in a single evening, are comparably chaotic behind the scenes with girls changing in the wings and rushing onstage as they position the last strap of their costume, most neo-burlesque dressing rooms are much more relaxed. In the film *The Velvet Hammer Burlesque*, the girls hang out backstage, drinking champagne, putting on makeup, sewing and adjusting their costumes, smoking, gossiping, giving each other tips on tassel twirling, and generally having a great time.

Most burlesque acts today are about the length of a two- to four-minute song, so much of a two-plus hour show is spent backstage. Though most of the time everyone is just hanging out, talking, and casually

getting ready, the atmosphere is one of anticipation and energy as most performers are chomping at the bit, ready to bust out on the stage. They nervously check and re-check to make sure their pasties are sticking as they should and that the snaps and velcro are secure but within reach, so everything will stay on as long as it needs to and still come off easily.

At the large-scale group shows and conventions, the scene backstage is more like it used to be in the days where friendships were forged between the stripteasers as they hung out behind the scenes, but everyone traveled so much they often only saw each other again if they were booked into the same theater. Backstage at Tease-O-Rama, The New York Burlesque Festival, and other group shows are ideal places for the community to meet, check in with each other, and have a moment to chat as they're waiting to go onstage. In the dressing rooms of Tease-O-Rama, The World Famous *BOB* stopped to offer encouragement to the members of the Fat Bottom Revue as they waited to be called upstairs, while last minute additions to Kaplan's World Famous Burlesque finale practiced in the hallway, sliding across the floor and clutching fabric hearts to their pastied chests. The Baggy Pants Comics lounged in chairs, tossing lines back and forth, preparing for their next bit. On her way back to her dressing room from the stage, Kitten DeVille stopped to compliment Dita Von Teese's white rhinestone gown as Von Teese headed up for her act. There was a near constant rotation of performers marching between the dressing rooms and the stage, their faces fixed with concentration as they went over every move in their heads one more time, and performers skipping back down the stairs, high from the adrenaline rush of the audience's applause.

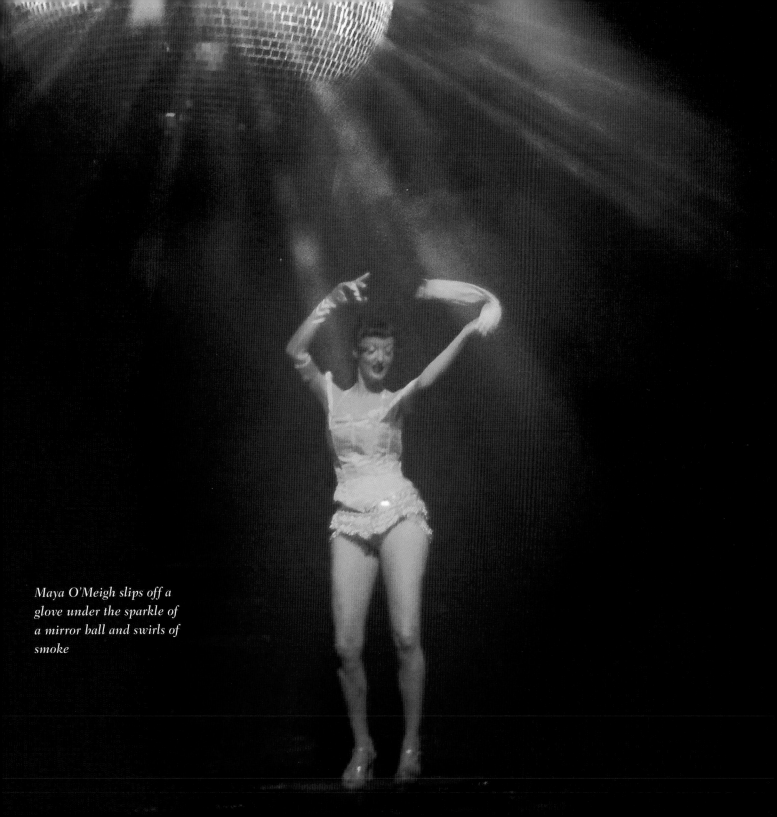

Maya O'Meigh slips off a glove under the sparkle of a mirror ball and swirls of smoke

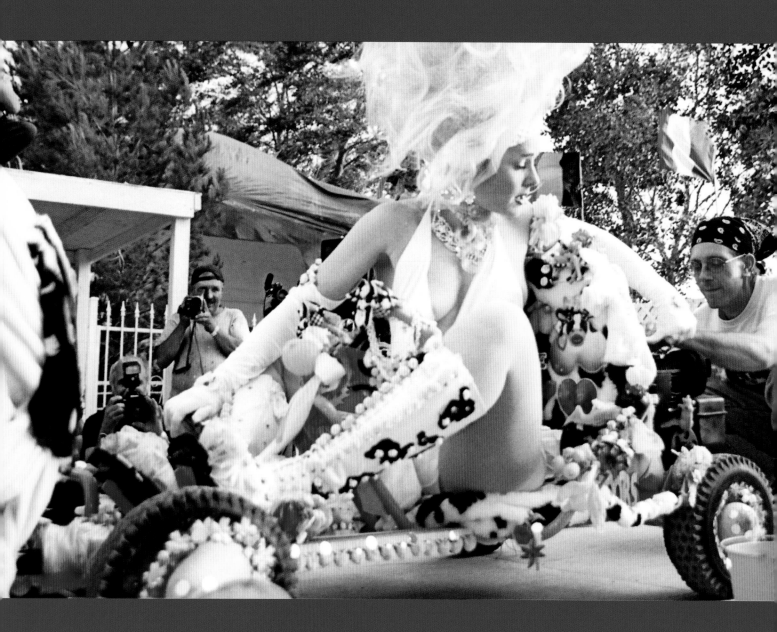

The Styles of Burlesque

All That Style

New burlesque is based on the original ideals of burlesque, but the final vision of each performer is often far beyond what anyone from the Golden Age would recognize as burlesque. New and old burlesque has varied and complicated roots. Historically there were many different forms that were all called burlesque, but the threads that held them together were their sexuality and their humor, just as it's done today.

Yet there is also a mixing of genres that makes traditionalists cringe. From French cabaret to '60s go-go dancing, the new definition of what can be considered burlesque has expanded. Some neo-burlesque performances are edgy and others classic; while most try to entice the audience, some challenge and seem to want to scare them. Sometimes there is a message in the dancer's movements and sometimes it's all in fun. But in the end, it's all burlesque.

Bringing Back the Classic

Historian Rick Delaup has been trying to convince some in the community to re-create the original acts of the 1950s and complains, "You don't see authentic burlesque being done today. I think that Dita is very close. She is inspired by Lili St. Cyr and what she does is really close to that. She really knows how to do striptease, the way that she takes off a stocking or takes off a glove. These little details really make a difference."

However, though the women of new burlesque aren't strict re-creations of bygone performers, many still try to evoke the past with their style of

Roobie Breastnut clowns around on her Boob Mobile at the Exotic World Pageant.

burlesque dance. Dita Von Teese is one of those performers and started off performing burlesque as a feature adult entertainer. "I spent years touring strip clubs where the only thing people appreciate is shock value and typical bleachy-blonde looks. But I believed in this, and I knew that there were other people out there that did too."

Von Teese used the strip club stages of Orange County to perfect her stage presence and vintage-style striptease. When she met Catherine D'Lish, she found her perfect match. The two had a love of the old burlesque and classical training that informed their acts. D'Lish had the ability to create the costumes of Von Teese's dreams and the two friends influenced and inspired each other while still defining their own personal style.

When Von Teese appeared on the cover of the December 2002 issue of *Playboy,* her pale skin, raven hair, and her body, tightly bound in an elaborately decorated corset, stood out from the typical covers that featured tanned, all-American looking girls. Burlesque performers once filled the pages of men's magazines, and to the many performers and fans of burlesque it seemed as if this could be proof that burlesque was really back.

Von Teese's high visibility has helped the word about burlesque enter the mainstream once again. She pitches her burlesque to the widest possible audiences, attempting to scoop the whole world into her fantasyland of feathers and giant martini glasses.

Rather than push the envelope toward edgy or challenging performance art, she presents burlesque that reflects the elegant acts of Lili St. Cyr crossed with the saucy and fun attitude of Tempest Storm, and then combines it with the qualities of an MGM color extravaganza and the glitz and glitter of a Las Vegas showgirl. One gets the sense that her goal is to put onstage something as indescribably pretty as possible.

In concert with her visual sensibilities, Von Teese has a brilliant sense of what looks good, what will wow an audience, and what will impress burlesque aficionados. One of her loveliest and most ingenious acts is her carousel horse number. Starting with calliope music playing before the curtain opens, it takes the audience a minute to recognize that what they're listening to is David Rose's *The Stripper* rendered as a carousel song. As the curtain is raised, Von Teese is revealed perched on a sparkling carousel horse, outfitted in a pink top hat and fantasy circus costume, complete with a rhinestone-studded horse crop in hand.

Two-time winner of the Miss Exotic World competition, the aforementioned Catherine D'Lish embodies the sensual movements of the old burlesque stars. She moves slowly, but never stops moving, drawing the audience in to her dance. Combining her first love with her newer passion, D'Lish sings as well as strips in some of her numbers. Her acts are plays on classic burlesque stripteases such as the fan dance, champagne bath, birdcage, and spider web.

The Legends

Some of the legends still do take to the stage occasionally. Satan's Angel made her first appearance in thirty years at the 2003 Tease-O-Rama. Dee Milo and Gyna Rose Jewel both performed at the 2002 Tease-O-Rama, and Jewel took the stage again in 2003. Many of the old-timers walk the runway at Exotic World, and Dixie Evans still occasionally brings back her Marilyn act. Tempest Storm has just never gone away. Born in 1928, Storm was a revered star of the Golden Age of Burlesque and was in the first show that Dixie Evans ever saw. Continuing to look good today with her red hair afire, she still has the moves, walking and sashaying, to captivate the audience. As she approached the catwalk at the Miss Exotic World competition and reunion, where eager photographers waited to snap photos of the septuagenarian stripper, she could be heard saying, "Eat your heart out! Eat … your … heart out!"

The famous Tempest Storm takes to the catwalk and takes it off for her generations of adoring fans.

The lovely Miss Catherine D'Lish perched in her birdcage

The use of the spider web in burlesque was interpreted in a number of ways: Tajmah in New Orleans played the innocent virgin ravished by the giant spider puppet that reached through the web; others constructed a web of sequins against a black curtain and had the arms of the "spider" reach out and tear their clothes off. But D'Lish's take flips that idea of the spider, and *she* becomes the spider. After stripping most of her clothes off, she climbs the web and strikes a number of athletic and nearly contortionist poses, moving slowly and very archnidlike around the web.

Starting out as a cigarette girl at swing dance and retro USO shows, Cherry Malone, another burlesque classicist, has evolved into a "Goddess of Burlesque," as she calls herself. Her tributes to the great Sally Rand's fan-and-bubble dances strive to re-create the classic acts. Her own inventive and often comedic acts combine burlesque comedy with burlesque striptease as she trots out onstage in a stuffed DD-cup bra and buck teeth, then strips out of the outlandish costume to reveal her true (and much more lovely) form or segues from a sensual belly dance to a comically juxtaposed, high-energy dance set to MC Hammer's "Can't Touch This."

The Shim Shamettes, one of the first neo-burlesque troupes, danced classic burlesque from the 1950s against the classic jazz striptease backdrop of the Shim Sham Revue. Taking inspiration from nearby Bourbon Street and its rich burlesque history, they brought everything from lavish ensemble scenes to

Shim Shamette creative director Loreli Fuller's re-creation of Evangeline the Oyster Girl to the stage of the historic Shim Sham Club. They later scaled down and became the more compact Southern Jeze-Belles headed by Nina Bozak, and then disbanded when the famous Shim Sham Club shut down in 2003.

Striving to dance as they did in the 1950s, Dirty Martini's incredibly expressive dances are captivating. The way she unzips her dress while giving the audience a saucy and secretive look and then lets it fall as her fans wrap around her larger-than-life hourglass figure as she performs the classic balloon dance, fan dance, tassel twirling, striptease, and shadow dance is utterly classic. Coming from a background in performance art and dance, she became curious about the history of burlesque dance and started researching the fan dance in 1995. Her first performance was one of the most unusual modern debuts; it took place in post-war Bosnia in Sarajevo right after the war where she was traveling with a touring theater company. A whirlwind of dance and color, Dirty re-creates the old bump and grind while adding bits of her classical dance training, such as toe-shoe work; she, like the women of 1950s burlesque, never seems to stop moving.

Though she had already been performing her own acts before she met Kitty West, Jane Blevin became known for her rendition of West's famous Oyster Girl act. Starting out in New Orleans, she organized small but popular shows featuring herself and her friends, including Catherine D'Lish. She took the act on the road in 1997, eventually making it out to Los Angeles where she briefly joined the Velvet Hammer. Though Johnny Depp's infamous Viper Room is identified with the "burlesque-flavored" cabaret act the Pussycat Dolls, Blevin was the first to bring burlesque to the Viper Room stage, inviting *Catherine D'Lish (left, in her peacock dress)* and Velvet Hammer girls to perform. The management objected to the way some of the girls looked—some because of their tattoos, others because of their less-than-perfect bodies—so Blevin quit and has not performed since. The Pussycat Dolls were made up of professional dancers and featured pop-star cameos from the likes of Carmen Electra, Christina Applegate, Gwen Stephani, and Christina Aguilera.

Not everyone is strictly interested in burlesque as it was in the 1950s. Because it started in the 1890s and lasted into the 1960s, there are a lot of styles and eras available to emulate. Though she can sometimes be found shimmying to a 1960s beat, usually Kitty Diggins channels the vamps of the Jazz Age with miles of beads and kohl-rimmed eyes, or reaches further into history to the Old West and the feisty spirit of the saloon gal. Diggins uses Jane Blevin's old oyster shell to create a 1920s-style birth of Venus act like the old Evangeline the Oyster Girl or Legs-a-Weigh Loreli's Sex on the Half Shell act. With her wide eyes, cupid mouth, wild curls, and her ability to express herself through her face and body language, she evokes silent film stars such as Clara Bow and Theda Bara. Her timeless face and

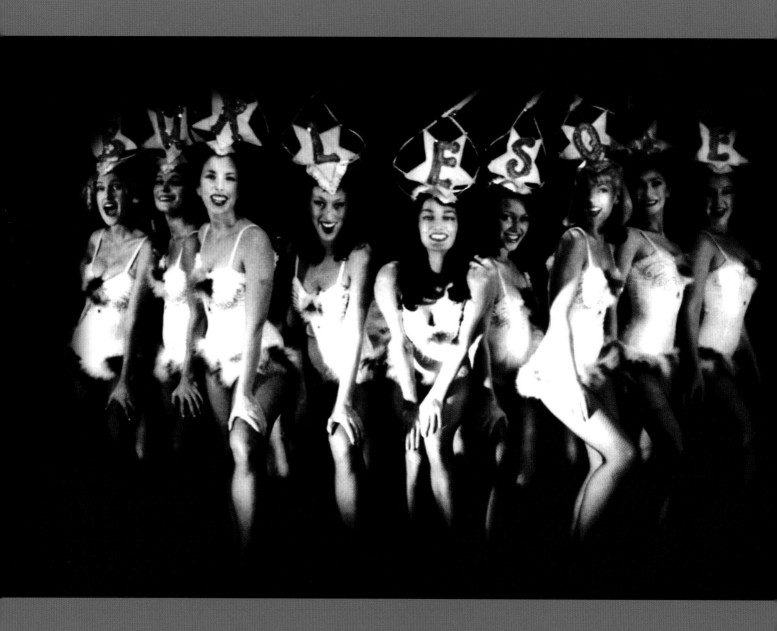

exotic movements bring the audience with her back into another era.

Trained in African, Cuban, and Haitian ballet and jazz, Ami Goodheart's dancing echoes women of the past like Josephine Baker and the early burlesque exotics and cooch dancers who mixed ethnic dance with more contemporary movement to create a unique style. Baker's dance alternated between unspeakably sexy movements and uproarious contortions, bending her limbs and rolling her eyes. Goodheart has that same winking sense of sexuality. Actually called the "Josephine Baker of the New Millennium" by Baker's own son, Jean-Claude Baker, Goodheart has been performing since she was seventeen, long enough to have inspired many other New York burlesquers. A multi-faceted diamond of the scene, she is choreographer, director, showgirl, singer, and dancer for her divinely decadent early century-themed productions. She opened a speakeasy in the early 1990s where patrons, entering through a plain gray door, would be greeted by a world of feathers and color. Though the illegal venue was wildly popular, it made more sense to move the showgirls to a legitimate venue and so Goodheart opened Dutch Weismann's, where many future burlesque stars, including Angie Pontani, were inspired by Goodheart's world of music and retro fantasy. Her shows are fun and sexy, full of feather headdresses, glittering costumes, and tightly choreographed showstoppers. Her latest production, *Rouge, the New Bohemia*, is a cabaret show starring Julie Atlas Muz and *BOB*.

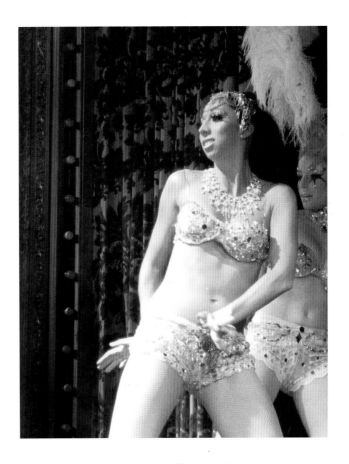

Ami Goodheart (above) is called the "Josephine Baker for the New Millennium" and is a pioneering performer/producer on the New York scene.

Shim Shamettes (left) were one of the first neo-burlesque troupes. Based in New Orleans, they performed large scale, extravagant shows in the vein of Ziegfeld Follies.

The Styles of Burlesque

Named "Best New York Based Dance Company" by *Show Business Weekly,* The World Famous Pontani Sisters' perfect coordination has been claimed to come from a kind of sisterly telepathy, keeping them in sync whether they're dancing in the street at the Coney Island Mermaid Parade or in the aisles of Marion's Continental restaurant. Delving into different decades and exploring various styles of dance, they've step-danced in shamrock headdresses, shimmied to "Viva Las Vegas" in leotards inspired by Elvis' jumpsuits, turned on audiences with their synchronized striptease, and paid tribute to their heritage dancing to "Mambo Italiano" or poked fun at it by playing hilariously clichéd bad-girl Italian princesses.

Angie Pontani discovered burlesque when she was eighteen and unsure of what she was going to do after having dropped out of college. "I saw this awesome show (Ami Goodheart's Dutch Weismann's) with these amazing costumes, and I thought that when I originally wanted to be a performer, that's what I wanted to be. I didn't want to be doing the dramatic works of Shakespeare," she pauses and then continues only half-joking, "they don't get to wear false eyelashes." Performing at first on her own, Angie later enlisted her sisters, Tara and Helen, and the three

(plus their sister Dana, who often steps up to the mic to accompany her sisters' dancing) of them soon lived up to their prophetic name, The World Famous Pontani Sisters.

The Los Angeles-based Velvet Hammer and the performers and groups that it has spawned seem like they wandered out of old burlesque portraits or off the covers of the Las Vegas Grind album. Strings of beads swing with the frenetic shimmying of their hips, and their costumes ride so low on their waists that you fear (or hope) that the pace and weight of the glittering strands will shake them right off. Troupe founder Michelle Carr's stage persona, Valentina Violette (*below*), revived the old act where a puppet is attached to and manipulated by the dancer, seducing and stripping her. Princess Kissameecoochie's name and act mirror's Princess Do May, who was known as the "Cherokee Half-Breed" in the 1950s, and plays up her Native American heritage with false rituals and "native" dances. Even when performing as the Buxotics in Lucha Va Voom between rounds of Mexican wrestling, they retain the high-energy bump and grind of '50s era greats such as Tempest Storm and Blaze Fury.

Burlesque As It Was reaches back into time for inspiration, not re-creating the past move-for-move, but researching acts and ideas from burlesque's past and bringing burlesque back in their own way. With a

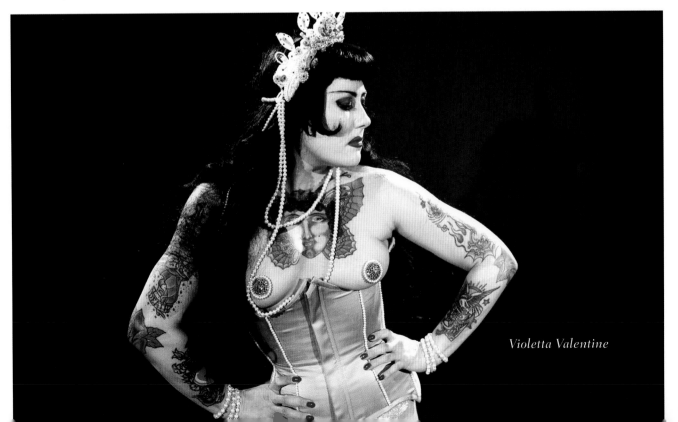

Violetta Valentine

Go-Go Girls

Part of the new scene are the go-go-girl troupes. The San Franciscan Devil-Ettes are an alterna-Rockettes troupe that kicks its way through complicated drill team-style routines. New Orleans' SophistiKittens dance to the sounds of the SophistiCats. The Go-Going-Gone Girls performed with San Francisco's Famous Burlesque, singing and shimmying in retro fringe costumes. Though not part of the original burlesque, their kick lines and go-go antics are cute and humorous and their hip-shaking action is like the bump, the grind, and the shimmy all rolled into one. They're highly visible in the burlesque scene, performing alongside and supporting burlesque. Devil-Ettes founder Baby Doe Von Stroheim created the Tease-O-Rama Burlesque Convention with fellow go-go girl Alison Fensterstock of the SophistiKittens.

The Devil-Ettes are synchronized sexpots and charm audiences with devilish drill team dance moves.

sense that more is never enough, their shows are glittery spectacles featuring such acts as "savage" girls in two-foot tiki masks leading a monkey onstage who strips off the costume to reveal a beautiful girl; a snow queen in a Ziegfeld headdress dancing to strains of Edith Piaf's rendition of "Falling Leaves;" a remote-control ventriloquist dummy who "sings" to his pineapple princess while the kitschy Annette Funicello song plays; and every show finishes with a grand finale of chorus lines of leggy girls in showgirl costumes, hula skirts, or roller skates while confetti rains down.

San Francisco's Famous Burlesque Revue is also one to revive the burlesque tradition. The Lollies and Kitten on the Keys grace most performances, but it has also included other local performers as well as traveling guests. Hot Pink Feathers, Simone de la Getto, and the Going-Going-Gone Girls have guest starred. Mig Ponce, known as Gorilla X "Gorilla to the Stars," hams it up with emcee Mad V. Dog and helps out with some of the girls' acts. Originally called Fisherman's Famous, the Famous Burlesque Revue was created by the show's former bandleader, Brian "Fisherman" Lease, but changed names when Lease moved to New York.

From mysterious silhouette dances to high-kicking can-cans, the Lollies' acts combine Weimar Berlin cabaret with 1920s follies. Known for their signature red-cloth roses and red-and-black 1920s and 1930s style costumes, they were originally known as The Cantankerous Lollies. Over the years, the Lollies have

been awarded "Best of the Bay" by the *San Francisco Bay Guardian* and the Miss Exotic World pageant trophy for the best burlesque group. Currently Jezebel, Margot Montmarte, and Delilah are the Lollies, but they have lost and gained performers over the years. Founder Harvest Moon moved to New York and performs as a soloist, though she occasionally returns to guest star. Simone de la Getto left the troupe to form Harlem Shake, a trio based on the old Cotton Club floor shows that aspires to bring burlesque to communities of color.

Moon originally brought Kitten on the Keys into the troupe, inviting her to accompany them. When Kitten joined the Lollies and Fisherman's World Famous Burlesque Orchestra, her burlesque career was born. Kitten's previous performance experience had ranged from bizarre performance art where the audience was encouraged to toss rings onto horns attached to her costume to playing naughty old-time music for events such as the Goethe Institute's Magnus Hirschfield's Museum of Sexology. Burlesque utilized her diverse experience and its combination of humor and absurdity with old-time music.

Up in Canada, Fluffgirl Burlesque Society founder Cecilia Bravo (a.k.a. The Blaze) produced monthly shows for two years before they began producing larger scale burlesques with American burlesque stars such as Dita Von Teese and The Pontani Sisters at Vancouver's historic Commodore Ballroom. Always incorporating a theme, Fluffgirl shows span acts from the fan dances of the 1930s to mod go-go shows of the

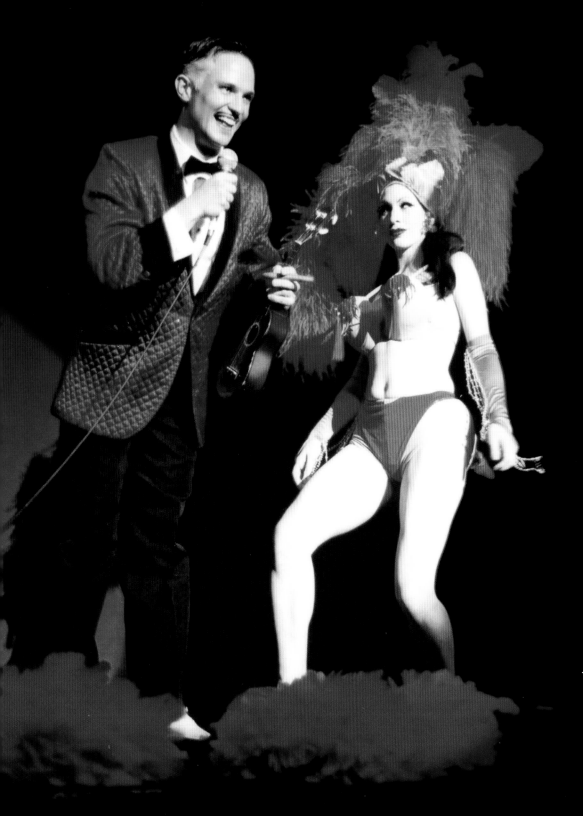

Bradford Scobie (a.k.a. Jr. Kaplan) and Miss Delirium Tremens hamming it up for laughs in a Kaplan's burlesque skit.

1960s, all the while incorporating variety acts as the original burlesque shows did.

Tweaking Tradition

The spirit of the new burlesque truly is taking an old art form and making it your own. For some, just delving into history and creating something based on it is enough, but for others there is a desire to create something truly different. Sometimes that means bringing in other art forms or taking a fantasy and amplifying it to highlight the comedy and the bizarre beauty of something the audience won't expect. Much of this desire comes from the fact that we have more to be inspired by. Laura Herbert explains: "Even back in the 1940s and '50s, at the height of their publicity stunts, people were clever but they weren't that clever. We have so much more at our disposal now."

Kaplan's World Famous Burlesque is an acid trip of Vegas showgirls stripping to reveal spinning tassels attached to plush, softly sculptured, busts and derrieres; dancers spinning in hoop-skirted flamenco dresses while a mostly naked man wearing bull's horns and a nose ring stampedes toward their fluttering red ruffles; the troupe streaming across the stage in follies-style spectacles wearing little puffy heart costumes and fountains of shiny red tinsel hearts erupting from pillbox hats. Burlesque stars Dirty Martini, Julie Atlas Muz, Tigger, Anna Curtis (a.k.a. The Lady Ace), Miss Delirium Tremens, and

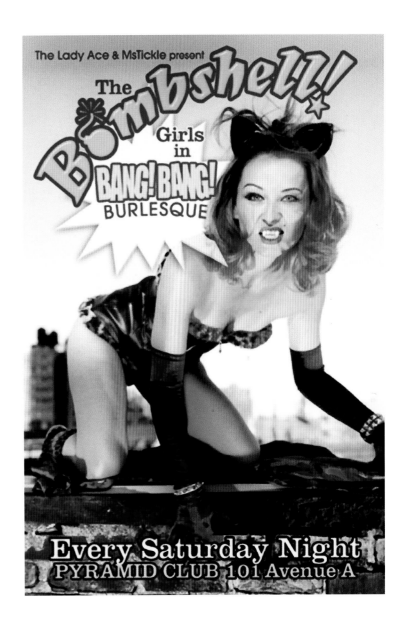

Bradford Scobie join Debra "Kaplan" Roth and her vision of burlesque as the Ziegfeld Follies meets *The Muppet Show.* It's traditional in the sense that it uses chorus numbers, good old striptease, and humor combined with glamour and sex, but from that platform it launches itself to a planet of pure and inspired fantasy.

But the now-disbanded Gun Street Girls were the first to really mess with the idea of what burlesque is. "We always considered it a benediction that the week that we started our show Edward Gorey and Screaming Jay Hawkins died," Bella Beretta reflects. "We kind of absorbed something in that into the show. Really if you want to get down to the brass tacks of The Gun Street Girls, it's where Edward Gorey and Screaming Jay Hawkins meet."

Though The Gun Street Girls did start out with belly dancing and parasol acts, they also included less-traditional acts such as Beretta's punk rock tribute to Joey Ramone set to Billy Idol's "Dancing with Myself." Her original vision was to do a very Edward Gorey-meets-Berlin-in-the-1930s burlesque called Blue Bijoux, but her love for guns and her sister Bree's affinity for knives led them to create something more violent and edgy.

Her other great inspiration is Tom Waits. Beretta attended a Tom Waits' show in Seattle and he sang "Gun Street Girl." "He halted all the sound and it was dead quiet and he sang, 'with a head full of bourbon and a dream in the straw, and a gun street girl was the cause of it all.' It just was like getting punched in the sternum. I went home and stayed up all night, and was obsessing. He was taking his very sinister, twisted view of what the world is like, where it's very ugly, but it's the ugly that's so beautiful, and that's what I wanted to create with burlesque."

Based in part on old pulp novels, the troupe took on a story line of its own, each member creating a character that connected to the others. Their "Rain Dolls" show was a fifty-five minute play set to Tom Waits' music, taking the audience down Gun Street through burlesque numbers and character interaction.

Former Gun Street Girl Candy Whiplash, who got her name while performing with a whip to a New York Dolls' song, has been changing her style to be "a little more soulful now" that she was in The Gun Street Girls. Her acts range from a pink and frilly Mae West meets Jayne Mansfield act performed to "Girl Can't Help It" to a tense and tantalizing tango number to the Rolling Stones' "Paint It Black" to a showgirl number set to the classic big-band piece "Brazil," complete with a giant yellow-and-blue headdress and a strategically placed banana. However, she still doesn't do "burlesque revisited." Instead, she'd rather "do it a little more edgy and modern and do things that people haven't done a gazillion times. I'm not trying to relive the past and I certainly wouldn't want to."

Part clown, part Anime cartoon, and part classic burlesque, Amber Ray mixes it all up and comes

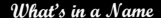

What's in a Name

One tradition that has carried on from the Golden Age of Burlesque is the fanciful monikers that performers adopt. Tempest Storm, Blaze Fury, Val Valentine, Countess Ruhkova, Lotus DuABois, J'Aimee, and Sequin were the names back then. They also often had catchphrases to go with their names such as Valerie Parks "Your Favorite Blonde Striptease," Pepper Powell "Torrid Titian Haired Tantalizer," Scarlett O'Hara "The Exciting Lassie with the Classy Chassis," or six-foot-plus-tall Lois DeFee "The Eiffel Eyeful."

Often, to capitalize on something the public was already enamored with, peelers were compared to big-name stars and took on similar names such as Rita Grable and June Harlow. Some just added a clever tagline as did Ann Perri "The Parisian Jane Russell" and Dixie Evans "The Marilyn Monroe of Burlesque," while offering to show fans more than the real stars would.

*Lovely "Hot Pepper" Powell,
photographed performing
in her heyday, shows what's
in a name.*

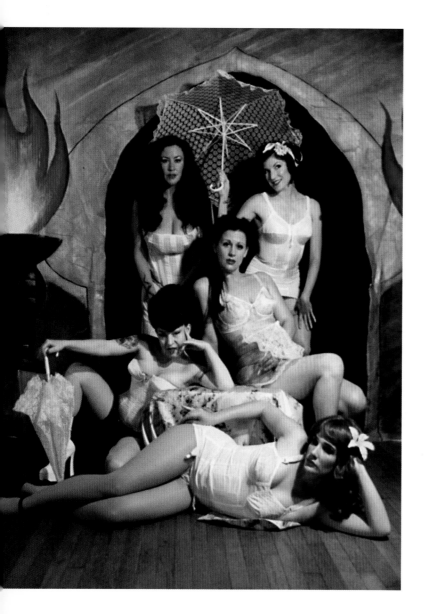

out with something completely new. She dances a traditional fan dance with peacock feathers but wears a blue wig that matches her blue satin costume and tops it off with a crown of glittered peacock eyes. Sometimes painting her face to become the living Anime-like cartoon character Kabuki Kitty or a Versailles Pierrot, she has an entire cast of characters within her that emerge onstage. Creating dance from her background in ballet and kung fu, she mixes it with her love of the Cirque du Soleil.

Anna "The Lady Ace" Curtis runs The Bombshell! Girls with Melissa "Miss Tickle" King, and though they can do a lovely fan dance, they also push the envelope with edgier acts. The Lady Ace takes on female stereotypes, in one act going from happy bride to harried mother to a divorcée on the run. Their enchanted mirror act set to Mozart's "Requiem" is decisively haunting as Miss Tickle is lured into and trapped in a mirror by her own image, The Lady Ace. It's also comedic as The Lady Ace follows every movement Miss Tickle makes, until she turns away. Then The Lady Ace leans in to whisper what turns out to be a command to strip.

The earliest show in New York was the Blue Angel. Founded in 1994 by Uta Hanna, her goal was to create a strip club where women would feel comfortable attending. In its early days it featured lap dancing and more nudity, but cleaned up with the rest of the New York strip clubs … mostly. Offering everything from Bonnie Dunn's New Orleans-influenced

burlesque to cathartic public therapy from Velocity Chyaldd, its notorious reputation attracted the famous, including Drew Barrymore who jumped onstage to do her own striptease. Now called Le Scandal, it still features a mix of vaudeville, burlesque, circus, and performing arts. Le Scandal Cabaret, now run by Bonnie Dunn, "is unique in that I try to hire performers that have a definite and unique talent to highlight their strip act. They all incorporate eroticism into their acts, yet they do not all perform the classic striptease."

Carrie "Miss Firecracker" D'Amour is a pioneer of Boston Burlesque, having been a part of the Burlesque Revival Association and Through the Keyhole Burlesque. While in those troupes, she developed an idea for "grotesque burlesque" that combined her love of 1960s horror films with her love of burlesque. Like The Gun Street Girls, she wants to set herself apart from cute and pretty burlesque, so her troupe, Black Cat Burlesque, aims to put the bump back into the night by exhibiting acts such as a zombie girl wrestling match or a Lizzie Borden tap dance along with flying ghost props and illusions for a 1960s spook show effect.

On the other coast, Mimi Le Meaux and Mistress Persephone are Dames in Dis'dress, and they too have a darker brand of burlesque, using hard rock and morbid themes to create acts that evoke 1960s b-exploitation horror films or just put an edge of darkness on traditional burlesque. For example, Le Meaux emerges from the paper screen of a plush velvet keyhole, brandishing a black cane and wearing a bowler low on her heavily kohled eyes. Their early performances at the rockabilly convention Viva las Vegas influenced later troupes like Bella and her Gun Street Girls.

Eve Wynne-Warren of Dames A'Flame is named for her alter ego, Torchy Taboo: The Human Heatwave. Her signature act ends with her bra aflame. Fascinated with the history of burlesque and its ability to be sexy without being "merely sexual," Wynne-Warren started out as a Bettie Page look-alike and a stripper who wore crazy costumes. Coming from that background, it makes sense that though her troupe practices vintage striptease, it also plays with

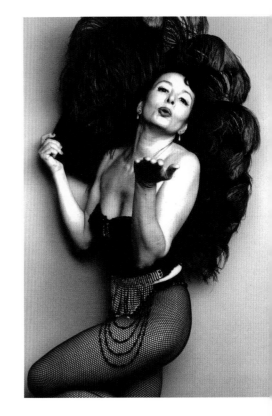

Bonnie Dunn (above) New York performer and producer, combines business savvy with sultry, light-hearted performance

Dames A'Flame show off the cooler side of their fiery personas

The Styles of Burlesque

Harvest Moon (above) shows off a special talent for flexibility

The Wau Wau Sisters (opposite) strike a pose during their irreverent, acrobatic "Catholic School Girl" routine

the art form. For the New York Burlesque Festival, Torchy spent a song making and eating a giant, messy sandwich covered in mustard, which, as she ate it, got all over her so she had to take off her stained clothes. Fellow dancer Deeply Madly danced out in a stunning Indian costume joined by a fellow dressed as a giant cob of corn. Madly seductively stripped him of his leaves, then, when the excitement of the moment got to be too much for him, he "popped," revealing a bag of popcorn hidden behind the last leaf.

But Julie Atlas Muz is by far the most experimental burlesque artist. Laura Herbert has seen Muz perform numerous times in New York and nationally, and she is amazed by how Muz "does these high-concept pieces. When Julie does her rope act, that's a hell of a statement." Muz has the ability to look sexy while eating the head off a rose and spitting it at the audience. In a hilarious performance that in other hands could be a stark and serious performance art piece, she paints herself silver and has an astronaut plant a little flag in the crack of her "moon." The recipient of numerous grants, Muz is heavily involved in performance outside of burlesque, but for her, performance art and burlesque seem to meet, merge, and mingle seamlessly. Appropriately, the *New York Times* calls her "The bemused blonde of downtown performance art."

Circus

In the Golden Age, burlesque shows spent their summers traveling with carnivals as "girl shows." The

carnies moved across the country side-by-side with the likes of Sally Rand, Gypsy Rose Lee, and Blaze Fury. The spectacle and exotic nature of the two very American art forms of circus and burlesque work as well together now as it did then.

The Bindlestiff Family Cirkus promotes their program as "High Heels and Red Noses." Headed up by the whip-wielding Mistress Philomena and the disturbed and disturbing Mr. Pennygaff (Stephanie Monseu and Keith Nelson), the show places amazing stunts next to sexual humor next to striptease. For instance, Philomena performs a drunken striptease on the trapeze and uses her whip to knock the head off a long-stem rose held in the clenched butt cheeks of an audience member.

The Wau Wau Sisters (Tanya Gagné and Adrienne Truscott) are a high-flying, bawdy, country-song-singing, irreverent gymnastic and striptease duo. Their acrobatic Catholic schoolgirl act set to Night Ranger's "Sister Christian" ends with Truscott tied to a wooden cross and "Sister" Gagné stretched out in ecstasy before her. The act was such a hit at the 2002 Tease-O-Rama that they were asked to reprise it the next year. They work physical and verbal double entendres with their dual dynamic of dirty innocence, all the while playing up their "sisterly love."

Coney Island's Burlesque started out bringing together sideshow and burlesque under the name Tirza's Wine Bath. Tirza and her famous wine-bath act was the last burlesque "girl show" in Coney to shut

Kitten on the Keys (right) is a multi-talented burlesque darling who does everything from cutesy flapper to saucy Sophie Tucker.

down. Though it was best known during its Coney days, it had traveled the carnival circuit for years. Tirza, still alive in Florida, sent a cease-and-desist letter, and the show changed its name to Teasers Wine Bath and then to Burlesque at the Beach.

Headed up by burlesque star Bambi the Mermaid and sword swallower The Great Fredini, it features freak show stunts alongside beautiful burlesque and, in the case of Bambi, sometimes a mix of the two. "I like to mix the freak show with the burlesque and sometimes I eat bugs as a beautiful mermaid and that really wigs people out. I'm more interested in delivering a good time, delivering a spectacle, and if someone tells me I'm demented, that's a big compliment to me."

Founder of The Cantankerous Lollies and San Francisco Circus School graduate, Harvest Moon is trained in acrobatics and trapeze arts, molding her style of circuslike striptease. She can spin multiple hula hoops or contort and balance a glass on her torso, all while taking off her top.

Keri Burnseton started the community performance group Fluid Movement in Baltimore. Fluid Movement creates roller-skating examinations of Frankenstein, tragic French synchronized swimming circuses, and other wonderful and wacky productions.

Though she had this terrific outlet, Burnseton wanted to be able to do more spicy and sexual numbers, so she created Trixie Little, a trapeze-swinging, evil-fighting, stripping superhero. She creates full "episodes" of her adventures fighting her nemesis, the Evil Tap-Dancing Hate Monkey. He matches her acrobatic moves by letting her down to pummel him with fake wrestling moves that could play on any professional wrestling mat, but suffers the final humiliation of losing his green satin shorts to the pink-clad heroine, followed by one of her patented healing spankings. Only showing audiences part of the story when she travels, at home in Baltimore she's able to "put together a whole story with dance, burlesque, and acrobatic routines moving the whole thing along."

Bawdy Belters

The performer most directly influenced by the tradition of the burlesque bawdy songstress is Suzanne Ramsey, Kitten on the Keys. She has the ability to take seemingly innocent music, add it to a performance, and make the song mean something very different than was intended. Take, for instance, her decidedly raunchy interpretation of "The Good Ship Lollypop," where she implores you to "put your tootsie roll in my sugar bowl!"

Starting out in a band called Sugar Baby Doll with Courtney Love in the 1980s, Kitten quickly tired of the drug-addled rock 'n' roll lifestyle. After a long musical hiatus, she reemerged as Kitten on the Keys, named after a raucous old piano tune and influenced by Fanny

Brice, Shirley Temple, Helen Kane, and all the old music that had been seeping into her brain during her long career working in vintage clothing stores.

She started out using older material, mostly brought to her by Bob Grimes, a well-known San Francisco sheet music collector. She started performing on her own and with Fisherman's Famous Burlesque, and even had a chance to play on local TV where Grimes saw her playing his music. "It just made him so happy because those songs just sit there and no one does anything with them because they all want Cole Porter and Irving Berlin. I like the real strange stuff so he saves it for me now."

Soon she moved on from old ditties such as "My Girl's Pussy" to create her own wacky novelty songs including "Grandma Sells My Panties on eBay" and "Mr. Buzzy Happiness," in which she duets with a Hello Kitty vibrator. "I continue to expand my ribald singin'/thread sheddin' while playing piano, accordion, and ukulele. Though, you really need to be careful with that darn accordion … it pinches nipples like crazy!"

Bonnie Dunn of New York's Le Scandal takes standards and melds them to her own sensual and eccentric vision, whether it's stripping as she sings a particularly sultry version of "Summertime" to a muscular African American male dancer or changing the lyrics of a *My Fair Lady* song to "I *Should* Have Danced All Night" and coming out in a dress with an obvious belly bulge, finishing with a fake onstage birth.

Dr. Vaginal Davis

Drag and Queer Burlesque

BOB is a larger-than-life, female-female imper-sonator, "so basically I'm a drag queen, but I'm a girl. I impersonate myself and different aspects of blonde bombshells that I love. That sounds very conceptual because it is." When she was fifteen, *BOB* decided she wanted to be a drag queen and left home when she was sixteen.

Raised by the gay community in Hollywood, she finally announced that her dream was to be a drag queen. "They all kind of looked confused and said, 'Well you can't really do that because you're a girl.' Not that I think they were trying to limit me, but they had never seen it done, and it kind of challenged the identity of a drag queen, or the definition of it." In the end, especially as she started incorporating joking sexuality into her performance such as mixing a martini in her F-cup bra, what she was doing was better defined by the new term, burlesque.

In a way, most neo-burlesque is female-female impersonation. Burlesque performers, like drag queens, are more woman than the average woman. Both wrap themselves in corsets and stockings, jewels and fabrics, wigs or coiffed hair, and stage makeup—he trappings of stereotypical femininity. In the 1970s, after the days of high glamour came to a close, most women lost the habit of wearing fake eyelashes and high heels, but drag queens never gave up glamour. Drag queens are sometimes parodies of women, but more often they are superwomen. They embody all the femininity that women rejected in the ultrafeminist years, helping to keep the wig and other glamour industries alive after most of the female population turned their backs on them.

Drag queen Dr. Vaginal Davis hosts Bricktops at the Parlor Club in Los Angeles where Kitty Diggens, Kitten on the Keys, The Velvet Hammer and other neo-burlesque performers have graced the stage. Her controversial blackface numbers are an homage to turn of the century minstral shows, which are closely tied to early burlesque.

Though burlesque plays to everyone, there are troupes that are specifically "queer." BurlyQ: A Queer Cabaret was spawned from the desire to make sexy entertainment for other women. Their performers come from diverse performance backgrounds including gymnastics, striptease, capoeira, and ballet. They perform classic burlesque, wild stripteases, and lovely group numbers, but with a specifically lesbian twist.

Sissy Butch Brothers, Tara "Red" Vaughan Tremmel, and Gwen Lis have been working on a documentary on the history and revival of burlesque called *Gurlesque Burlesque*. Filmed mostly at Tease-O-Rama and Exotic World, they explore what burlesque's popularity means in the context of various sexuality and gender issues. Realizing through their filmmaking that Chicago needed to be part of the revival and they needed to bring burlesque home to their community, they began staging burlesque shows to benefit their film.

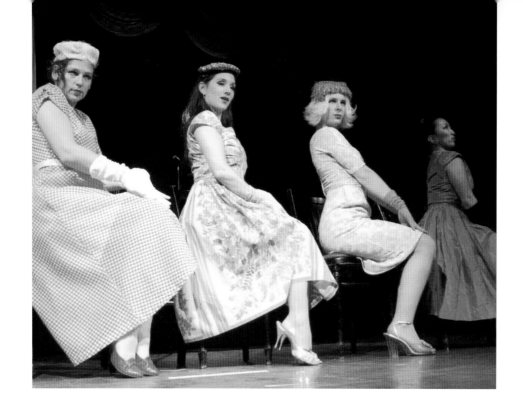

The ladies from BurlyQ (left), are based in Seattle and incorporate lots of traditional burlesque talent with a decidedly lesbian twist.

The Wau Wau Sisters (right) are a high-flying, bawdy, country-song-singing, irreverent gymnastic and striptease duo

Lesbosagogo in Phoenix, Arizona, performs sexy choreographed dance to new music, titillating lesbian audiences with their brand of neo-burlesque. The curvaceous quartet was created by founder Angela Pulliam, who fights homophobia and stereotypes that assume that lesbians are unattractive. Lesbosagogo dancer India protests, "That's just not true. Lesbians can be beautiful, too, and people need to see that celebrated."

Yet there isn't always an intended message, even if the audience finds meaning within the acts. Burlesque As It Was incorporated female drag into their acts, including an act with a girl in a full-vinyl catsuit being "tamed" by a drag king lip-synching to the lyrics of "You're My Little Pussycat Now," as well as a lascivious version of "Thank Heaven for Little Girls" sung by a woman in a suit, à la Marlene Dietrich, while another woman fan dances behind her. Though these acts were born partially out of necessity because of the lack of men involved in their shows and partially out of a sense of what the performers considered to be sexy, they received compliments from lesbians and others who appreciated the representation of their community onstage.

Popping Personas

A performer's name is quintessential to their persona, but sometimes a name just has a certain loveliness, such as Catherine D'Lish, Indigo Blue, or Amber Ray. But more often, modern performers try to say some-

thing about the character they're creating by giving her the perfect name, from the diminutive but powerful burlesque superhero Trixie Little to Bella Beretta and her love of weaponry and pulp attitude to Dirty Martini and her sparkling 1950s cocktail era-personality to the aerial burlesque artist Violetta Volare of Oracle Dance whose last name means "to fly" in Italian.

By taking on a new name, performers are taking on a new identity. While some aspects of their burlesque personality carry offstage, for most performers the character they create onstage represents all the pieces of themselves that they keep repressed in their day-to-day lives. For others, they are just magnifying their everyday personality times ten when they are onstage, presenting an overinflated, larger-than-life version of themselves.

Many performers don't reveal their real names even to the burlesque community. Some have jobs that would object to their interest in old-time stripping or are worried about the potential of a future employer having a problem with it, while others have families that wouldn't approve. But most often performers consider burlesque to be a completely different piece of their lives and their selves. Often, burlesque performers can be unassuming, almost shy, offstage. Kitten on the Keys, when she's Suzanne Ramsey, still retains her oddball sense of humor, but she's much more soft-spoken and often shows up to gigs in tennis shoes and a comfy pink tracksuit with Hello Kitty accessories. Dita Von Teese is still dressed to the hilt

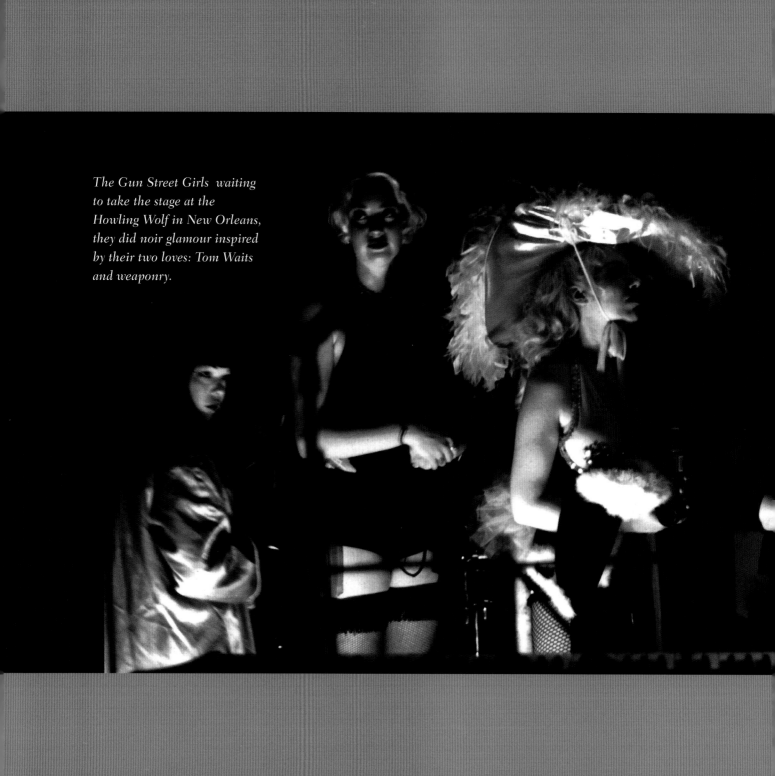

The Gun Street Girls waiting to take the stage at the Howling Wolf in New Orleans, they did noir glamour inspired by their two loves: Tom Waits and weaponry.

in vintage finery when she's offstage, but she has a quiet and gentle way of speaking and a soft accent that reveals her Midwestern upbringing.

Troupe Dynamics

Working in groups is never easy. Most burlesque troupes get along because they have a strong leader or because everyone has a say and it works as a collective. However even in the best of troupes, things don't always work out and people move on. People get tired of being in the show and sometimes the show gets tired of them.

It's difficult to sustain a troupe when most of the money goes back into the next show, and when the people in charge are usually learning as they go instead of starting with a solid business sense. And artistically working in a troupe requires compromise, which can aggravate and amplify the different needs and desires of each member.

The World Famous *BOB* joined the Glamazons for a short time, but soon found that she liked being a solo performer instead. She realized, "I wanted to be a Spice Girl and then I was, and I decided I didn't want to be a Spice Girl any more. It's hard to find four other girls that match me, to be honest." While she had envisioned the group as more of a Russ Meyer-style romp, the other performers had in mind a more bawdy Broadway show based on their theater talents. She learned a lot from the experience and said it was like going to school.

Lavender Cabaret is different from most troupes in the neo-burlesque scene. "All the girls in other troupes own what they're doing and work more as a collective. We just have a different model," explains Franky Vivid who, with partner Michelle Lamour, hires trained dancers because they need a high level of talent for the rigorous routines that Lamour choreographs. "We hold auditions and hire and tell them, 'This is what we're doing.' The girls love the show and love what we're doing, and we're a family, but they feel a little less ownership." The women aren't part of the decision making in the troupe and are essentially paid to do Vivid and Lamour's show, so they don't have as much invested in the troupe personally.

Troupe leaders, no matter what the dynamic, take on more than the rest of the troupe. Most wear multiple hats: creative director, performer, costume designer, producer, media contact, booking contact, and so on. Since they set the rules and the vision for the group, they take on greater responsibilities. They often even go as far as helping set up the venue to be sure that the seating is optimal, working with the lighting and sound techs so the show runs smoothly.

The Men of Burlesque

Only a handful of men are part of the neo-burlesque scene and usually only appear as musicians and emcees. Eric Christiansen of Dane's Dames, Franky Vivid of Lavender Cabaret, and Brian Lease who occasionally organizes shows are the only men who

Mig Ponce's Gorilla X "Gorilla to the Stars" (above), does celebrity guest appearances at many burlesque shows as well as hamming it up in classic burlesque comedy routines.

have significant leadership roles. Gorilla X, the comics, and the occasional fellow who is used as a prop to sing or dance get to occasionally share the stage with the women, but for the most part they're behind the scenes or have very set roles.

There are only a handful of men performing burlesque striptease in its new incarnation. Tigger has been performing the longest, starting out in the early New York burlesque shows of Red Vixen Burlesque and the Blue Angel. He sometimes performs in drag with Kaplan's or in acts where he's playing a drag queen, such as in his ode to trashy streetwalking cross-dressers. Other times he just strips and tries to make the audience laugh. In his performance after the 2002 Mermaid Parade he came onstage with a horrendous (painted on) sunburn and stripped out of his tacky tourist outfit as if every inch of his skin was in pain.

Tigger was extremely surprised to get to the first Tease-O-Rama and find that there were no other men performing. "On the way down (from New York) in the van, *BOB* asked, 'Oh, Tigger, aren't you going to be excited, the only boy.' And I said, 'Oh please! Every city if not every troupe in every city should have at least one of me somewhere, right?' And lo and behold, there were men, but they were emcees, they were baggy pants comics, they were musicians, they were managers, it was really odd. What male roles there were, were generally traditional."

Tigger thinks that women are more comfortable exploring roles and exploring their sexuality onstage. "Men aren't exactly the best at being loose about their roles, while women are used to adapting. They're raised to adapt. It's a man's world, so they learn to adapt. Faggots likewise, we learn to adapt. I think men are very skittish about stepping outside of those bounds and to feel like a fool is something they're really afraid of, which clearly doesn't bother me in the least."

Someone else who doesn't seemed bothered by the possibility of ridicule is San Francisco's Rocky Roulette. In his signature act he hops around on a pogo stick and strips off his breakaway suit to finally reveal his muscular body and a pink sequined thong. He's also stepped off the pogo stick for an act where he starts out as a geek and finishes stripped to socks and a thong, breaking plates to Greek wedding music.

Where Are the Baggy Pants

A huge part of old burlesque was the men in the baggy pants. They were the comics who first provided structure to the show and then acted as filler to break up the girls' acts. In an attempt to keep all aspects of burlesque alive, Tease-O-Rama has included the Baggy Pants Comedy, a revue that takes classic routines and updates them for today's audiences by using current events and pop culture references. Some of the more revivalist shows, such as Dane's Dames, Burlesque As It Was, and Fisherman's Famous Burlesque, still use comics to emcee and break up the girls' acts with funny scenes and comedy bits and sometimes to be part of the acts.

Dane's Dames have comics at their helm who echo the past when peelers performed side-by-side with the funny men. Using inventive acts that pay homage to old comedy bits, Eric Christiansen's alter ego Eddie Dane and his Dames have created acts that integrate comedy and striptease for a seamless show. In their "Dame-O-Matic" act, Dane ropes a rube (comedy partner Marcelo) into buying a machine that will create the girl of his dreams. In classic burlesque style, the machine makes girl after girl according to his specifications—a jungle girl emerges when he requests a girl who likes to get wild and crazy, when he asks for a girl who's made just for him the Bride of Frankenstein pops out, and in the end, after he asks for a girl with the combination of all his desired traits, he peers inside the machine and Gorilla X, the show's ape, lurches onto stage. Using old tunes from the 1950s and 1960s to complete the time warp that they've created, Dane's Dames adds to the traditional formula of funny men and pretty women and makes it work like it always did.

The Burlesque As It Was duo of Abe Stempler and Sid Stremple (Scott Zuchowski and Jason Stoval) drag the old humor out of the basement of burlesque, dust it off, and make people laugh, groan, and cheer. Running the gamut from old vaudeville to a more 1960s Dean Martin and Frank Sinatra cocktail style, they write much of their own material and gather

Baggy Pants Comedy Revue comics (above) making laughs between the ladies in a classic baggy pants routine

Scotty the Blue Bunny (right) stands seven feet tall in heels and ears, every inch a delight and truly a sight to behold.

the rest from old joke books and the 1968 Jason Robard film *The Night They Raided Minsky's*. They even once attempted a piece from Moliere's bawdy satire *Tartuffe* for the troupe's Ooh-la-la Burlesque Français show, drawing high praise from the theater buffs in the crowd, but a lot of blank stares from the "average Joes."

But aside from the comic-heavy troupes, most shows at least have an emcee, such as Mr. Lucky and Juan Rapido for the Devil-Ettes, Miss Astrid of the Va Va Voom Room, Junior Kaplan of Kaplan's World Famous Burlesque, Mad V. Dog of Fisherman's Famous Burlesque, drag king Mr. Murray Hill (The Hardest Working Middle-Aged Man in Show Business), Scotty "the Blue Bunny" Grabell, and Kitten on the Keys to keep audiences in their seats while sets are cleared from the stage and the girls have a chance to change outfits.

Mr. Lucky and Juan Rapido introduce the Devil-Ettes in a mostly straight emcee style, though Mr. Lucky does pepper performances with his signature beat poet-like versions of Rat Pack standards. Kate Valentine, who poses as the very dark, dry, and funny Miss Astrid, berates the crowd, teases the performers, and speaks in an unidentifiable eastern European accent. Performing in Victorian lampshade hats, corsets, and an eye patch, she entertains the crowd between acts, and her presence sews together an evening, making something that could be a disjointed array of acts into a real show.

Junior Kaplan, show host and proprietor of Kaplan's World Famous Burlesque whose show is populated by his ex-wives, is played by New York nightclub oddity Bradford Scobie, whose banter is brilliant and nonstop. Wearing the devilish and manic grin of a showman, you suspect that every word is a lie, but you hang on the edge of your seat waiting to hear his next zinger. Kaplan's has some incredibly complicated costume changes and Junior manages to keep the crowd's attention with his stories about his "family" business: "The higher the skirt, the louder the hooting, meant the higher the ticket price … in other words, bada-boom equals cha-ching."

Mad V. Dog of Fisherman's Famous, dubbed "San Francisco's favorite emcee" delivers a lot of groaners, but does it with such earnest panache that you can't help but stay with him. As he famously says, "I have great respect for old jokes! Old jokes are not to be laughed at!"

Mr. Murray Hill embodies classic comedians like Jackie Gleason and Benny Hill. As a drag king, Hill gets away with a pervasive lust for the ladies that could be creepy and would likely not be tolerated from a real middle-aged emcee. With his impeccable showmanship, if the roly-poly mustachioed comic had been around back in the day, one can imagine that he really could have been at the edge of the stage ogling the girls and wiping the sweat of desire from his brow, while warming up the crowd with the ever-positive attitude of, "Folks have we got a show for you!"

Ronnie Magri and His New Orleans Jazz Band (above) poster announces their Shim Sham Review burlesque show

Ronnie Magri and his band (right) mix multiple genres into their shows, everything from the 30s through the 50s

Scotty the Blue Bunny stands eight feet tall from the heels of his platforms to the tips of his ears. A veteran of the Bindlestiff Family Cirkus who eats fire and performs other sideshow feats, his primary function in the burlesque community is to introduce the gals and insult the hecklers in the audience. He's not always as mean as he appears onstage, and he has played more important and supportive roles behind the scenes, including mentor to Julie Atlas Muz for her show "Love, Guts (Cha Cha Cha)."

For the most part, however, new burlesque has all but done away with the tradition of the men in the baggy pants. Partially because the old jokes, though historically interesting, aren't really all that funny to new audiences even when updated. They elicit groans, verbal tomatoes, and jeers of "get off the stage and bring on the dancing girls." Modern comics don't work either, as they clash with the vintage feel of most burlesques and too many have a tendency to weave misogynistic humor into their sets, which would be unacceptable in a show that is otherwise woman positive.

One theory suggests that modern burlesque doesn't need the variety because it *is* the variety. Trapeze artists, bawdy songstresses, sultry songbirds, circus girls, fire dancers, and other acts that combine striptease with offbeat acts keep the interest of the audience. However, the widely accepted theory on the death of the baggy pants is that burlesque is a women's movement and primarily a *young* women's movement.

After standing in the audience watching boys in bands, male DJs, and men generally dominating whatever scene they were a part of, this is the girls' chance to create something of their own. If men banded together to bring baggy pants comedy back, it might have the same success.

The Music of Burlesque

Traditional burlesque, mostly because of the era and since it was a theatrical presentation, was always set to live music. Today, most performers prefer to set their shows to recorded music. The expense of hiring musicians, the lack of bands equipped and interested in playing burlesque music, and the reliability of recorded music for perfect choreography make live music a less attractive option for most troupes and single performers. There are, however, a few shows that try to incorporate live music to harken back to the good old days.

Many of the foremost burlesque bands are connected to Brian "Fisherman" Lease. The San Francisco Famous Burlesque Orchestra, founded by Lease in 1997 and now headed by Paul Bergmann (Thinking Fellers Union Local 282, Mingo 2000), strives to preserve the tradition of live music in burlesque. Playing a variety of classic striptease tunes, grindcore, show tunes, and jazz, the orchestra is an integral part of the San Francisco Famous Burlesque Revue featuring The Lollies, Kitten on the Keys, Mad V. Dog, Gorilla X, plus Hot Pink Feathers, Simone

de la Getto, the Go-Going-Gone Girls, and other performers from San Francisco and beyond. They've performed at Tease-O-Rama and as the house band at the Miss Exotic World pageant, accompanying the new stars of burlesque as well as the great Tempest Storm, Dee Milo, Isis, Dixie Evans, and other living legends. After moving to New York City in 2001, Lease re-formed as Fisherman's Xylophonic Orchestra to play with the innumerable burlesque shows in the city such as Burlesque at the Beach, the Va Va Voom Room, and The World Famous Pontani Sisters, to name a few.

Down in New Orleans, before the Shim Sham closed, Ronnie Magri and his New Orleans Jazz Band covered the great tunes of the golden burlesque age and knocked out the 1940s and 1950s bump-and-grind beat for teasers at the club. Billed as the Shim Sham Revue, they started out backing up the Shim Shamettes. During that time they made a recording of their burlesque tunes including the original composition for Bourbon Street headliner "Evangeline the Oyster Girl."

In Toronto, an eight-piece band called Jack the Ripper and the Major Players provides the soundtrack

of rhythm-and-blues chords to vintage striptease beats for the Dangerettes, while Trixie Little uses live music from the jazz improv band The Financial Group when she's at home performing in the Baltimore and D.C. area. "They play keyboard, sax, saw, drums, bowls, bass, and so on. They 'burlesque-ify' all kinds of tunes from David Bowie's space oddity for my rocket number to Esquivel for my fight scenes with the monkey. My total fave though is when they play the burlesque standard "Moonglow" for my black-light trapeze strip." They close the show with that tune and in the glow of the black light, Little's left pasty says "The" and the right one says "End."

Other troupes use less-traditional live sounds to back their stripteases. Burlesque As It Was started out using a combination of canned and live music for their shows, featuring local Denver bands such as The Perry Weissman Three jazz combo to the 32-20 Jug Band. They also set an entire show, "Spy in the Taj Mahal," to exotic surf sounds of Maraca 5-0. DeVotchKa's gypsy rock accompanied Catherine D'Lish and Oracle Dance on the BurlesqueFest tour and at the 2003 Tease-O-Rama.

Touring psychobilly band Big John Bates combines forces with the devilish Voodoo Dollz for highly dramatic live shows featuring fire dancing and burlesque numbers choreographed to the hard driving punk/retro rockabilly sound. Red Light Burlesque in Austin has their own band and performs to primarily low-down guitar-driven

Big John Bates and his band have joined forces with the Voodoo Dollz (above), regularly appearing together

DeVotchKa (left) first played with burlesque in Denver and found their gypsy rock style was a natural fit

The Styles of Burlesque

blues. Miss Satanica Szandor uses a one-man band, Mr. Uncertain, and also occasionally includes a cellist and drummer in the act.

The use of modern music has been hotly contested among fans and performers. Some are adamantly against the use of anything written after the 1960s, feeling that burlesque set to modern music with contemporary costuming or choreography is not burlesque. Most performers use retro tunes for their numbers, however others find more inspiration in modern music and effectively mix today with yester-year to create innovative burlesque. The old-school burlesque music doesn't do much for Bella Beretta. "It's just not music I love to dance to. I can see a burlesque number in a Motorhead song as easily as I can in a Dean Martin song. I look for theatricality in things. Firewater, Tom Waits, Nick Cave, Devil Doll … it's all huge music with a very operatic sense."

The Wau Wau Sisters use everything from Night Ranger to Guns 'n Roses' "Welcome to the Jungle." While Kitten on the Keys sings a sweet lounge version of the Sex Pistols "Anarchy in the U.K." And London's Whoopee Club performers strip and pose numbers to The Cramps, Kate Bush, Nick Cave, Yeah Yeah Yeahs, and Gogol Bordello.

Chicago's Lavender Cabaret founders Franky Vivid and Michelle "Toots" Lamour have created a show that is at once thoroughly modern and totally retro. Citing influences as diverse as Ziegfeld, Fosse, Michael Jackson, and Charlie Chaplain, the troupe sets their shows to the beat of a decidedly different drummer. While putting burlesque in the middle of an evening at a dance club would generally be mixing oil into water, the music that Vivid composes for the dancers, mixing modern beats into traditional striptease classics, allows them to fit in to any modern venue. Their dances are very Fosse/Broadway like … until they turn around to the strains of the burlesque classic, "Take It Off the E-String, Play It on the G-String," and flash the audience their thong-clad bums.

Ooh-La-La Presents created by Michelle Scheffer and Heather Bruck (a.k.a. Kitty Crimson), started out in Denver's Burlesque As It Was, but the troupe wanted to work with music beyond the pre-sixties music that Burlesque As It Was required. They created a high-energy mix of modern and retro burlesque, alternating between modern and vintage tunes, setting the scene for short, sexy, and funny vignettes that varied from tongue-in-cheek cheerleading routines to punk rock antics.

Trained ballerina and New York burlesque girl Miss Delirium Tremens believes that music doesn't necessarily change the heart of the dance and compares this to the modern interpretation of ballet. "Ballets have been done by major companies (American Ballet Theater, Joffrey Ballet Company, New York City Ballet), which use decidedly modern music such as Prince, George Harrison, Gershwin, Richard Rogers, to name a few. These are still ballet, not modern dance, not something else, but ballet. If ballet can use modern music, surely burlesque can as well."

Mr. Uncertain

Coney Island's Bambi respects that others find more inspiration in new music, but explains that it's not her bag. She prefers exotica or striptease music, something with drama and various points in the music to set a visual joke. Thrilled by how connected she feels to the original burlesque dancers and how classic she feels when she gets the chance to dance to live burlesque music, she says, "I'm getting into Fisherman's live music now that we have him here in New York. The live factor throws you off guard and keeps you on your toes. You have to be willing to improv and that is challenging. When you use CD music, it really is like an art piece. There is a beginning, middle, and end. You know exactly where everything is going to be, you know right when you're going to deliver the punch line and I'm kind of a control freak so I like that. But doing these live shows with the live music makes me feel really old school, how it really was. There are so many unpredictable moments, and I think that really is old burlesque."

Though he admits that as a musician he's biased, John Bates can't imagine "that anything canned would compare to live music for burlesque. Good musicians can pick up what a dancer needs and what an audience wants, things that recordings can never do such as altering tempos or the overall meter of a song, using dynamics to change moods, and the potentially rawer sounds of live instruments. There's nothing like a really mean horn to put an edge on things."

Billed as "America's Favorite Burlesque Game Show" This or That! literally gets
the audience involved in its mischief. Hosted by The Great Fredini and Julie Atlas
Muz (center) and featuring (from left to right) Ula the Painproof Rubber Girl,
Throwdini, Tigger, the hosts, Miss Tickle, gorilla, The World Famous *BOB*, and
Dirty Martini.

Festivals and Tours

Freelance writer and burlesque fan Alison Fensterstock wrote an article in the summer of 2000 on the rising movement of neo-burlesque. As she researched she found that there were even more performers than she had ever imagined. About the same time, Baby Doe, the creative director/choreographer for the Devil-Ettes, was inspired by her experiences at the Las Vegas Grind weekender and wanted to create something similar for new burlesque enthusiasts.

In the fall of 2000, word spread that there was going to be a convention, something to gather all the glittery dancing girls together from across the country (and in England's Stella Starr's case, across "the pond"). The chance to gather in one place and to have a chance to meet others with their same passion seemed too good to be true.

At that time burlesque existed in New York, L.A., San Francisco, Seattle, Denver, New Orleans, Atlanta, and Memphis. Canada had The Fluffgirls in Vancouver and a smattering of other gals in Toronto, while Stella Starr was helming the Vavavavoom over in Brighton, England. Everyone was fairly spread out and had few if any opportunities to see other burlesque besides their own.

When it was finally announced that the convention, dubbed Tease-O-Rama, was to take place in New Orleans the next May, the buzz started. The lineup, featuring nearly every burlesque performer and troupe that existed at that time, included The Fluffgirl Burlesque Society, Dane's Dames, The Devil-Ettes, Fisherman's Famous Burlesque band with Kitten on the Keys and The Cantankerous Lollies, The World Famous Pontani Sisters, Dirty Martini, Julie Atlas Muz, The World Famous *BOB*, Bonnie Dunn, Miss Astrid, Tigger, The Gun Street Girls, Memphis Confidential, Stella Starr's Vavavavooom, Kitty Diggins, Torchy Taboo and Dames A'Flame, the Velvet Hammer, Burlesque As It Was, Sophistikittens, Zoe Bonini and the New Orleans Dolls, Shim Shamettes with the Shim Sham Revue Jazz Band, Dita Von Teese, and Catherine D'Lish. DJs Otto Von Stroheim of the Tiki News, Brother Cleve, and Patrick Robinson managed the music for the ladies and spun vintage hits between acts.

Amazingly, all the acts were original and different despite the fact that no one went in knowing what most of the other acts were. Everyone had their own unique take on the old art from pop culture references such as Memphis Confidential girl Francean Fanny's "I Dream of Jeannie" act to the surreal homage to Marlene Dietrich's *The Blonde Venus* by Casey Daboll (a.k.a. Honey Touché) of Denver's Burlesque As It Was, who stripped out of a gorilla costume. There was everything from classic balloon popping dances by Dirty Martini to burlesque bordering on performance art by the New Orleans Dolls to adorable 1960s Rockette-style go-go dancing by the Devil-Ettes.

Out in the audience were future burlesque stars

such as Amelia Ross-Gilson who would later become Miss Indigo Blue of Seattle's BurlyQ, Kelly Garton of Hot Pink Feathers, Amber Ray, Anna "The Lady Ace" Curtis who would go on to form New York's Bombshell! Girls but was at Tease-O-Rama photographing for *Hustler,* and Laura Herbert who played a significant support role for modern and living-legend burlesque performers through her involvement with Exotic World. For Herbert, "The first Tease-O-Rama was the single most mind-blowing event of my life. It was transformative. I've never felt so good about myself and my generation, and this crazy kumbaya optimism came over me and I was very much in a Helen Reddy (who penned the feminist anthem *I Am Woman)* moment."

In one weekend a community was born. Everyone left with stars in their eyes and dreams of what this little revival could become. Over the years the event has grown in scope, moving from city to city, including more living legends, more daytime classes, and more acts as the community grows. Tease-O-Rama represents the great spectrum of burlesque, a balance of new, daring, innovative, and cutting-edge stuff next to numbers that pay homage to the original art.

In reaction to the wide popularity of burlesque, new festivals have been created. The Pontani Sisters combined forces with New York promoter Thirsty Girl

Productions to present the annual New York Burlesque Festival. Performers fly in from all over the country to perform next to the bounty of New York burlesque talent. The idea that the definitions of new burlesque have always been loose and free is especially true in New York, and as Tigger says, "If it's sexuality with a wink and something over the top, then it probably counts as burlesque." At the New York Burlesque Festival, happy, glittery, naked dancing from the Dazzle Dancers, sexy majorette routines from Oh De Twirlette and Twirla, weird performance art from Tofu Honey Pie, and the Ukes of Hazzard's amusing dueling ukuleles all performed as part of the new burlesque.

Peelers have also gone out on the road. New York performers including Kate Valentine of the Va Va Voom Room, who started her burlesque career in Los Angeles, rejoined L.A.'s the Velvet Hammer for a series of shows and took Va Va Voom Room to San Francisco's York Hotel. Denver's Burlesque As It Was brought in Dita Von Teese, Catherine D'Lish, The Gun Street Girls, Margot from The Cantankerous Lollies, Kellita from the Hot Pink Feathers, and Kitten on the Keys for Burlesquefest and Burlesque XXXmas. In addition, Jerri Theil of Denver's Nobody in Particular Presents launched a nationwide tour based on the popularity of those initial Denver burlesque shows called BurlesqueFest tour, featuring Kitten on the Keys, Catherine D'Lish, Kitty Crimson, Empire Burlesque Follies, and Oracle Dance.

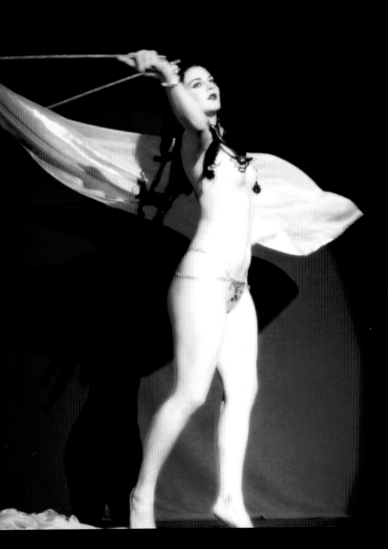

Burlesque scholar Lola the Vamp (above)

Stella Starr (right)

Burlesque International

Burlesque has taken a long and circular journey, starting out in the United Kingdom where it was originally born with Lydia Thompson and her British Blondes, and then moving to America where it was reworked and reborn again and again and again, only to head back out across the Atlantic and back to Britain.

In London, former stripper Lara Clifton met Tamara Tyrer, a video artist and graduate of the Royal College of Art, in a fan dance class Tyrer was teaching. A few months later they launched the popular monthly Whoopee Burlesque Club at The Cobden Club, a Victorian burlesque hall, starring British neo-burlesque queens such as the voluptuous tassel tosser Immodesty Blaize and male burlesquer Walter, who performs burlesque in the style and dress of an English dandy.

Whoopee shows mostly feature burlesque that has closer ties to pre-1940s burlesque. They make use of the old tableau vivant shows, re-creating paintings and sculpture against a projected back-drop. Clifton and Tyrer's inspiration comes from Busby Berkeley, the dark and surreal aesthetics of David Lynch, and artist/filmmaker Matthew Barney, whose own aesthetic is a combination of Berkeley and Lynch. Though they use a mix of vintage and modern canned music, they also have an eight-piece house band, Flash Monkey, whose repertoire ranges from 1950s exotica to soulful gypsy tunes.

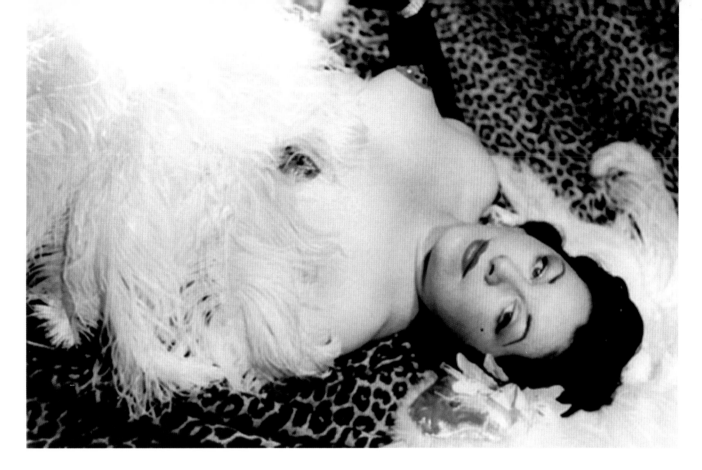

In addition to the shows, there are the stand-alone performers. With her dark black hair, milky white skin, penchant for pink feather fans, and comfort with both the burlesque and fetish scene, Gwendoline Lamour begs comparison to the American burlesque queen Dita Von Teese. A scholarly stripper, the classically trained actress with a master's degree in performance also has professional experience as a writer, director, performer, and teacher. Her acts range from the classic fan dance to a sexy kitten striptease where she crawls across the stage toward a saucer of milk. Reaching back into history to create a cross between tableau vivant and burlesque striptease, Lamour has an elaborate girl on a swing number that she based on the 1767 Fragonard painting "The Swing."

Stella Starr, daughter of underground filmmaker Jeff Keen, started coproducing a weekly cabaret night in Brighton, U.K. in 1993 called "Andy Walker's Fame Frame" at the Zap Club. During that time, she started incorporating burlesque into the show and then eventually launched her own show, "Vavavavoom! A Marriage of Burlesque Vaudeville + British Music Hall with Music from the 1940s–50s."

Fellow U.K. girl Lucifire performs burlesque that combines her other, more sideshow-oriented talents including walking on glass, blockhead, bed of nails, eating live bugs, and live stapling and piercing. She also likes to play with fire eating (hence her name), as well as blowing fire and setting various parts of her body ablaze. In her burlesque she utilizes characters from the movie *Rosemary's Baby*, incompatible Siamese twins, and a lesbian Frankenstein b-movie character of her own invention.

On the other side of the world, Erochica Bamboo, a Tokyo oil painter who got "tired of waiting for her paint to dry" was inspired by the burlesque tradition that American striptease artists had brought over when they performed in Japan during the 1950s and 1960s. She performs mostly at "hostess clubs," where men purchase the company of a woman for dinner and conversation. Bamboo's challenge is to get the patrons to look up from their dates to watch her show. Though many of her acts reflect the hypermodernity of Tokyo, her best acts, including the act that won her the title of Miss Exotic World 2003, use traditional burlesque costuming, movement, and energy that harken back to American teasers of yesteryear.

Lola the Vamp is an Australian researcher, musician, and artist who discovered burlesque while researching the history of corsets for her Ph.D. She found that burlesque melded her two passions, music and art, and the more she investigates the art of burlesque the more authentic her performances are.

As a result, they inform her research in a living, immediate way that just reading or looking at images can't offer. Crafting costumes based on old photographs and research that describes the dancing and costuming of pre-1920s burlesque, Lola's performances echo dances that previously could only be seen on scratchy black-and-white films.

As American burlesque's popularity grows, it's inevitable that it will continue to be imported, translated into other languages, and absorbed into other culture's traditions and dance. Who knows, maybe the circle will continue and the flavors of international burlesque will some day infuse American burlesque.

Babette LaFave from Canada's Empire Burlesque in one of her surrealist burlesque numbers

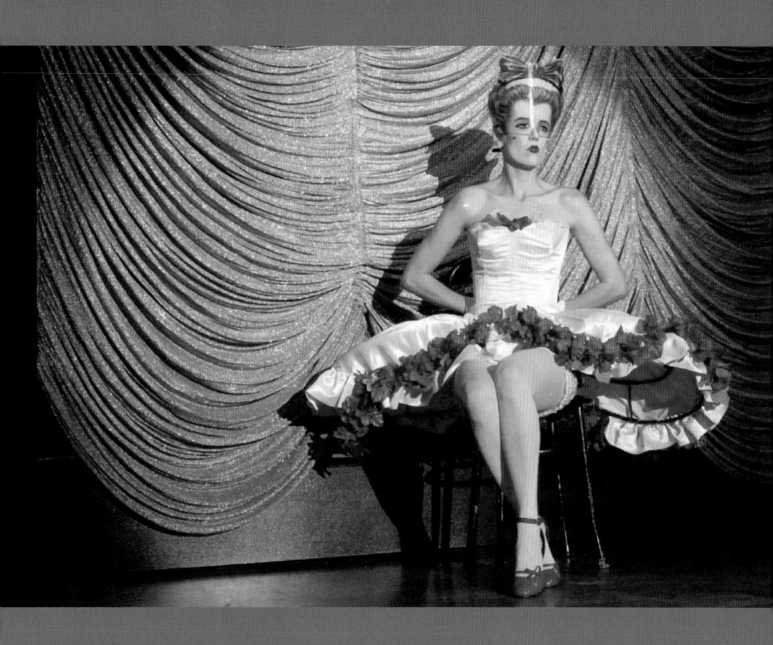

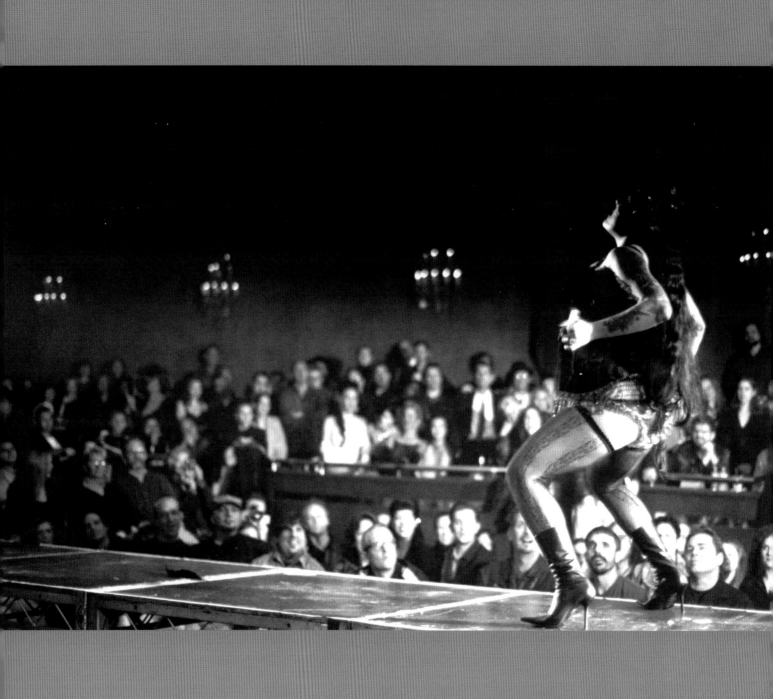

The Voyeurs

Why Do They Come?

Burlesque is all about the tease and what you don't show rather than what you do. It is innocent in comparison to some of the flesh displays common on television, movies, and the Internet, but it is still naughty fun. Clothes are being removed, bodies are moving in a sensuous dance, and a seduction is being staged. Whether it's funny or seriously sexy, the central point of burlesque is to seduce the audience, inviting them into the performer's fantasy for a song or two. In a world of *Temptation Island* and HBO's *Real Sex*, burlesque stands in stark contrast with its emphasis on the beauty and fun of sexuality and the female form along with its ability to entice more by showing less.

Modern burlesque audiences are incredibly diverse. The older generation comes out to see the art form that they once witnessed and loved, and the younger generation comes out of curiosity and then comes back because they're hooked.

The Gun Street Girl audiences, for example, were very mixed. Bella Beretta says that a variety of people came out and they each had their separate attraction to it: "The goth kids loved us because we had people in our troupe who were part of the goth community. Jazz bohemians came out because we were Tom Waits related. Gay, straight, boy, girl, hipster, non-hipster, it was really a wide array."

The audiences for Seattle's Fallen Women Follies was, according to Miss Indigo Blue, "mostly leather dykes because they were the girlfriends and the community of everyone who was performing. But over the years word got out about how amazing the performances were and the show expanded to be more of a variety show as the audiences expanded to be an amazing cultural mix of people."

Michelle Carr peels off her corset under the spellbound gaze of the audience at the American Music Hall

Audiences are always looking for something new, even if it's just something old made new, but that isn't the only appeal of burlesque. The far-reaching appeal of burlesque comes from the inherent naughtiness of a sexy girl show, mixed with the inclusivity of the performance. Not only do the performers represent a variety of humanity, but the performances themselves aren't specifically aiming at one demographic.

Tigger explains that burlesque "literally can play to anybody and frequently to people who would never in a million years want to see 'Untitled Ecstatic Pain Ritual' or 'Brief Architectural History of the American Closet, Part One,' which are among shows I did. And yet there they are screaming and laughing at my burlesque."

Bella Beretta has an agenda with burlesque. "By doing burlesque I'm able to lure people in to see a show because of the word *burlesque* and have them walk out feeling like they got hit upside the head." She tries to challenge the audience, to lure them in with the sexiness of burlesque, but send them out the door changed somehow. Beretta takes the Diana Freeland quote, "Give them what they never knew they wanted," and expands on it. "I want to give them what they never knew they wanted, but now that they know it this way, they don't ever want to go back."

The ability to both challenge and entertain the audience can also be a draw, especially for anyone looking for something that isn't just pure entertainment, but also isn't so difficult that it's not fun. Burlesque can reside in the valley between performance art and showgirl spectacles, and as a result it can be interesting to both anyone tired of meaningless entertainment and those interested in more serious theater who want to see something more frivolous, but still not aimed at the lowest common denominator.

As the media has caught on, it has increased the audience, and more shows are able to exist and sell out. Though burlesque plays to anyone, it doesn't always play everywhere. Angie Pontani finds that because of the popularity, "Now I get clubs calling where they're playing boom-boom-boom music saying 'Yeah, burlesque is great! Can you guys come down?'" Helen continues, "and they throw us on between the techno music. Of course it doesn't really work because it just breaks up the night, but they hear that burlesque is hot so they want us in there." More modern-style burlesque troupes such as Lavender Cabaret and Ooh-La-La might be able to fit into a club atmosphere, but most performers' retro style and music just wouldn't be a good match.

The A-Peel of Burlesque

The homemade, do-it-yourself quality of burlesque also has an appeal to audiences. Not only are most of the costumes made by the performers, but they often also create the sets and the props. From Trixie Little's fields of glittering bananas to Bella Baretta's mechanical gypsy booth, they are still professional-looking stage sets, and anyone who didn't know would have no idea

that the performer created them themselves. However, those who are in the know appreciate the effort. That crafty ingenuity combined with the pride and happy sense of accomplishment is projected to the audience, keeping them engaged.

The same ability to appeal to so many resulted in an immediate popularity of the art. Akin to burlesque foremother Lydia Thompson's appeal to the 1870s audiences, even neo-burlesque shows in smaller cities such as Memphis and Denver sold out the first time they did a show. Francean Fanny of Memphis Confidential remembers that the now-disbanded troupe was "a short lived but phenomenal success. The saucy, racy, yet never indecent production put together some of the area's best talents for sold-out shows every time."

According to The World Famous *BOB*, men and women love watching burlesque because, "Women see it and they feel empowered and guys see it and they feel that this is something new, it's not just another strip club. I've talked to some guys and they're usually into it for two reasons: one, they appreciate the thought behind the actual presentation, and two they like to see boobs."

Burlesque isn't like anything else found in modern entertainment. It's not like going to the theater, but it has those elements. It's not like seeing a band, but there is music. It's related to going to a strip club, but the sexuality isn't as blatant. It helps that the entertainment has a sexy payoff, but a lot

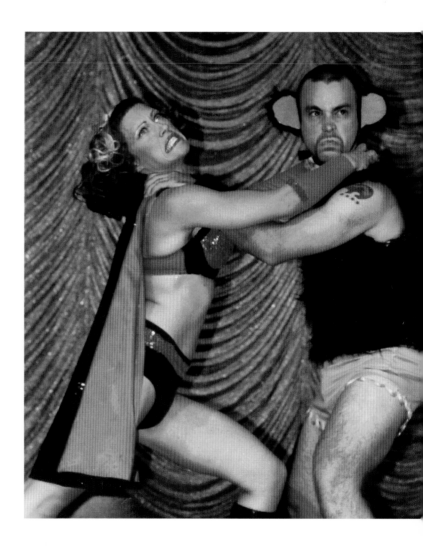

Trixie Little (above) fights off the obnoxious Evil Tapdancing Hate Monkey with the powers of cuteness.

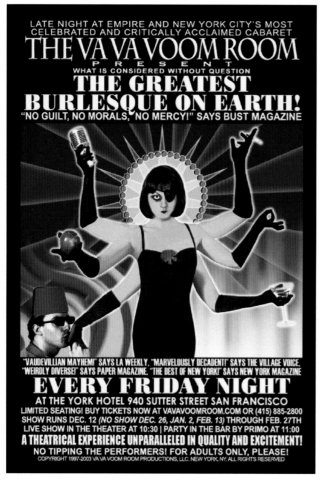

LATE NIGHT AT EMPIRE AND NEW YORK CITY'S MOST
CELEBRATED AND CRITICALLY ACCLAIMED CABARET
THE VA VA VOOM ROOM
P R E S E N T
WHAT IS CONSIDERED WITHOUT QUESTION
**THE GREATEST
BURLESQUE ON EARTH!**
"NO GUILT, NO MORALS, NO MERCY!" SAYS BUST MAGAZINE

"VAUDEVILLIAN MAYHEM!" SAYS LA WEEKLY. "MARVELOUSLY DECADENT!" SAYS THE VILLAGE VOICE.
"WEIRDLY DIVERSE!" SAYS PAPER MAGAZINE. "THE BEST OF NEW YORK!" SAYS NEW YORK MAGAZINE
EVERY FRIDAY NIGHT
AT THE YORK HOTEL 940 SUTTER STREET SAN FRANCISCO
LIMITED SEATING! BUY TICKETS NOW AT VAVAVOOMROOM.COM OR (415) 885-2800
SHOW RUNS DEC. 12 (NO SHOW DEC. 26, JAN. 2, FEB. 13) THROUGH FEB. 27TH
LIVE SHOW IN THE THEATER AT 10:30 | PARTY IN THE BAR BY PRIMO AT 11:00
A THEATRICAL EXPERIENCE UNPARALLELED IN QUALITY AND EXCITEMENT!
NO TIPPING THE PERFORMERS! FOR ADULTS ONLY, PLEASE!
COPYRIGHT 1997-2003 VA VA VOOM ROOM PRODUCTIONS, LLC. NEW YORK, NY. ALL RIGHTS RESERVED

*Poster for New York's Va Va Voom Room (above)
announcing the late night cabaret*

*Henry Fonda Music Box Theater, Tease-O-Rama (right)
showing reactions from the crowd during a set*

of the appeal of new burlesque is that it is unique, but audiences can still relate to it. There's a sense of fun at a burlesque show that turns the evening into a huge party. Audiences often dress up, sometimes dressing with the theme of the show, as is the case with London's Whoopee Club where patrons dressed as sailors and mermaids for their nautical show.

At the 2003 Miss Exotic World competition and reunion, pinup photographer and burlesque performer Candy Whiplash pondered the popularity of new burlesque and why so many men and women were attracted to it and asked, "Who's to say what the grand reasoning is? Will people cling on to it?" Looking around at the large crowd gathered she answered herself, "Obviously there are a lot of people here at this event. They could be at a strip club right now and they aren't, they're here in the middle of the desert."

The Female Audience of Burlesque

In *A Horrible Prettiness: Burlesque and American Culture*, Robert C. Allen admits that it is hard to trace when burlesque lost its female audience, but the move from the original burlesque pioneered by Lydia Thompson to its next incarnation was the first step. It mixed with old minstrel shows and featured song, dance, and variety more than narrative or drama, appealing to the lower classes more than the middle to upper class that Thompson had played to.

At the same time, vaudeville was starting to

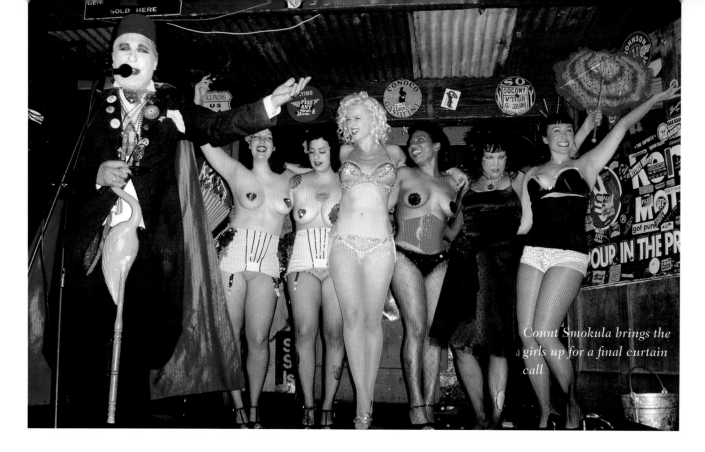

Count Smokula brings the girls up for a final curtain call

attract the crowds that were leaving burlesque by also offering a variety show, but a clean show, in theaters with marble floors and fancy lighting. As burlesque lost its wide appeal, it couldn't keep up with the spread of vaudeville as it infiltrated every city in the country. Burlesque stayed mainly in the larger coastal cites, relegated to specific "burlesque houses," and became known for its ethnic humor and choruses of scantily clad women. Respectable women stayed away from burlesque and instead went to vaudeville shows, leaving burlesque to working-class white men.

This trend continued into the next century, and, for the most part, burlesque became bawdier

and increasingly lowbrow, delivering what its male audience wanted. However in the 1950s, after burlesque had moved into nightclubs, women started to join men in the audience again. Living Legend Kiva, who started performing in the 1960s, said that, "Burlesque was something that men and women would come to see, not just men. It was very clean. Women were there to see the wardrobe and the men were there to see the girls."

There were many grand clubs at that time such as the Tropics in Denver, which, according to a profile in the summer 1956 *Cabaret Quarterly*, featured dinner and a show in a fantasy environment featuring pools of

live alligators, six-foot-tall voodoo masks, a rainstorm fountain effect along the walls, and an outdoor dance floor and garden. The loosening of society's collar that occurred in the cocktail era, along with the combination of dinner and dancing in a club atmosphere with local high-class exotic dancers and touring stars, made burlesque a possible destination for couples out on the town looking for a cabaret club with a little more spice. Mildred Baldwin, who visited the Tropics in the 1950s with her husband, Galen, loved the atmosphere and the dancers. ("I suspect he went there a lot without me too," she said with a wink.) Though they were stripping, she thought their dancing was beautiful: "What those women did was art."

However there were, in the 1950s, seedy dives that women were not as comfortable visiting. Baldwin felt distinctly differently about Sid King's place on the other side of town from the Tropics. Though the peelers at Sid's were billed as burlesque and there was a spider girl, a Russian "princess," and other themed acts, the one time she went she found them to be talentless and their dancing vulgar. As times changed, so did the clubs. As full nudity and racier acts became more acceptable and desirable in clubs, it became less appealing for women to go to a strip show or for men to take them there. Places such as Sid's became the norm, and they eventually developed into today's strip clubs.

Today, with the return of burlesque, women are also returning to the audience in greater numbers than they have since the earliest days of burlesque in the nineteenth century, when it was legitimate and popular theater. If early twentieth-century burlesque was "everyman's" entertainment, then new burlesque is "everywoman's" entertainment. Women come to burlesque looking for what they think is sexy and what can make them feel like they're sexy too. Burlesque striptease is closer to what a woman imagines when she thinks of stripping—the costumes, the lighting, the glitter, and the sensual and creative dance. Women leave burlesque shows with a new or renewed sense of their own sexual attractiveness. They identify with the women onstage, and though they might not have the courage to actually get up on the stage and dance, they can imagine themselves up there more than they could at a strip club. Women use burlesque events as a good excuse to dress up, identifying even more with the performers by putting themselves on display in their fanciest or sexiest outfits. Inspired by a burlesque show, many women go home and do a strip for their lover or for themselves in front of the mirror.

Performers often realize that what they are doing is feminist from the reaction of the audience. Candy Whiplash has had "a lot of girls approach me at shows and say, 'What you're doing onstage is what I do in my living room, but I've never been brave enough to do it. Thanks for embodying that for me.'" She also eliminates from her acts any connection to modern stripping, which tends to make most women uncomfortable,

and she tries not to "do anything that caters to males more than females. I like to cater to the whole audience and make the audience feel comfortable and happy." Colleague Bella Beretta agrees and remembers that the obsessive Gun Street Girls' fans were women. "I think it's because we gave them these superheroes. We gave them something to latch on to, in a sense. Women in the audience left our shows thinking, 'Wow, she can be flippant, she can be rude, she can be really sexy, she can be big—I want to be like that.' I hate the word *empowered*, but I think that's what they felt."

Interestingly, the love for and empowerment from burlesque sometimes crosses over into the strip club world. There is a growing female population at mainstream strip clubs. For some, it's a bit of a coup to invade what is seen as exclusively male territory; for others it's a fascination or amusement with seeing men's reaction to the fantasy females onstage.

Even burlesque performers have sometimes joined the strip club audience and found that dancing partially naked on the burlesque stage has changed their views of women on the strip club stage. Kellita of Hot Pink Feathers found that her perspective had changed between her first visit to a strip joint and her second visit years later. She originally visited a club because she wanted to integrate striptease into her own Brazilian-based dance and needed to see how it was done. The scene immediately turned her off. "I don't know if it was the night I went or the crowd that was there or who and where I was in my life, but the women didn't seem like they were having fun or celebrating themselves or being celebrated, and the men seemed like they were hiding and shameful. Everyone felt diminished." On her second trip to the same club four years later, after she had been stripping in burlesque for a couple of years, more of the strippers seemed like they were having fun and she had a completely different emotional response. "I don't know how much of that is me, and how much I've changed, but I didn't feel the shame or so much apathy for the women. I didn't feel the same amount of judgment that I once felt."

Perhaps those in burlesque who at first could not relate to modern strippers now can because of their own performance experience. Burlesque dancers know the feeling of the audience's gaze on their bodies and have learned the power of a sultry glance or a suggestive body movement. Their dance is more about art than money, but they still want the validation of the audience, the acknowledgement that their number was in some way a turn-on, just like any other stripper, past or present.

The Male Gaze

In a world where ultratan, thin, and busty *Maxim* girls rule, it's hard to believe that men would be interested in burlesque. Modern pornography that, by and large, features tanned women with slim figures and large breasts is aimed at men, so logic would leave us to believe that Amazons such as *BOB* or slim contortionists such as Harvest Moon would not attract a male audience.

Laura Herbert thinks that more women find burlesque a turn-on because, "Men would be fine with a more explicit, less tell and more show. And for women it's a scientific mixture of lighting and rhinestones and loose glitter and great music." Franky Vivid disagrees that burlesque is just a girl thing. Often it's assumed that women love burlesque because of the production values and the lighting and men don't need or want that. Franky counters that the men who "are coming to burlesque instead of strip bars are coming because they enjoy the production too. They enjoy the tease. Some of them are idiots and they get disappointed when you don't go all the way, but to a large extent I think guys would love to share their sexuality with their girlfriends, and this is something that both sexes can enjoy and get something out of it."

Men are in the audience, offering appreciative howls and wolf whistles, asking for autographs and photos after the shows, and, as was witnessed at a Dita Von Teese performance, jumping out of their seats and high-fiving each other at the removal of a stocking. However, sometimes the gaze is just not so kind. There are many men and women who don't like the look of neo-burlesque performers, whether it's their figures or, in the case of historian Rick Delaup, they hate the tattoos. "I think tattoos, onstage, read like big bruises on the body. I don't know how you can do beautiful, glamorous burlesque with tattoos." *New York Press* writer J. R. Taylor maliciously commented, "What could possibly

Delerium Tremens, at Otto's Shrunken Head in New York City, feigns shyness (above) while teasing her audience. Most burlesque performers say they find what they're doing very liberating.

compete with the First New York Burlesque Festival, that is, besides the unique spectacle of cigarette butts and pigeons? Fortunately, the fest brings in burlesque acts from outside New York, which saves the event from doubling as a tattoo convention."

The subcultures—punk, rockabilly, goth, general retro—that make up most of the burlesque community are part of a generation that is extremely accepting of tattoos and those who don't have them seem to be the exception. Bella Beretta, San Francisco's Eva Von Slut, Mimi Le Meaux, and the Pontani Sisters all have a number of tattoos, and many others such as *BOB*, Kitty Diggins, and other well-known burlesque stars are also tattooed. As burlesque moves out of the underground where tattoos and piercing are more accepted, this comment is likely to be repeated.

However, for the most part, though audiences are still generally more than half female, the men who are attending are enjoying what they see. They like the more comfortable atmosphere where they can enjoy a strip show without feeling the pressures of the money-driven strip club atmosphere, and often they too like the variety of women. Though the strip club dancer is a fantasy, the burlesque performer presents another fantasy—the fantasy of real women, women who look like women they date or just see on the street, in an exotic and erotic dance number.

Dirty Martini agrees and thinks that, "Men are just loving it, they're loving the ingenuity, the glamour,

and sexiness." She does still complain that too many men are still terrified of a woman doing burlesque and being sexually aggressive onstage. "Sometimes it's hard to be an over-the-top girl and still be able to find a man to love you. So it's a pretty incredible thing that these women are doing this now." Bella Beretta and the vicious vixens of The Gun Street Girls tended to intimidate most men. "Our best response was always from the ladies. The guys dug us, but I think we scared them a little bit, which was fully my intention. If you can get over the fact that you're terrified of me and still get turned on, that's a really good thing." Julie Atlas Muz, often parodies sex and sexiness, fellating a rose and then biting off the head and spitting the petals at the audience or pretending to be molested and attacked by a fake bloody rubber hand, and admits that while women just laugh, men tell her that she's frightening.

Models on magazine covers and stick-figure pop stars on MTV are the prevalent image of women in modern society, and often men need to be able to step out of that closed mind-set to be able to appreciate burlesque. They also have to be able to move away from the ideas that are promoted by strip clubs, to leave the Money = Sex equation that exists in that world.

Getting the Audience Involved

There is an awful gap that exists between how women perceive themselves and how the world sees them. Burlesque has the power to erode if not entirely

Let the dancing begin; (right) an after show party cranks into gear after a Tease-O-Rama show.

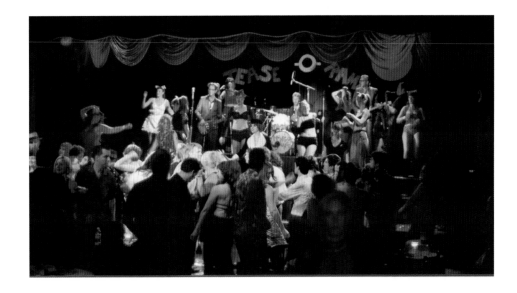

demolish that disconnect. A radical mind shift can happen in a woman while watching another woman who looks like them take the stage with confidence. While they listen to the appreciative applause of the audience as the performer exposes her body, they suddenly realize that they too have that power, and sexiness isn't limited to women with perfect breasts and waistlines. By learning to love what they have and who they are, they can be just as captivating as the women on the burlesque stage.

Burlesque embodies the spirit of *Flashdance* and *Gypsy*, the idealized image of a stripper, the archetype of the peeler that was generated by Salome and reinforced by Hollywood. It's the female fantasy of a stripper who has command of the audience by doing what she wants onstage, rather than what she thinks she has to do to retain the male gaze. Performers are presenting what appeals to them, and because of that it ends up appealing to other women.

In an article on the new burlesque in *Time Out London,* Sam Pow observed, "The old adage that (heterosexual) women dress for each other is old hat. They are now undressing for each other." Women who are drawn to burlesque soon find themselves wanting to learn even if they don't have the inclination to perform onstage. As women approached them after shows, new burlesque performers realized that this was another place they could use their burlesque skills—to teach others. Strip aerobics and stripping videos have become more popular as a novel way for women

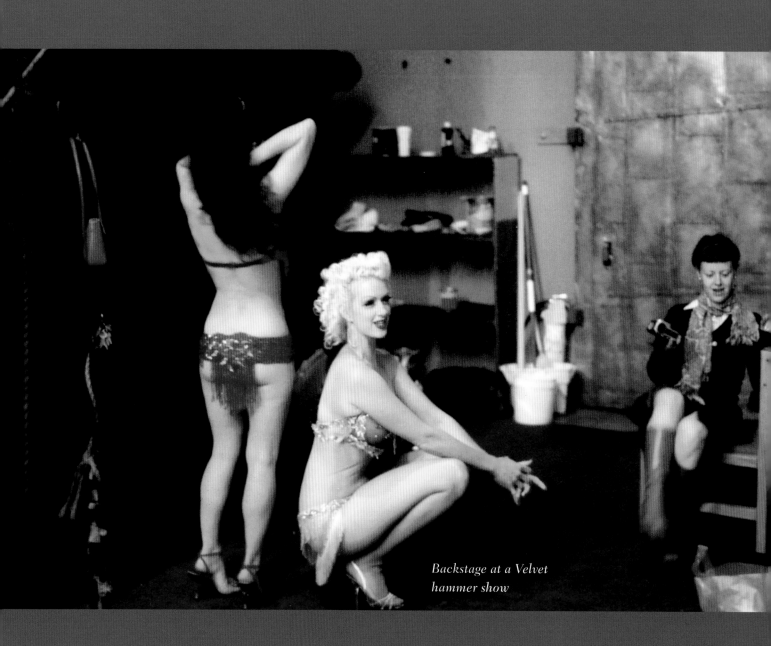

*Backstage at a Velvet
hammer show*

to get into shape, and Sheila Kelly even appeared on *Oprah* to promote her book and video, *The S Factor: Strip Workouts for Every Woman*.

However, burlesque has a different appeal. There is a set of prescribed moves in modern stripping and only a certain type of woman can really look good posing bent over with the seriously sexy attitude of a stripper or crawling the length of a neon-lit stage. Burlesque doesn't require that women be sex goddesses or have the athleticism to swing around a pole. Instead, burlesque encourages women to do whatever feels sexy to them, to wrap themselves in boas and sequins and be confident that no matter what their body looks like, if they can shake their hips to a beat and embrace the idea that they are sexy, the audience (whether a crowd, the woman's lover, or just her own reflection in the mirror) will see what they feel and react positively.

The feedback for Heather "Miss DeMeanor" MacAllister's Fat Bottom burlesque workshops has been consistently positive and reflects other performers' testimonials on how new burlesque is perceived by the women onstage and the women in the audience. They felt empowered by seeing them-selves "reflected in a body-positive way." Similarly, At Miss Indigo Blue's Tassel Twirling class at the Tease-O-Rama convention, boobs of every age, shape, and color were represented. The narrow room was filled with forty topless women sporting tasseled pasties watching each other, offering encouragement as the tassels moved around and around, and suggestions if the tassels weren't quite moving in the direction they were supposed to. Though they were among strangers, the look in each and every woman's face was not of embarrassment or discomfort, rather their expressions alternated from deep concentration as they attempted the next move to astounded joy as the tassels whipped around in unison.

Burlesque is acceptable, naughty fun. At a bachelorette party where a burlesque gal is hired to teach lessons, everyone from the mother of the bride to her youngest sister will dig into the costume bag and join in, moving their hips around as they learn the slow and then the fast grind, or as they bump left, right, forward, and back to the beat of an old burlesque tune. When the time comes, they'll throw their clothes around, peeling off gloves, mermaid bras, and sparkly skirts with abandon, each incorporating the old moves with their own style. At the end, as they put the shiny costumes away, they compliment each other's newfound abilities and chat about their love lives, pondering their lover's reaction if they bring a little burlesque into the bedroom or if they themselves would ever be brave enough to "take it off" onstage.

As the visibility of burlesque grows, so does the number of women moving from the audience to the stage. Numerous girls can't resist the lure of the stage after seeing a show, and *BOB* and Bella Beretta have given them the chance to perform in their amateur nights. The great number of shows that exist has allowed innumerable opportunities to get involved for

anyone who has the desire. Even in the earliest days of neo-burlesque, women in the audience were inspired to join in after seeing a show.

The audience and the performers love that the sexy playacting that everyone has indulged in, from the first time they stole their mother's heels and lipstick to vamp in the mirror, doesn't have to be kept hidden any more. World Famous Pontani Sister Helen Pontani loves that in burlesque "anything you used to do in front of your mirror, practicing to music on the radio and putting on a feather boa, now you can take it to the stage."

Family Entertainment

Though it is far from family entertainment, many burlesque performers' families support what they're doing and even attend shows. When Bella Beretta started up The Gun Street Girls, her mother was shocked and asked, "What the hell are you doing?" But then, as Beretta retells it, "She came and saw our first big rock show and was completely blown away." After that she paid for the website as her donation to The Gun Street Girl cause, had a sticker on her car, and always wanted a special T-shirt that said, "My Gun Street Girls Beat Up Your Burlesque Dancer." Beretta's dad was as supportive, going to the shows and trying to give them advice on numbers.

"If you want to talk about a shift in era, when burlesque was burlesque, it was stripping. It was something a woman of ill repute did. And you look at the people doing burlesque now and half of our moms come to our shows." Beretta feels that it's much more acceptable now. "Our families support us, love us, wear our T-shirts, tell their friends. That's the difference. It isn't family entertainment by any means, but it's also not a shocking scandalous thing any more."

The rest of the Pontani family shows up for the World Famous Pontani Sisters' gigs, most of the parents of the women of Burlesque As It Was attend their shows, Catherine D'Lish's mother met her out on the road when she toured with Burlesquefest, and Amber Ray's father and stepmom came to see her at the New York Burlesque Festival. "My father, being an artist, Zen Buddhist, and a Triumph motorcycle expert, was very proud of me and he understood and saw what I have been pushing for the last seven years of my life and why I wanted to do it. After a torrential adolescence, needless to say, my parents are very proud of me, *finally*."

Bawdy beauty, Dirty Martini caught in mid-twirl

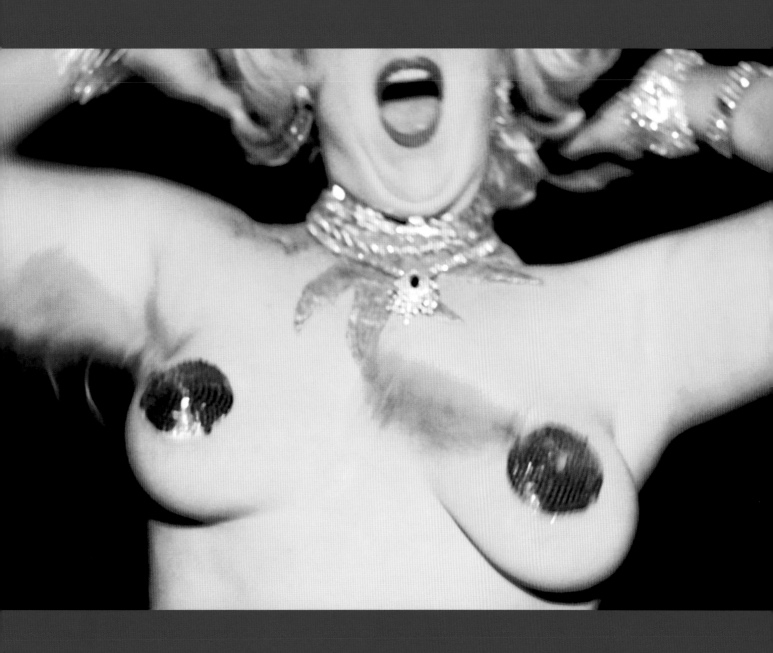

Troupes, Clubs, and Select Web Sites

Atlanta
The Doll Squad: www.dollsquad.com

Austin
Kitty Kitty Bang Bang™: www.kittykittybangbangshow.com
Red Light Burlesque: www.redlightburlesque.com

Baltimore
Trixie Little: www.trixielittle.com

Boston
Black Cat Burlesque: www.blackcatburlesque.com
Through the Keyhole Burlesque: www.thruthekeyhole.com

Chicago
Lavender Cabaret: www.lavendercabaret.com
Sissy Butch Gurlesque Burlesque: www.sissybutchbrothers.com

Denver
Burlesque As It Was: www.burlesqueasitwas.com
Ooh-La-La: www.oohlalapresents.com

Detroit
Sparkly Devil: groups.yahoo.com/group/sparklydevil*Atlanta*
Dames A'Flame: www.damesaflame.com

Los Angeles
Kitty Diggins: www.kittydiggins.com
Bella Beretta: www.bellaberetta.com
Kitten Deville: www.kittendeville.com
Lucha VaVoom and the Buxotics: www.luchavavoom.com
Pussycat Dolls: www.pussycatdolls.com
The Fishnet Floozys: www.thefishnetfloozys.com
BRA (*Burlesque Revival Association*): www.burlesquerevival.org
Velvet Hammer Burlesque: www.velvethammerburlesque.com

Duex Filles: www.deuxfilles.net
Princess Farahana: www.princessfarhana.com
Selena Luna: www.seleneluna.com
Dita Von Teese: www.dita.net
Catherine D'Lish: www.cdlish.com

New Orleans
Gio, Burlesque Queen of New Orleans: www.giotalks.com

New York City
Amber Ray: www.amberray.net
The Bombshell Girls: www.thebombshellgirls.com
Bambi the Mermaid: www.bambithemermaid.com
Bindlestiff Family Cirkus: www.bindlestiff.org
Burlesque at the Beach: www.coneyisland.com/burlesque.shtml
Dirty Martini: www.missdirtymartini.com
Le Scandal: www.lescandal.com
Little Brooklyn: www.littlebrooklyn.com
Lukki: www.lukki.com
Miss Delirium Tremens: www.missdeliriumtremens.com
Mr. Murray Hill: www.mrmurrayhill.com
Scotty the Big Blue Bunny: www.scottybunny.com
The Glamazons: www.glamazongirls.com
The Great Fredini: www.thisorthat.tv
The Wau Wau Sisters: www.wauwausisters.com
The World Famous *BOB*: www.worldfamousbob.com
The World Famous Pontani Sisters: www.pontanisisters.com
Ula the Pain Proof Rubber Girl: www.painproofrubbergirls.com
Va Va Voom Room: www.vavavoomroom.com

Portland
Lucy Fur: www.lucyfurpresents.com

Sacramento
Cherry Malone: www.cherrymalone.com

San Diego

Mimi Le Meaux & Dames in Disdress: www.mimilemeaux.com

San Francisco

The Devil-Ettes: www.devilettes.com

Dane's Dames: www.danesdames.com

Gorilla-X: www.gorilla-x.com

Eva Von Slut: www.deadgirl13.com

Harlem Shake: www.harlemshakeburlesque.com

Hot Pink Feathers: www.hotpinkfeathers.com

Kitten on the Keys: www.suzanneramsey.net

Kitty Kitty Bang Bang SF: kittykitty.davedeluxe.com/main.html

Ms. Demeanor's Fat Bottom Revue: www.bigburlesque.com

San Francisco's Famous Burlesque: www.sfburlesque.com

The Lollies: www.thelollies.net

Felicity and Molotov: www.felicity-and-molotov.com

Seattle

BurlyQ: A Queer Cabaret: www.burlyq.com

Candy Whiplash: www.candywhiplash.com

Glitzkrieg Burlesque: www.glitzkriegburlesque.com

Burning Hearts Burlesque: www.seattleburlesque.com

Vermont

Spiel Palast Cabaret:
www.tenthousandvisions.netfirms.com/cabaret/index.html

Australia

Lola the Vamp: www.lolathevamp.net

Canada

Fluffgirl Burlesque: www.eyeteaser.com/fluffgirl

Skin Tight: www.skintightouttasight.com

Japan

Erochica Bamboo: home.att.ne.jp/grape/erochica

United Kingdom

VaVaVaVoom: www.vavavavoom.co.uk

Bands

Big John Bates and the Voodoo Dollz:
members.shaw.ca/bmotel/index.html

The Sophistacats and Sophistakittens:www.thesophisticats.com

Fisherman's Burlesque: www.fishermansburlesque.com

DeVotchKa: www.devotchka.net

Devil Doll: www.devil-doll.com

Magazines

Atomic Magazine: www.atomicmag.com

Star and Garter Burlesque Magazine:
www.starandgartermagazine.com

Pink Pussycat Productions: www.pinkpussycat-productions.com

Bust: www.bust.com

Photographers

Victoria Renard: www.victoriarenard.com

Raoul Gradvohl: www.cmp.ucr.edu/site/exhibitions/gradvohl

Katharina Bosse: www.katharinabosse.com

Luke Littell and Laura Herbert: www.exoticworldusa.org

Laure Leber: laure@laureleberphoto.com

Misa Martin: www.misamartin.com

Don Spiro: www.donspiro.com

Films

Guerilla Monster Films: guerrillamonsterfilms.com

The Velvet Hammer Burlesque: www.itsachick.com

It's Burlesque: www.aande.com

Costumes

Blues and Burlesque Costumes: www.bluesandburlesque.com
Burlesque Costumes: www.burlesquecostumes.com
Twirly Girl Pasties: www.twirlygirl.net
The Costumer's Manifesto: www.costumes.org

Festivals and Shows

Epicurean Productions: www.epicureanproductions.com
This or That!: America's Favorite Burlesque Gameshow:
www.thisorthat.tv
Show Nightclub: www.shownightclub.com

Miss Exotic World Competition:
groups.yahoo.com/group/missexoticworld
Coney Island: www.coneyislandusa.com
Tease-O-Rama: www.teaseorama.com
New York Burlesque Festival:
www.thenewyorkburlesquefestival.com

Legends

Exotic World Burlesque Museum: www.exoticworldusa.org
MisGalatea: www.geocities.com/misgalatea/Burlesque2000.html
Satan's Angel: www.satansangel.com

ETC

Kara Mae, burlesque fan: www.karamae.com
Library of Congress American Variety Stage:
lcweb2.loc.gov/ammem/vshtml/vshome.html
Jo "Boobs" Weldon's Fanzine:
www.gstringsforever.com/burlesque.html
Joe Bates: www.joebates.com
Bootleg Burlesque: www.bootlegburlesque.com
Der Dumboozle?: www.geocities.com/~jimlowe/newindex.html
Palomar Agency: www.palomaragency.com/index.htm

Groups

Tease-O-Rama: groups.yahoo.com/group/teaseorama
Burlesque Revue: groups.yahoo.com/group/burlesquerevue
Miss Exotic World Competition:
groups.yahoo.com/group/missexoticworld
TEASE! The Magazine of Sexy Fun!:
groups.yahoo.com/group/teasemag/
Toronto Burlesque and Vaudeville Alliance:
groups.yahoo.com/group/Toronto_Burlesque_Vaudeville_Alliance

Bibliography

Sobel, Bernard. *Burleycue: An Underground History of Burlesque Days*. New York: Farrar and Rinehart, Inc., 1931.

Sobel, Bernard. *A Pictorial History of Burlesque*. New York: Bonanza Books, 1956.

Allen, Robert C. *Horrible Prettiness: Burlesque and American Culture*. Chapel Hill: The University of North Carolina Press, 1991.

Rothe, Len. *The Bare Truth: Stars of Burlesque from the 40s and 50s*. Atglen: Schiffer Publishing, Ltd., 1998.

Rothe, Len. *The Queens of Burlesque: Vintage Photographs from the 1940's and 1950's*. Atglen: Schiffer Publishing, Ltd., 1997.

Stencell, A. W. *Girl Show: Into the Canvas World of Bump and Grind*. Toronto: ECW Press, 1999.

Hellman, Harald. *The Best of American Girlie Magazines*. Köln: Taschen, 1997.

Corio, Ann. *This Was Burlesque*. New York: Grosset & Dunlap, 1968.

Parker, Derek and Julia. *The Natural History of the Chorus Girl*. Indianapolis: Bobbs-Merrill Company, Inc., 1975.

Muller, Eddie. *That's Sexploitation: The Forbidden World of "Adults Only" Cinema*. London: Titian Books, 1997.

Index

143

Credits

Don Spiro is an L.A. based freelance cinematographer with several short films and videos to his credit. Having worked professionally as both a union camera assistant and lighting technician since 1991 on such shows and films as *Malcolm in the Middle* and *Memento*, he is experienced in a wide range of formats and styles. His hobby of still photography also requires he spend a lot of time with burlesque performers. His main camera is still the same Nikon FE he bought new in 1978. Associated for years with the Velvet Hammer Burlesque troupe in Los Angeles, he has collaborated on programs, posters, and portraits for the Velvet Hammer and Lucha Vavoom and was the cinematographer on his girlfriend Augusta's recent documentary, *The Velvet Hammer Burlesque*.

pages: vi, 16, 19, 22, 25, 26, 30, 32, 35, 36, 37, 39, 40, 46, 51, 52, 57, 58, 61, 64, 66, 70, 72, 75, 76, 79, 84, 85, 88, 94, 98, 99, 102, 106, 113, 116, 118, 122, 127, 128, and 134

Laura Herbert is a writer, photographer, producer, and aspiring mudflap girl. A connoisseur of pin-up art and artifacts, and self-confessed "burlesque nerd," Laura is also webmistress of exoticworldusa.com, the official Exotic World Burlesque Museum website, which she runs with her fiancé, Luke.

Luke Littell is a filmmaking, naked lady-lovin', red-blooded American. He lives in New York City with his fiancé, Laura, and their pitbull, Roxanne. Luke is an active archivist of the national burlesque scene and serves as Marketing Director for the Exotic World Burlesque Museum. He and Laura were engaged at Tease-O-Rama!

pages: 15, 12, 29, 32, 34, 48, 54, 56, 59, 83, 86, 95, 100, 117, 121, 125, 131, and 133

Laure Leber *pages: 63, 114, and 137*

Richard Heeps *pages: ii, 18, and 73*

Dave McGrath *cover*

Misa Martin *page: 107*

Dixie Evans and The Exotic World Museum *pages: viii, ix, xi, 9, and 12*

Catherine D'Lish *pages: 69 and 80*

Bombshell Girls and The Lady Ace *page: 89*

Big John Bates and the Voodoo Dollz *page: 111*

Dames A'Flame and Madly Deeply *page: 92*

DeVotchKa *page: 110*

Gorilla X *page: 104*

Kitten on the Keys *page: 96*

Lavender Cabaret and Franky Vivid *page: 31*

Ronnie Magri and His New Orleans Jazz Band *pages: 108 and 109*

Stella Starr *page: 119*

Wau Wau Sisters *page: 101*

Jo "Boobs" Weldon *page: 27*

Library of Congress *pages: 3 and 6*

Author's Collection *pages: xii, vi, 2, 4, 8, 10, 11, 21, 33, 41, 43, 82, 91, 93, 117, and 126*